Watercolor

Fundamentals for beginners

Author: Arco Editorial Team
Editor: Francisco Asensio Cerver
Publishing Director: Nacho Asensio
Graphic Design & Layout: David Mataró

Copyright © 2000 Atrium International

c/ Ganduxer, 115, 4°
08022 Barcelona, Spain
Tel.: 34-93 418 49 10
Fax: 34-93 211 81 39
E-mail: arcoedit@idgrup.ibernet.com

ISBN: 84-8185-229-5
Dep. Legal: 48561-99

Printed in Spain

LEARN HOW TO PAINT IN WATERCOLOR

Starting on the next page the perserverant reader will find the fundamentals with which to learn how to paint in watercolor, a wide range of practical advice introducing them through a carefully planned program to the techniques of controling the paintbrush, how to handle the paper and other materials -all of which are essential elements when making your artistic inspiration a reality on the paper.

Arco Editorial Team is a group of professionals integrated in the Fine Arts' World whose profession and vocation is to teach students interested in the different pictorical tecniques. Over these 20 chapters we deal thoroughly and in detail with the subjets that we teach our students everyday.

We do this fully confident that our role in this task consists of explaining how to master the techniques and to reveal to the pupil all the practical experience that we have picked up as professional painters and teachers over many years.

The reader can be confident that they will be guided through the different practical exercises that are included in the book in such a way that their painting instinct is fine-tuned. At the end they will have a pleasant memory of their first steps in the world of watercolor.

Choose your materials and let's begin!. Disconnect from the rest of the world and dedicate two or three hours to painting. It will soon become a real passion. Pay attention and do not rush into the next topic until you dominate the one you are working on. Combine reading the text with doing the practical exercises. Awake the artist you have inside you with discipline and continuous dedication and, above all, remenber that only by mastering the basic techniques will you be able to mould your ideas on canvas or paper, converting them into the works of an artist.

Arco Editorial Team.

TOPIC 1

MATERIALS (1)

Watercolor is a painting medium made up of pigment, Gum Arabic and glycerin, all of which are dissolved in water. When the watercolor paint is wetted with the brush the gum Arabic, which contains the pigment, is softened so causing it to impregnate the brush. This is the basis of the painting process.

Among the common packagings, watercolor tubes allow the painter to control the amount used. Watercolor in little pans is suitable for immediate use without there

being any waste.

The basis of the watercolor technique are the superimpositions and transparencies, which means that the more water added the more transparent the resulting watercolor will be. As it is a transparent medium it has to be painted on white paper and its great advantage is that almost transparent colors can be obtained.

The brushes require special care for the way the paint takes to the paper depends on them.

Restoring a dry watercolor

A watercolor stroke or stain can always be changed, although it is dry. It only has to be dampened so that the water dissolves the gum Arabic containing the pigment, making it more liquid and easy to handle. This option means that the manufacturers can offer dry watercolor paints or semi-wet pastes.

Immediate dissolving

Watercolor in tube form can be dissolved immediately and therefore gradations (the passing from one shade of color to another by very small degrees) are easy to do. The watercolor color becomes more luminous as it is made more transparent by the water. As more color is added and the water solution becomes more concentrated, the transparency is reduced. Therefore the color loses the luminosity given by the white background.

THE TUBES

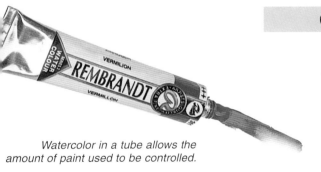

Watercolor in a tube allows the amount of paint used to be controlled.

A sticky touch

One of the principal characteristics of a creamy watercolor must be its oily stickiness. The paste must be creamy with a uniform plastic texture. This is achieved with finely selected materials, high quality ground pigments, and, even more complicated, a delicate balance between solubility and practicality. High quality creamy watercolors are very soft and on contact with clean water (preferably distilled) give rapid, uniform blendings.

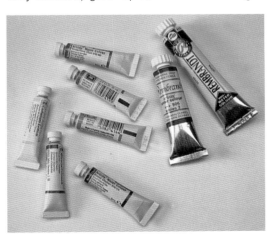

High quality watercolors in a tube. The components are carefully selected.

Creamy watercolors

It is the gum Arabic which gives the watercolor its adherence properties: it is the agglutinin. Under normal conditions the gum Arabic is hard but soluble in water. The glycerin provides the humidity and prevents the gum Arabic from solidifying. In the old days a creamy watercolor used to contain water mixed with honey, a humidifier and preservative.

The watercolor paint must be dissolved in water before painting. This involves wetting it with the brush. However, if the watercolor is doughy the painter does not have to soften it up for it easily dissolves into the water.

High quality watercolors are characterized by the way they quickly dissolve in water, offering subtle transparencies without losing their tone.

High quality creamy watercolors are very soft. Contact with clean water gives a speedy and smooth blending.

Steer clear of creamy school watercolors

Even a hobby painter must always use quality products right from the beginning. If you start out with cheap watercolors for schools you will never get satisfactory results. The colors will be dirty or dulled, the mixes incomplete, and the characteristic watercolor light will be missing.

Watercolor in a tube favors the dissolution and the creation of films.

The tubes must remain closed

When you are working with tubes be careful to put the lid back on after every use to avoid accidentally swapping the tops, and dirtying the different colors which would be noticeable every time the color came out. Putting the top on properly avoids oozing out and the color drying up.

Two samples of gradations. The first has been done with a quality watercolor, and the second with school watercolors. Which color is worth having?

THE PAINT BLOCKS

The necessary quality level

Many different types of watercolor are on offer. They can be broken down into three groups according to the target group the product is aimed at: schools, the hobby painter or the professional artist.

To begin it is necessary to remember that school watercolors are widely used. Watercolors for hobby painters come in various qualities according to the brand; if you are going to work with these it is worth using recognized brands. Watercolors for professionals are manufactured by prestige brands and give optimum results both in terms of color luminosity as well as in dissolution. The drawback is that they are expensive for the amateur.

Compare the results with good watercolors and with simpler ones. You can then decide on the price-quality trade-off you want.

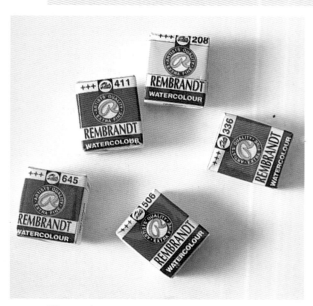

Watercolors come in pans to be fitted into the palette.

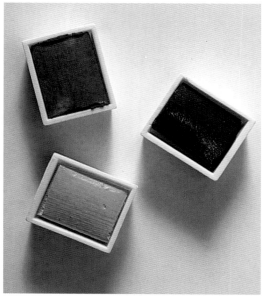

The watercolors in pan form can be dry or semi-humid. The choice is a question of taste.

Compare a mix done with a simple watercolor to that done with a professional watercolor.

Dry and semi-humid watercolors

Watercolors in pans can be dry or slightly pasty. Dry watercolors are hard and you have to wet them before the paint becomes liquid. The semi-humid watercolors contain a humidifier, before bull's bile was used, which avoids the gum Arabic drying out completely and favors the uniform flowing of the paint on the paper.

Quality watercolors should not give any dissolution problems as the components are carefully selected. However, logically the rapid dissolving of a pasty watercolor means that it is slightly more versatile than a solid watercolor.

The pans do not have to be cleaned after each use

The watercolor mixes are carried out in special palettes with little dishes. Whenthe water evaporates, the watercolor dries but it does not lose its effectiveness. The dishes must not be cleaned after each session: the color can be reused another day just by wetting it.

Watercolors must not crack

A quality watercolor must present a smooth and shiny surface. When it is wetted and dries out again its surface should recover its rubbery look. Some low quality watercolors crack on the surface when they dry, which is an indication that the components of the paint medium are not balanced.

Immediate dissolving

Dry and semi-humid watercolors are usually wetted in the little dishes so that they do not run. An advantage over the tube watercolors is that there is no waste because only the paint impregnated in the brush is used. Choosing one or another watercolor is a question of taste: the results are the same if you compare dry watercolors with the semi-humid ones.

Only if a watercolor dissolves immediately can it be considered high quality. Dry watercolors can take longer than the semi-humids to impregnate the brush, but many watercolorists prefer the former because they are cleaner.

When dissolving in water it is wise to use distilled water, so avoiding salt and impurities in normal tap water that can alter the structure of the paint. However, many painters consider that this is taking unnecessary precautions and therefore dilute the watercolor with normal water.

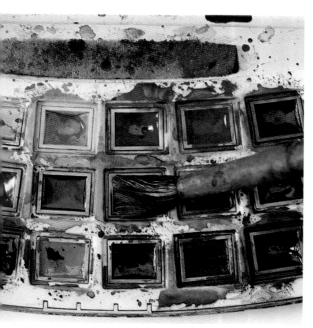

To use a watercolor pan it is only necessary to rub it with a wet brush.

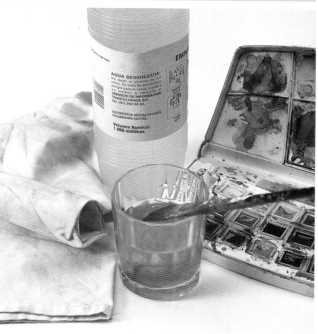

The watercolor softens up with the humidity of the brush. It is advisable to use distilled water to avoid the alkalinity of normal water, although the majority of watercolorists use tap water.

THE BRUSHES

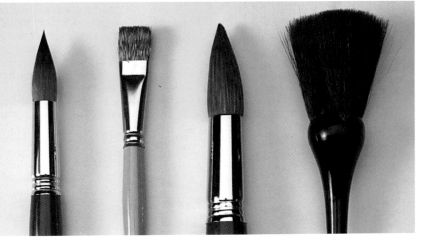

A range of watercolor brushes: sable hair, mongoose, ox and wolf hairs.

Watercolor brushes

Without doubt the best brushes for water-color are the ones with sable or mongoose hair. Although these tools are expensive their perfect stroke makes them the ideal watercolor brush.
Ox hair brushes do not form such a good point as the sable brushes but they allow quite good quality work. On the other hand synthetic brushes give a good stroke and point, but, so far, a synthetic brush with the same absorption qualities as sable hair has not been found.
Finally, Hog brushes are rougher but they can be useful for some works.

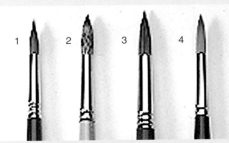

Sable hair brush (1), Mongoose. (2), Ox (3) Synthetic (4). The differences between them are clear from the color of the hairs.

Water absorption of the brush

The brush retains water because the natural hair has a scaled texture which prevents the water slipping down the surface.

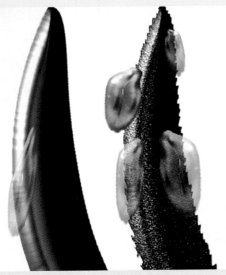

(Left) amplification of a synthetic hair brush. (Right) amplification of a natural hair brush.

The requirements of a watercolor brush

The brush is the principal tool of the painter with which they take the paint from the palette to the paper. The brushstroke gives the picture form and composes the characteristic staining.
The watercolor brush must have the qualities that permit a very liquid or very precise stroke. Therefore the hair must be soft, springy and able to recover its shape when wet. It must be absorbent but allow the paint-load to be laid onto the paper.

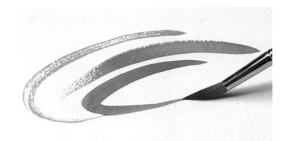

The watercolor brush must be springy and absorbent so that a continuous stroke can be made.

Brushes that must be avoided

With a few exceptions it is always advisable to use good quality brushes. School brushes and brushes for other mediums have to be ruled out. School brushes are normally of pony hair, are not firm and do not make a point. Too hard brushes, or brushes with split hairs are of no use either because they make a precise stroke difficult. The watercolor paint can not be distributed correctly over the paper.

School brushes like these are to be avoided: you cannot trust the results they give.

Soft but firm, sprinngy brushes are suitable

The best brushes for painting watercolors do not go limp when they are wetted, instead they keep their shape despite the water load.
The elasticity of the brush allows it to recover its shape after a stroke has been made. However, a watercolor brush must not be hard but rather the opposite. Its softness determines the precision of the stroke.

After wetting and stroking with the brush it must recover its shape.

The brush hair must be soft, elastic and able to recover its shape when it is wet. It must be absorbent but allow the paintload to be laid onto the paper.

Fan shaped brushes. They are ideal for doing films.

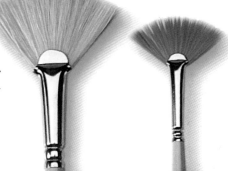

THE PAPER

White papers with body are suitable

Watercolors are painted principally on paper. Although a great variety of papers exist in the market not all of them allow good work. Choosing an adequate paper is fundamental for getting a good watercolor result. Many different types of paper textures are sold for the different varieties of work.

Watercolor papers can be smooth (with little or no grain) or textured. Thick grained papers are only suitable for special work. In general, medium grain paper is the most widely used.

Watercolor is a completely transparent medium that becomes luminous due to the whiteness of the paper. This means that the paper used must be pure white.

As watercolor is a watery medium the paper is continuously getting wet. Thin papers, which weigh little, soon become soggy because they do not have enough body. Therefore papers with sufficient body are recommendable.

Papers which must be avoided

Too absorbent papers should not be used because they do not allow the paint to be correctly distributed. Glossy papers are also ruled out because the excessively smooth surface does not allow the watercolor to penetrate into the pore. Colored papers dull the luminosity of the paint and prevent pure colors being obtained. These type of papers are aimed at opaque paintings, or temperas or pastels.
Very fine papers have to be rejected because their lack of body means they become soggy, wrinkle and do not let the brush flow smoothly.

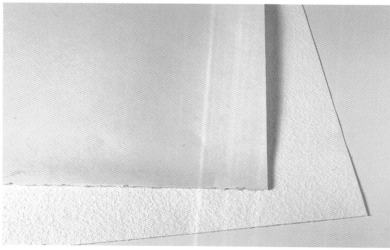

Watercolor is a completely transparent medium that becomes luminous due to the whiteness of the paper and therefore the latter must be completely white.

Colored paper is not recommended because it takes luminosity away.

It is important that the paper has body.

Different types of paper and the way they respond to the stroke

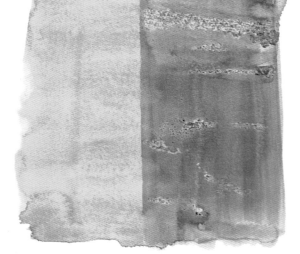

Low quality papers must be avoided.

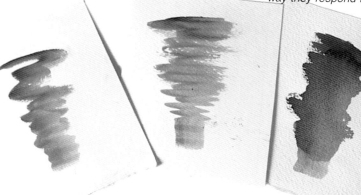

Choose quality watercolors

It is always better to go for watercolors that offer a guaranteed quality. The colors will be more luminous, the mixes richer and the color blending immediate.

The firmness of the brush

The brush must recover its shape, even though it may be soft, and be able to hold the load.

Pans or tubes: the most comfortable

Semi-humid watercolors are the most comfortable to use. The pan form is more practical than the tube.

Do not paint on just any paper

You have to choose papers suitable for the work that you are going to do. It must have body (acceptable weight), be white and be lightly sized.

DISSOLVING

How to dissolve creamy watercolor from a tube

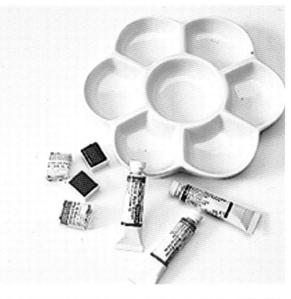

Creamy watercolor comes in tube and pan form.

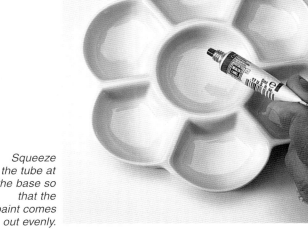

Squeeze the tube at the base so that the paint comes out evenly.

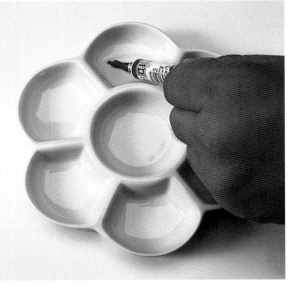

Squeeze a little amount on to the palette, dragging slightly.

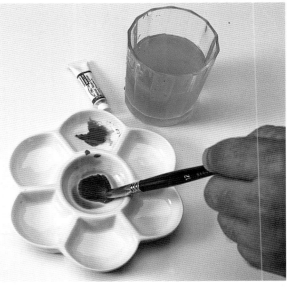

Brush the paint lightly with a little water. Place this load in a clean part of the palette and then add water until you get the desired tone.

Using the tube

Tube paints are a relatively new invention. The first prepared colors were launched in the market in the 18th century. They were sold in little bags that were pierced with an ivory or bone nail. Some time later a brass tube appeared. It had a plunger like a syringe. The tube continued to evolve until a tin tube with a lid came on to the market. Finally, the screw type lid was invented and was sold as it is today.

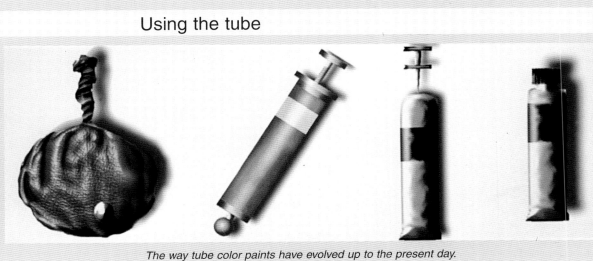

The way tube color paints have evolved up to the present day.

Taking semi-humid paint out of the tray

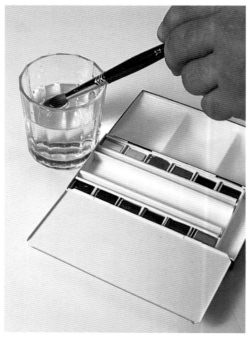

Wet the brush in clean water.

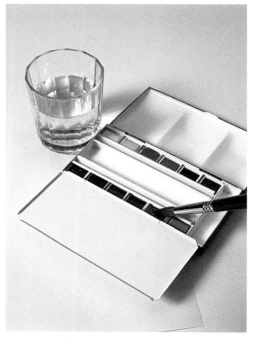

*Take up a small amount
of paint with the wet brush.*

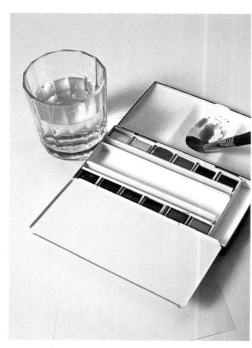

Unload the brush by dragging it on the palette.

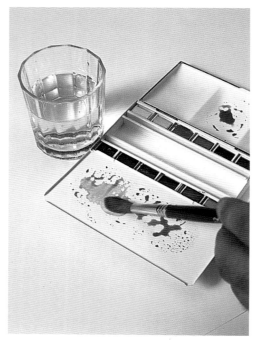

*Dampen the brush and wet the paint
on the palette until you obtain the consistency
required. It is the same procedure as
for the creamy watercolor.*

Paint in tubes

Paint out of a tube which has become
hard over time cannot be recovered. In
contrast, watercolor in pan form can
always be used again.

How to dissolve dry watercolor pans

Dry pan watercolor is a very common form
of presentation. To dissolve it requires a little
more time than the semi-humid pans.

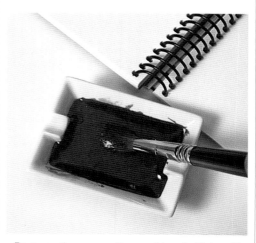

*Dampen the pans with a wet brush. Rub softly
until the watercolor dissolves and mixes with
the water.*

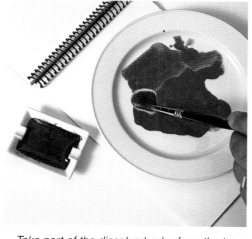

*Take part of the dissolved color from the tray
and place it on the palette.*

Do not spoil the brush

When dissolving the watercolor
do not apply too much pushing
or grating pressure on the
dry pans for this would perma-
nently damage the hair tuft.
Dilute the watercolor with the
brush at an angle and going
round in soft circles.

Dry or semi-humid watercolor

When deciding on dry or semi-humid watercolor,
remember that the latter dissolves immediately
without it being necessary to rub the pans with the
wet brush. However, the semi-humid watercolor
allows a greater quantity of paint to be placed
on the palette and therefore the colors can be
denser than those obtained from dry pans.

TESTING THE PAPER

Color on dry paper

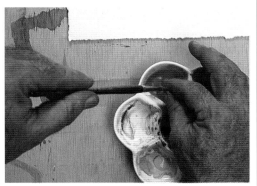

Wet the brush in clean water and make a watercolor blue wash on the palette. Gently squeeze the excess water out of the brush rotating the hairs into a point between the fingers.

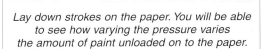

Lay down strokes on the paper. You will be able to see how varying the pressure varies the amount of paint unloaded on to the paper.

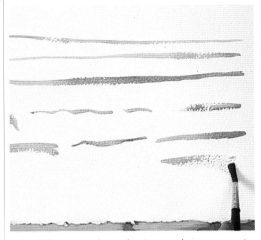

Do different strokes: short ones, long ones, etc. When the watercolor has run out, wet the brush once again in the palette.

Watch out

When you want to do a long and continuous stroke, do not put down a fresh stroke overlapping a dry one. Adding two tones will produce an abrupt change. To avoid this effect the second brushstroke must be applied while the first is still wet.

How to avoid the paper wrinkling

As the watercolor wets the paper the soaked pores expand. This dampness wrinkles and cockles the surface of low weight papers. To avoid this, wet the paper completely and then before it is totally dry stretch it over a frame or board, held by sticky tape. Once it is dry it will be totally tense and will permit painting without wrinkles or cockling.

Conclusion on papers

The best papers for watercolors are lightly sized, white in color and with a lot of body. Medium grain is best for all types of work.

Always choose the right paper

The grain of the paper can always be seen at first sight. Watercolor papers can be fine, medium or thick grained. *Fine grain* is perfect for precise works. To get this finish the paper is pressed cold during its manufacture. *Medium grain* is the most heavily used by watercolor painters. It favors precise work but is also used when the texture of the paper is to play a role. *Thick grained* paper has a very marked texture and is often used for special work. It is not recommended for a beginner.

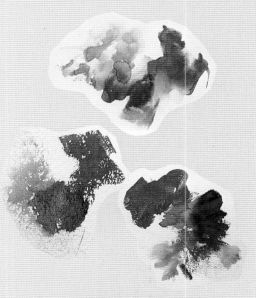

Color tests on fine, medium and thick grained paper.

The color chart is a guide for the artist.

COLOR ON WET PAPER

Testing color on wet paper

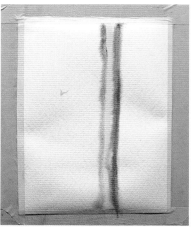

Place the paper on a rigid support. Hold it with sticky tape.

Wet a wide brush in clean water and use it to dampen all the paper in such a way that the humidity is absorbed.

Take watercolor from the palette and make a fine brushstroke on the wet paper. Repeat the operation with different colors.

Use various colors before the paper dries. The strokes swell out and their edges blend into each other.

DIFFERENT PAPERS

The weight of the paper

The grams of the paper measure the density in grams per square metre. Therefore, lightweight papers (50 to 75g/sq metres) are thin and have little body. High gram papers (250 to 400g/sq metres) are hard papers which can absorb a lot.

Different papers: the thinnest are low weight.

Absorption by the paper

Take different types of paper of distinct grains and weights. Place the fine grained, light papers on the left, fixing them with sticky tape on to a rigid support as indicated in the diagram.

Wet the brush in the palette and do similar, very wet brushstrokes on all the papers.

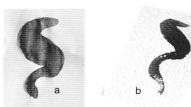

Thin papers wrinkle and cockle whereas the thicker ones have tolerated the slacking produced by the wetness well. Observe the different strokes done on the fine grain paper (a) and that which appears on the thick grained paper (b).

When the colors dry they become concentrated and saturated on the surface of the paper. Note the difference between a freshly painted color (a) and an already dry one (b).

TOPIC

MATERIALS (2)

Watercolor brushes are delicate tools that require special care. The type of hair chosen is determined by the requirements of the technique. As watercolor is completely liquid it needs an elastic hair with a high load capacity and a good point for the stroke. These instruments are manufactured with high quality synthetic or natural hairs. Of the natural hair brushes, the red sable and the Siberian mink ones stand out for all their characteristics are ideal for the watercolor brush. Sable brushes are expensive and therefore the artist usually has at hand cheaper ones, like ox hair or artificial ones.

Knowing your brush is fundamental for getting the best results. This is why we are going to study this tool thoroughly in this chapter.

The shape of the brush determines its stroke and load capacity. The shape depends on the length of the hair and of the ferrule. The shape of the tuft can be as varied as the functions the brush is going to be put to.

In the following pages the different types of brushes, how to handle them, clean them, and look after them will be shown.

TYPES OF BRUSHES

A revision of the different brushes

Watercolor brushes come in a great variety of shapes and sizes. Depending on which brush is used, the brushstroke will vary in fineness and precision.

The most widely used brushes in watercolor are the round ones which lead into a fine point. It is very important that the point does not lose its shape, nor the hairs their firmness.

Flat brushes with sable, ox or synthetic hairs are also commonly used to do wide, continuous strokes.

There are other types of brushes which can have pony or goat hairs, but they are only suitable for doing washes.

Fan shaped brushes are only for doing delicate film work.

Fan shaped brush.

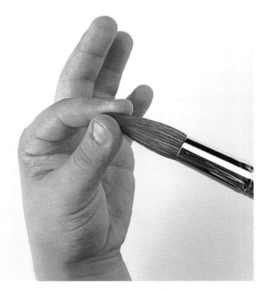

The tip of the brush must come to a point despite the thickness of the tuft.

The importance of the shape of the tuft

The tuft's shape is determined by the way the hairs are attached to the ferrule. Manufacturing a high quality brush requires great craftsmanship for the hairs are carefully selected and ordered before putting them in. The tuft determines the brushstroke. A round brush with a tip will give a fine stroke. A blunt but round brush (like pony hair ones) will give thick, loaded brushstrokes but without much point.

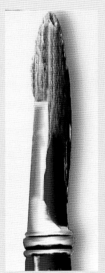

Cross-section of a brush: the ferrule gives the tuft its shape.

Different types of brushes for watercolors.

Round ferrule.　　*Flat ferrule.*

Synthetic brushes

Even though today high quality brushes are being manufactured, it still has not been possible to imitate the structure of natural hair, the texture of which permits it to retain more water. Round synthetic hair brushes do not make such a good point as natural hair ones. Neither do they retain so much water.

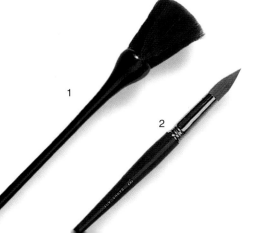

Wolf hair brush for washes (1) and round, sable hair brush (2).

The numbering of the brushes

There is a number on the handle of the brush which indicates its size. Depending on the brand, the fine brushes can be numbered 00000. As the ferrule gets bigger there are less zeros and the numbering becomes ordinal, starting from number 1 up to the thickest brushes, number 50.

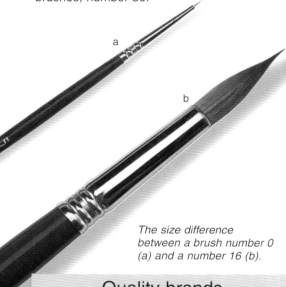

The size difference between a brush number 0 (a) and a number 16 (b).

Quality brands

The leading manufactures can usually be counted on to provide reliable products. However, as is to be expected, any brush made from top quality material, controlling the craftsmanship, is highly priced. Even so, an enthusiast must start out using good quality materials.

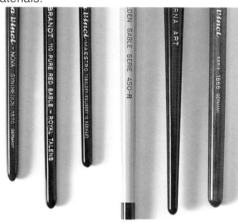

The handles of leading brand brushes.

Vital brushes

Although we have presented a wide range of brushes it is true that on few occasions all of them will be used. In fact to paint a watercolor, a pair of brushes will do. For example, a flat ox hair brush, number 16, and a round, sable hair brush, number 5, will suffice.

With these two brushes watercolor can be painted.

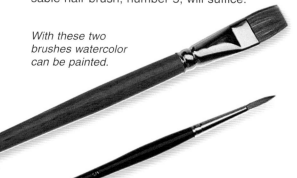

HANDLING THE BRUSHES

Choosing the range

Every painter must choose a selection of brushes. Experience gives you greater criteria. Many brushes are not necessary for just one gives a lot of possibilities. Nor is it necessary that all of them be sable. However, only good quality ones can be used.

Flat brushes

Flat brushes have a tuft the hairs of which form a line along the ferrule which is wider than the handle. The handle, too, is flat. A flat brush offers many uses, especially when a wide area has to be covered. On some works a house painting brush could be used, but only on very limited occasions.

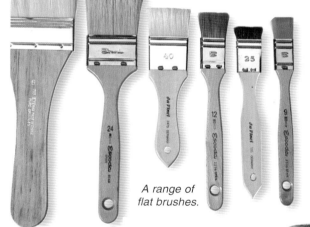

A range of flat brushes.

Flat brushes are useful resorts on a variety of occasions.

To start out the following range is sufficient.
- A little, Hog hair brush, number 40,
- A little synthetic hair brush, number 9,
- A flat, ox hair brush, number 16,
- Round ox hair brushes, number 14,
- Round sable hair brush, number 5.

As the numbering of the brushes gets smaller their quality must increase so that their springiness and tip are maintained.

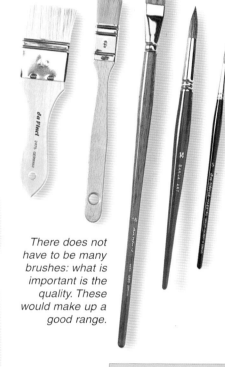

There does not have to be many brushes: what is important is the quality. These would make up a good range.

Looking after the tuft

The brush is a delicate tool: its hairs must be treated carefully. The brush must never be rubbed when it is dry for it would lose its shape.

The brush, watercolor and the paper

The tuft of the brush has a certain absorption capacity. When it is dipped in the watercolor and discharged on the paper, the pore gradually absorbs the paint's dampness. This means that the watercolor is difficult to correct once it has dried.

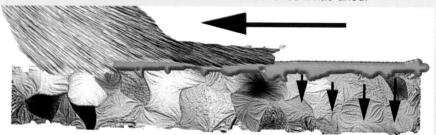

When the wet brush is passed over the paper, the color is absorbed and penetrates into the pore.

How to use color

Once the paint has been deposited on the palette, the amount of water added depends on what you are going to do with the color. To make very transparent colors, wet the brush in clean water and discharge it on the paint on the palette. Drag the brush over the paint: its now ready to paint on the paper.

The paint can be stretched out until the desired transparent tone is achieved.

After each session

The brushes must be stored completely clean. Only in this way will you be able to start the next session sure that the brush is in no way contaminated. Although good quality brushes normally have a resistant varnish on the handle, and chrome on the ferrule, they must never be under water too long. Dry them well after each session.

CLEANING THE BRUSHES

Only water

Watercolor technique is different to other painting media in that the materials worked with are soluble in water. Gum Arabic, which is the principal agglutinin of the watercolor, dissolves just by touching it with water. The brush hairs are easily cleaned just by rubbing them lightly with the fingers under a running tap until all the color is out.

> The brushhairs are easily cleaned: just put them under a running tap.

Cleaning while working

Watercolor is one of the most delicate painting media. However small any color addition may be, a nuance change is produced. When painting with watercolor you do not need a wide range of brushes, but the ones you use must always be clean for any paint left over would alter the new wash. To keep the brushes clean wash them in a jar of clean water every time you change color. The dirtying of the water in this jar can be taken advantage of for certain washes or mixes.

Drying the brushes

After every work session the brushes must be cleaned thoroughly. The wet hairs are soft, and, although the good quality brushes recover their shape quickly, if you do not dry them they can become deformed. The brush must be dried with a soft cloth or absorbent paper, always going with the hairs, pressing but not twisting. Just getting rid of the excess water is sufficient unless they are going to be stored for a long time, in which case they must be completely dry to avoid putrefaction and mold.

You have to press the brush without bending its hairs.

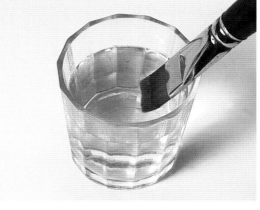

The brushes are washed in running water until all color traces are removed.

You must have a large jar handy in which to rinse the brushes after each color change.

Reshaping the tip

After washing the brush and absorbing the excess water with a clean cloth or paper, it is advisable to reshape the tip with the fingers before the tuft dries. Just rubbing the ring and index fingers, and the thumb over the tuft, and softly turning it will leave the point in good shape.

It is advisable to reshape the brush point before it dries out completely.

How to hold the brush

Although there are many ways to hold the brush, these are the most frequent.

LOOKING AFTER THE BRUSHES

The brushes and their container

The brushes should never be left standing on their point, neither when being used nor dry. In the former case, to rinse them just shaking them in a jar of water and then placing them point upwards in a dry jar is sufficient. When the brushes are dry the point is much more delicate: protect them against knocks and never support them on their point.

How the brushes must be placed: point upwards.

Using a brush holder

A brush holder is used to support the brushes while you are working with them or to dry them without bending the tuft. This simple aid consists of a metal container with a grip to which the brushes can be fixed by the handle. As the brushes are hanging they can soak in water with getting the ferrule wet.

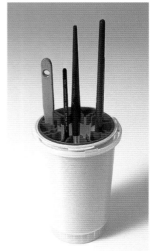

This brush holder can dip the tuft in water without them touching the bottom.

A homemade brush holder

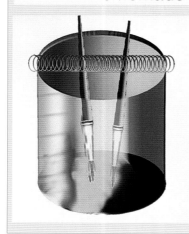

It is easy to make your own brush holder. You only need a food tin with blunt edges, or a plastic container (like a bottle cut open). Then place a spring across the top, supported by holes cut on both sides.

A basic brush holder made out of a plastic bottle and a spring.

A wicker cloth

The brushes can also be rolled up in a little wicker cloth that is sold for this purpose. It is a very practical way of protecting the brush as it provides rigidity.

A rolled up wicker cloth allows the brushes to be carried safely.

How to carry them

There are special brush holders for carrying them. However, they can be transported inside a rolled up piece of cardboard or newspaper. The point of the most delicate brushes can be protected with thread.

It is important that the point is protected against bending or distortion in general. Therefore, if the brushes are wrapped in newspaper, leave enough space so that the point does not knock against anything.

Some quality brushes come with a plastic tube to protect the point. Keep the tube for when you have to store or carry them.

To protect the point, wrap it up in a thread.

A plastic tube protects the point and keeps its shape.

Take note

It is important that the brush tip is not squashed or deformed.

Do not use the same brushes for other media

A watercolor brush is an accurate, delicate tool. Other painting mediums, like oil or acrylic are dense and would spoil the hairs of the fine brushes. Oil paint has to be cleaned off with a dissolvent insoluble in water, which could leave traces in the brush and ruin the watercolor. Acrylic, despite being water soluble, dries quickly and therefore accumulates around the tuft base. It would eventually split it open, distorting its shape.

Storing the brushes for longer periods

When the brushes are stored for a longer time, moths could set in. To prevent damage or deterioration like this they should be wrapped in paper or in a wicker mat, and then placed in a box with naphthalene balls.

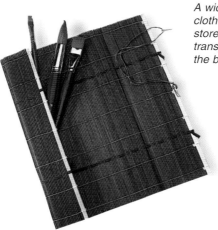

A wicker cloth to store and transport the brushes.

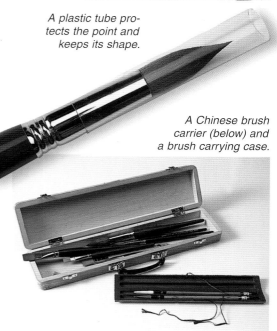

A Chinese brush carrier (below) and a brush carrying case.

STROKES

The stroke of each brush

The brush's tuft in great part determines the stroke. A brush can form different strokes depending on the brush pressure on the paper and on the way the brush forms a point. These exercises are carried out on medium grain paper.

It is advisable to practice as is shown in the pictures on these pages.

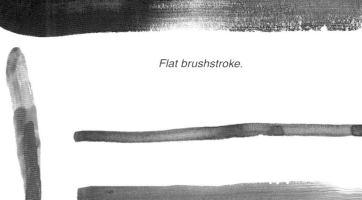

Flat brushstroke.

Round brushstroke.

The stroke of a flat brush compared to the stroke of a low-numbered round brush.

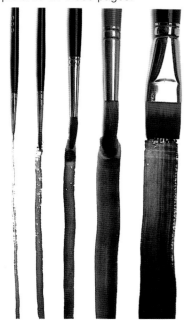

Different strokes with different brushes.

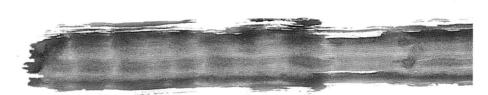

Dry stroke effect with a worn brush.

Possibilities with round brushes

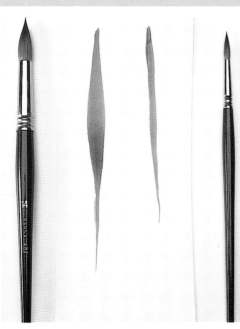

Strokes of round brushes getting the most out of the point.

To do thick strokes with a round brush you have to load on a lot of paint without saturating the tuft.

If the brush has lost its point, twist it in the palette to give it shape.

To do fine lines the brush has to be drained off thoroughly to get rid of any excess water.

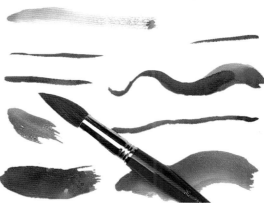

Stroke possibilities from one high numbered, round brush.

Possibilities with flat brushes

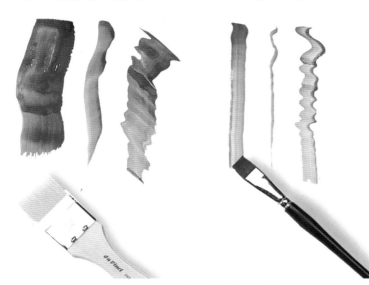

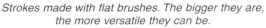

Strokes made with flat brushes. The bigger they are, the more versatile they can be.

Flat brushes allow greatly modulated strokes to be made.

Flat brushstrokes

Flat brushes are among the most useful. The versatility of the stroke allows all types of graphics to be made. This landscape has been painted with the flat brush that appears in the photo. The secret lies in taking advantage of the stroke and the drying time.

The importance of the tuft

Different strokes done with broken brushes. They completely lack accuracy but they can be useful to achieve certain effects.

A good condition tuft must be able to do a stroke without wasting paint or doing double lines.

Useful sizes

A watercolor brush offers a great variety of strokes so it is not necessary to have a wide range of brushes: a brush number 16, a flat brush number 24, and a pair of round brushes numbers 12 and 5 will suffice.

Small sized round brushes

The lower the brush number, the greater the quality must be to obtain maximum accuracy. Among the smallest sizes the most accurate are the round ones.

Brushes for big pictures

To paint large areas you need brushes that cover large surfaces and that have a high color carrying capacity. Flat brushes are ideal.

Care and transport

The brush point must be protected during transport, and the weight must never be supported on it. When they are stored they must be wrapped and protected against moths.

BRUSH MOVEMENTS ON THE PAPER

We have seen that one brush offers many possibilities. We will now put into practice different stroke techniques so that the enthusiast can become familiar with handling them.

Straight movements

After wetting the brush on the palette, spread it over the paper in straight line, parallel strokes.

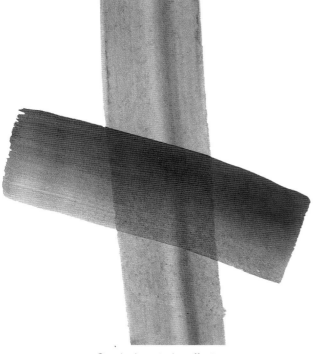

Overlaying stroke effect. Each stroke must dry before the one on top is put down.

Flat color effect. The strokes overlap each other on still-wet brushstrokes.

The white stroke

There is no white color in watercolor, however, many shades of it can be obtained. Pure white is the color of the unpainted paper itself. The different nuances of white are subtle films that are almost transparent on the paper.

In this picture Vicenç Ballestar did not use white; he just let the unpainted color of the paper come through.

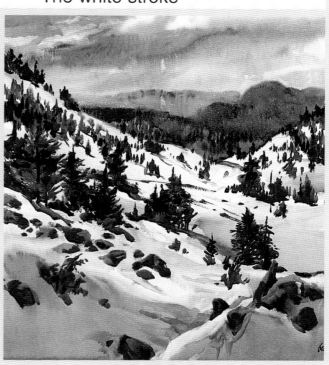

Curved movements

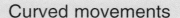

A curved movement can perfectly control the area to be covered.

In the small strokes the tension in the fingers leads the brush.

In the large strokes the wrist guides the brush movement.

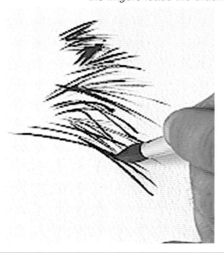

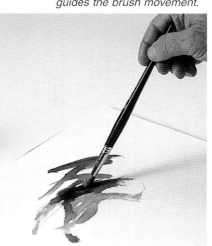

Movements with different brushes

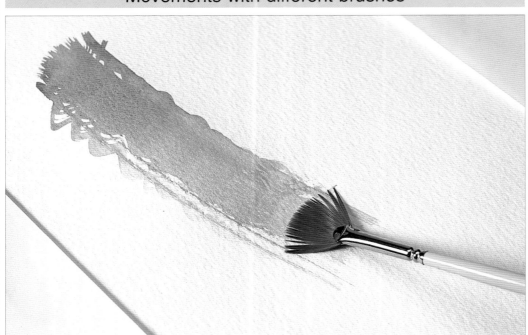

*Fan brushes allow very subtle films to be made.
Here a curved stroke is being used.*

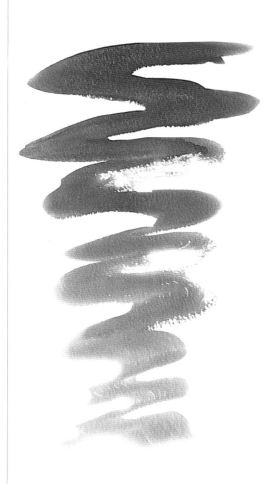

*To cover large areas with the flat brush
a zigzag movement can be made.*

*Rubbing in zigzag with an old, almost dry brush
gives this effect. Cross-texture effects can
also be made. In negative.*

Stains

*The drawing is fundamental. The pencil line
allows you to distinguish between the area
to be painted and untouched area.*

*Areas in negative are reserved, left unpainted.
It is important to practice
exercises like this one.*

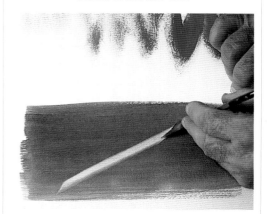

*A dry brush can also create white
strokes by absorbing
freshly laid paint.*

MATERIALS (3)

As has been shown on the previous pages, watercolor is a completely liquid painting medium. It is stating the obvious but they are very watery. The mixes have to be made on an adequate surface. In the following sections we will study the palettes available in the market, and another very practical tool for the painter: the palette box.

A palette box is used by many painters because it makes carrying the materials easier, while at the same time providing a good palette. The manufacturers offer them designed for tubes or pans, whichever is most convenient.

Which palette to choose?

Although this is a personal question it is worth starting to paint with a porcelain plate and a round palette that allow you to lay out the colors neatly. The enthusiast must choose from among the palettes that best suit their practical needs. Starting with a round palette they can get used to the process of taking a color, placing it in the middle and diluting it with water.

Pans

One of the palettes that can be chosen is formed by little removable pans or dishes which contain the watercolor, either in dry or semi-humid form. When the pans have been used they can be replaced separately and put in the right position. Often these type of palettes come fitted to box-palettes. Porcelain watercolor pans are also available.

High quality porcelain palettes with paint included.

TYPES OF PALETTE

Varieties

Watercolor paint needs to be mixed in opaque, white, and water-resistant palettes, of which there exist a great many. They come made of plastic or resin in the traditional bean shape. There are also plastic palettes with pans. These are normally round and the number of pans varies. They can be metallic but this makes the mixing difficult.

Perhaps one of the most practical palettes is a porcelain tray with square cavities for the paint and round ones for mixing. The palette-box beats all the others for practicality: it adds the usefulness of the box to the mixing possibilities of the inside lid.

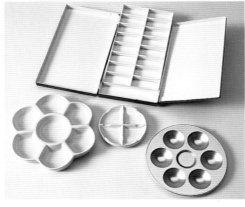

Watercolor palettes are very varied. Here is a good sample.

Usefulness of porcelain

Despite being fragile porcelain palettes are very practical because the completely white glass surface is more reliable for mixing colors than plastic. Porcelain palettes have a double cavity that can be used to place the paint when working out of a tube, or to create a tone when doing a mix.

Porcelain is easily cleaned. Plastic eventually ends up being stained by an undefined tone.

One very practical solution is to use a porcelain plate to do the mixes: it is the most practical palette.

How many cavities are necessary?

Each artist has his or her own preferences on palettes, which also depends on the type of work being done. An extensive palette is not necessary if a two-color wash is to be painted. However, it never goes amiss to have a wide, multi-use palette, whether it is for a monochrome piece or a colorist one.

If you buy watercolors in a box of pans, a range of twelve colors should be sufficient, although you can also start with twenty.

Pans out of the palette and mounted in it.

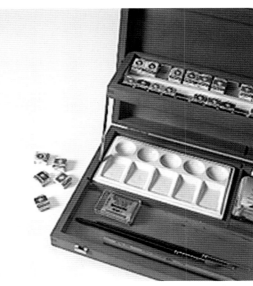

Replacing used up colors is important in any palette.

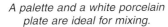

A palette and a white porcelain plate are ideal for mixing.

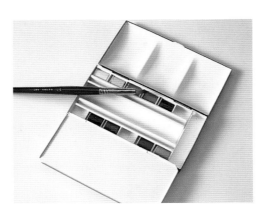

The cavities of the palette do not always have to be used. It depends on the type of work you are doing.

BOX PALETTES

Wide variety

The variety of watercolor products is one of the widest in the Fine Arts field. Basically a palette-box consists of several paint pans and a lid, or two, that is used as a mixing palette. However, there can be many variations on this: miniature palette-boxes with hard pans; plastic ones for tubes; enameled metal palette-boxes with a double lid; wooden palette-boxes with a wide range of palettes; porcelain ones, double pans, round ones, etc.

Miniature boxes

Miniature palette-boxes are aimed at painters who like to paint outdoors. They are also called pocket boxes for they can be so carried, or in a little bag. Some of them fit into the palm of your hand, but this does not mean that quality has been sacrificed. In fact the best brands pride themselves on constantly improving their design. They include a wide range of colors and a space in which to fit the dismountable sable brush. Many varied colors can be in the boxes as the size of the pans is very small. They can be replaced when they have run out.

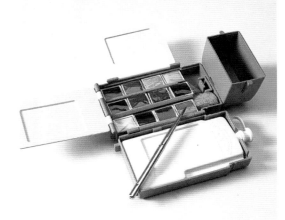

A pocket palette-box with dismountable brushes.

The color layout

Box-palettes with colors included already have a logical sequence. Take a good look at it to get into the habit of working neatly. Normally the colors are laid out in ranges and tones. First the brightest (the yellows); next, going with the tone, come the warm tones (orange, red, carmine, etc); some manufacturers then place the earth tones while others go for the cold colors (green, blue). The artist should follow the same criteria when laying out the colors.

A wooden case with ceramic deposits and a plas mini-palette. A luxury for a demanding painter.

A metal palette-box for paint tubes with a double mixing palette.

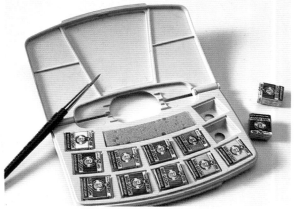

A pocket palette-box and replacement pans.

Cleaning and storing

During a watercolor session it is normal that the palette-box gets dirtied, above all the mixing lid. Once the session is over, if the palette-box contains liquid the best thing to do is to clean it with a damp cloth or tissue. There is no reason why the watercolor pans should get dirty as the brush that touches them must always be washed in clean water. However, if for any reason they have become stained just going over them with a clean, damp brush should get rid of the dirt.

The color distribution in the palette must follow a logical tone order.

A wet sponge is sufficient to clean the palette.

Dry colors in the palette

However old or dry a watercolor pan may be it can be reused, so do not throw away what is left at the end of a session. When you want to paint with it just go over it with a damp brush. It will soften up and eventually regain its painting qualities.

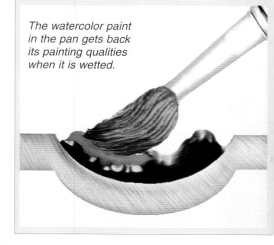

The watercolor paint in the pan gets back its painting qualities when it is wetted.

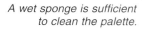

COLOR RANGES

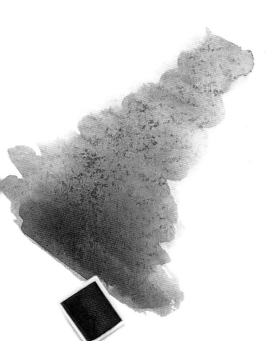

Availability in pans

Watercolors are distributed in all forms: the same range comes in tubes or in dry or semi-humid pans. The pan colors are easily recognized because they can be seen. However, the darkest tones can be confused due to the density of the dry watercolor. The painter must know where the colors are in the palette, but it is worthwhile doing color tests on the palette when painting.

A dark color sample from a pan. Until a test is done it is difficult to know the exact color.

Selecting tubes

It is common that an enthusiast, in the beginning, likes to buy a good collection of watercolor tubes, putting quantity before quality. This is an error because low quality colors give bad results and probably some of the colors will never be used. It is always better to buy a few, high-grade tubes. Prestige brands are expensive but they will never let you down.

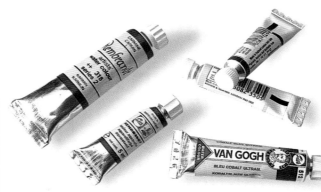

Good quality tubes. They can be bought one by one and in a small color range.

Avoid too wide ranges

A watercolor learner has to learn to get their colors from mixes. If they have a too wide range it will be too easy for them just to choose a color: the palette will be doing the work.

From the primary colors (dark blue, yellow and red) the others can be obtained. This does not imply turning one's back on the extensive watercolor chromatic range, but bear the primaries in mind.

Criteria for making a choice

Before going for one of the different watercolor presentations, it is worth recalling their pros and cons.

Watercolors in hard pans are replaceable. To dissolve them they must be lightly rubbed with a wet brush. Once they have dried out they regain their original hardness.

Hard watercolor pans.

The texture of the semi-humid watercolor means that it dissolves immediately when touched by the brush. Like the other watercolor pans they can be replaced in palette-box.

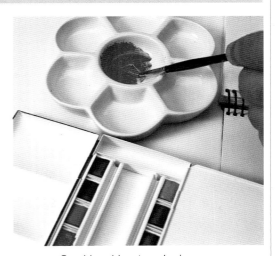

Semi-humid watercolor in pans.

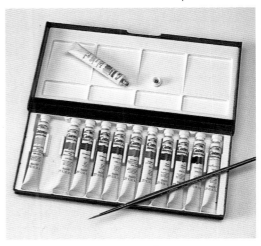

Watercolor in a tube is very practical. You need only squeeze out onto the flat palette the quantity that you are going to use. Once dry you can reuse it, but only if it is wetted again. Then using it is very similar to hard watercolor paint.

Watercolor in pan form can be replaced without changing the pan of the palette, making them ideal for one-piece palette-boxes.

Watercolor pans in a wooden box.

Watercolor tubes.

VITAL COLORS

The minimum range

The number of colors to be used largely depends on the necessities of the artist. However, whatever the case, you do not need a wide range to start out. Be sparing at the beginning so that you can learn to mix. As good habits and feeling are picked up the range can be widened.

Although it is not necessary to follow too strictly, you can start with this color range.

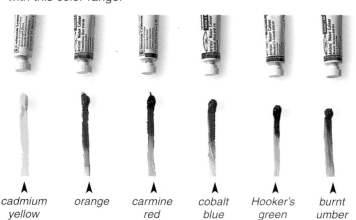

cadmium yellow | orange | carmine red | cobalt blue | Hooker's green | burnt umber

The right colors

To choose the right colors a range which includes the following is sufficient.

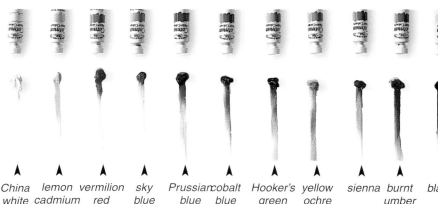

China white | lemon cadmium yellow | vermilion red | sky blue | Prussian blue | cobalt blue | Hooker's green | yellow ochre | sienna | burnt umber | bla

White does not exist in the color mixes. It is obtained by leaving the paper blank.

Watercolor and white

It is the transparency of the watercolor that gives it its characteristic luminosity. The colors become lighter and more transparent as the paint gets more watery. This can be taken to the extreme of gradating a dense, opaque color until reaching the white of the paper. Therefore paper plays the role of white. White cannot be made by mixing the colors: the paper must be left in negative, that is blank.

Colors for doing washes

A wash is one step before a watercolor. Although the same technique is used, there is only one color, or at the most two. A wash is characterized by being monochrome and the way the different tones combine together. Any color can be used to do a watercolor wash. However, the best results are obtained with earth colors and grays (background and Payne's gray gradations). Blues are ideal for landscape washes. As a wash is based on one color, it is best to start from dark to get as many tone shades as possible.

A wash is done with one sole color. It should be dark to get a good number of tones.

Using the color background

Using background is not very common among watercolorists as it makes things dirty and often its contrasts blot out its positive effects. However, do not rule it out completely; its usefulness lies in the rich range of grays it offers. In any case it should be used carefully.

Combining Prussian blue, burnt umber and green, a background color much richer in nuances than background itself can be obtained.

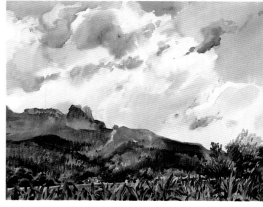

In this picture, despite the appearances, the white has not been painted. It is the white of the paper.

Good use of the palette

The most practical palettes have small pans in which the paint can be deposited.

The color order

The color order must be logically gradated to enable the colors to be used quickly and comfortably

Only the necessary colors

Only place on the palette the colors you will use. Do not fill up the palette with unnecessary colors.

Using background and white

Use background with moderation. Dark mixes can always replace it. There is no white in watercolor: it is obtained from the white of the paper.

Getting the most out of the palette

A pan palette is ideal for watercolor painting. The colors must be laid out logically so that they are easily and quickly found. You do not have to fill all the with tube colors, just the ones that are going to be used. The remaining empty pans are for mixes and intermediate tones.

CLEAN MIXES

Obtaining clean colors on the palette

It is not easy to describe what a clean color is as this quality depends on the colors that surround it. It is more accurate to define the cleanliness of a color according to the colors that compose it.

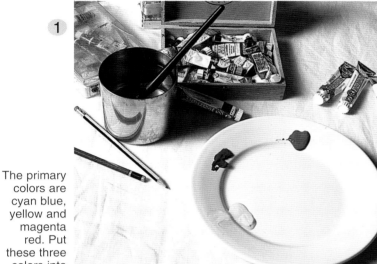

1 The primary colors are cyan blue, yellow and magenta red. Put these three colors into the palette.

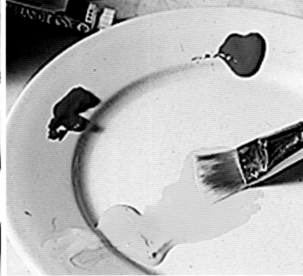

2 Wash the brush in the clean water jar and do the same with some of the blue.

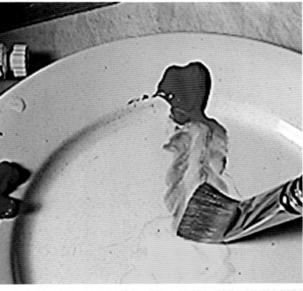

3 Take some of the yellow and drag it to the center of the palette.

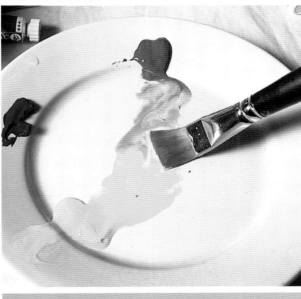

4 Add more yellow until a light green is obtained. Rotate the brush around in circles until an even mix is obtained.

5 The color is checked on a watercolor paper.

6 Try out the mixes of different primary colors.

Proportions to get colors right

When you have finished this exercise, do not clean the palette but go on to the next one.

Mixing primary colors gives secondary colors. It is important to know which colors can be obtained by mixing others.

The lightest color must always be placed first, and then on top of it add small quantities of the second color. It is easier to darken a tone than to lighten it.

The proportions are always approximate and based on intuition. These pictures only give an idea of what to do. Mixing cannot be explained by percentages.

Increase the quantity of one color or another in the mix. The color obtained will be closer to the dominant color in the mix.

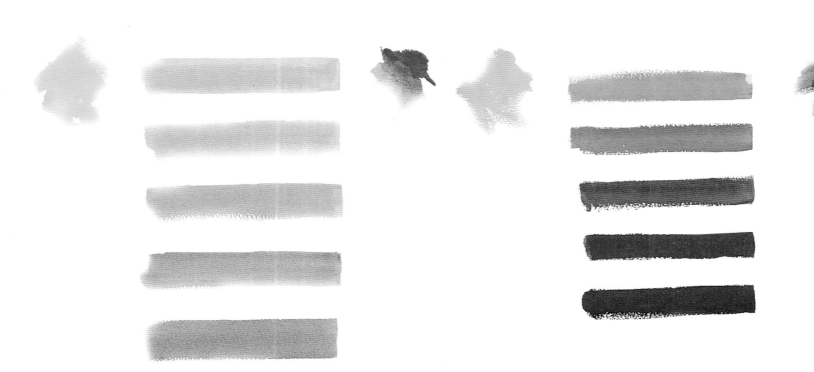

Yellow and blue produce a range of greens.

Yellow and red give way to orange colors.

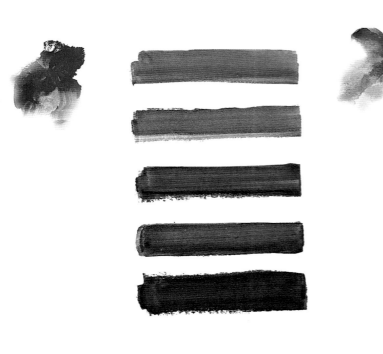
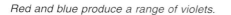

Red and blue produce a range of violets.

Practice obtaining whites by leaving spaces in negative and by gradating the mixes.

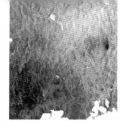

BROKEN COLORS

Broken Colors or Dirty Colors

With the other painting methods broken colors are obtained by mixing two complementary colors and white. As there is no white in watercolor you only have to mix two complementary colors.

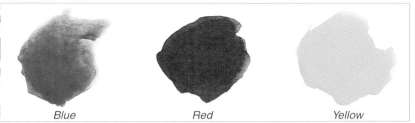

Blue Red Yellow

On watercolor paper stain the primary colors as shown.

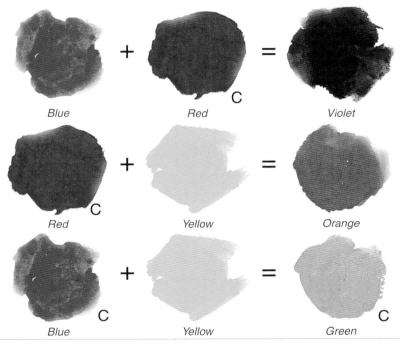

Blue + Red (C) = Violet

Red (C) + Yellow = Orange

Blue (C) + Yellow = Green (C)

COMPLEMENTARIES
RED AND GREEN
BLUE AND ORANGE
YELLOW AND
VIOLET

As we learned before, secondary colors are obtained by mixing primaries. Opposing colors are complementary.

Ranges of broken colors on paper.

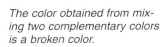

Gradations of the colors obtained. The transparent capacity of watercolor stands out.

The color obtained from mixing two complementary colors is a broken color.

Using background in mixes

Progressively adding background dirties the colors. This characteristic can be taken advantage of to get an interesting gray range.

It is very important that the watercolor painter knows the color's gt1 possibilities. Tests done on paper should never be considered useless for they will demonstrate the qualities of watercolor, looking for a tone, the performance of the tone and of the paper.

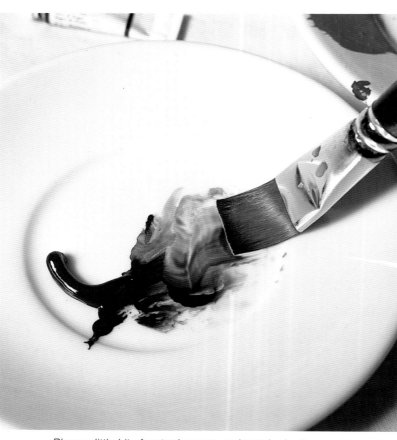

*Place a little bit of water in a pan and wet the background.
Do the wash in a pan or on the palette.*

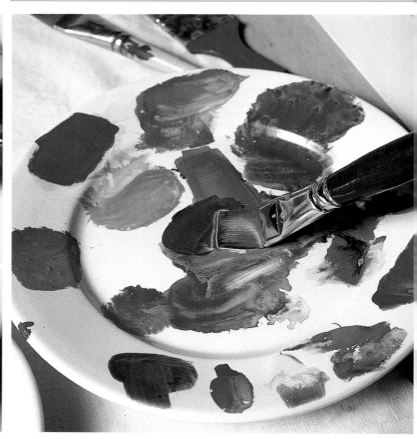

*Wash the brush. Take a little bit of background and
place it in one of the dirty color mixes.*

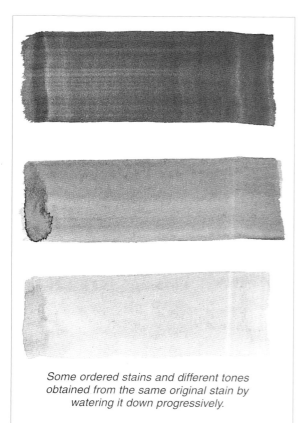

*Some ordered stains and different tones
obtained from the same original stain by
watering it down progressively.*

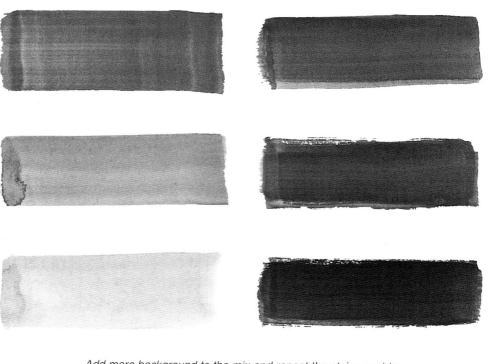

*Add more background to the mix and repeat the stains next to
each other. Note the way grays are obtained.*

TOPIC 4

MATERIALS (4)

The support in watercolor is paper. Hile the other painting media can be painted on all types of supports (wood, canvas, etc), watercolor is uniquely destined to be realized on paper. The quality of the paper determines the brushstroke and the final result of the work. It is fundamental to know which papers are for watercolor and the possibilities of the medium.

Watermarks

Watercolor papers have two sides, distinguished by their textures. Nowadays, one can paint on both sides for they both have the necessary degree of sizing to absorb color correctly. However, some papers, above all the old ones, do not have this double sizing so a watermark was very important to identify the right side. This is why the manufacturers adopted this custom. The mark is only visible when held up to the light, and today identifies the prestige of the manufacturer. As well as the watermark, some manufacturers like to do an embossing on the paper.

The watermark on a quality paper and the embossing of another brand.

THE PAPER

Quality papers

The principal characteristics of watercolor are its transparency and its totally liquid state. This is why the painting support (paper) is more important than with the other media. The weight (thickness) and the texture of the paper (grain) directly determine the results obtained by the watercolor.

It is fundamental that from the outset the painter becomes familiar with different types of papers, and that they practice on them. Practice will show them which papers suit their creative interests, which wrinkle and cockle because of humidity and which allow a light color.

In this chapter we will practice on different papers, and we will explain how to tense it to avoid sagging, wrinkles and cockling.

Handmade papers

Handmade paper is doubly valuable to the painter. Firstly because of its beauty and top grade quality, and secondly, it will partly condition the learning painter. Artisan paper has very varied textures. Some of them even include vegetable fibers, flower petals and small butterflies. There are artisan papers that appear very normal in weight and grain but are especially attractive because of the deckled edge which tells us that every sheet has been done individually.

The deckled edge

One of the characteristics that artisanal papers have is that the edges are not cut, instead the threads hang lose. This finish is called a deckled edge and it does not have to be removed. It enhances the paper and reveals that it is artisanal.

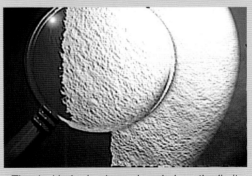

The deckled edge is produced along the limits of the artisanal sheet when the paper pulp is stretched over the sieve to be shaped.

Blocks of paper

One of the most useful paper formats is a block of sheets bound together but easily separable. Some watercolor blocks are stuck on all four sides so you can lean on the block while painting. You need not worry about the humidity wrinkling the sheet. Once the work is finished, you can separate the sheet with a spatula or a cutter.

Block sizes go from small notebooks, the size of your palm, 13 x 18 cm, to large blocks, 61 x 46 cm

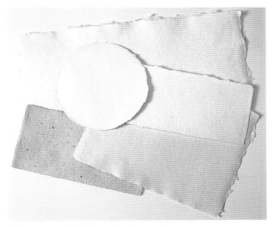

A sample of different artisanal papers.

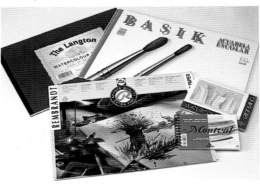

There are a great variety of bound papers for watercolors. You can choose the weight and size.

How to use the blocks

A block is suitable for all types of works, both outdoors and at home. Be patient when working when paper bound on all four sides: the paper must be dry before you ease it off. When a block is bound when a spiral you must wait for it to dry before closing it. Some of these notebooks have holes down the side so that they can be torn off easily without the paper leaving behind little tags.

Technical and artistic formats

There are many paper formats. In general, papers are referenced technically for size by the internationally recognized DIN -the higher the number, the smaller the paper is. THE size DIN-always is the standard sheet, while A-3 is bigger.

The watercolor artist tends not to refer to technical formats. For watercolors sheets measuring 50 x 70cm and 70 x 100cm, or in a roll, are retailed. Also all sizes of artisanal papers are available, going from round ones, long ones through to all types of miniature ones.

Paper for art can have all types of shapes and sizes.

The grain and color saturation

Papers with a thick grain retain more paint in their pore. When it dries by evaporation this produces a saturation of color. Therefore a coat of watercolor paint on a thick grain paper gives a very marked granulated effect.

Fine grained papers lack texture. The water in the watercolor is not retained and the drying is conditioned by the way the water accumulates on the smooth surface. The most suitable paint is medium grain for its texture is smooth and even. The water evaporates uniformly without excessive color saturation in the grain.

When the water contained in the paper grain evaporates, the color becomes concentrated producing a saturation of the color.

An example of a watercolor done on fine grained paper. The accuracy that can be achieved is astounding, but it requires mastery of color and drawing.

THE IMPORTANT OF THE PAPER

Grain and format

The paper grain determines its texture. A fine-grained paper has an almost smooth surface, while the thick grained paper has a rough texture.

High quality industrial papers are manufactured with a mould which gives them a different edge to the artisanal papers. These papers are gelatin sized to make them more resistant to the humidity. The paper grain is produced during the pressing, which can be done cold (C.P.) or hot (H.P.). Cold pressed paper, which gives a bumpy texture, is the most suitable for watercolor.

The paper format is also related to the weight. The bigger the paper is, the heavier and thicker it should be to avoid bending and wrinkling from the humidity.

Cold pressed paper (C.P.) takes on a strong, open-grained texture. Hot pressed paper (H.P.) has a compact texture and the grain is more closed.

Amplification of the paper grain. When the brush passes over the paper the color is dissolved. The bigger the grain, the more liquid that is retained.

The grain and detail

Works which require a great deal of detail should be done on fine grained paper. This smooth, poreless texture allows the thinnest brush to do all types of strokes. Works done on fine-grained paper tend to be naturalist or technical illustrations.

Choosing a quality paper

If it is important to have good watercolors and brushes, choosing a quality paper means getting the most out of these materials. These are the principal characteristics that papers from prestige brands have:

• Manufactured from cotton (minimum 50%)
• No acid content
• Gelatined on both sides to aid wiping and to make it resistant to continuous sponging
• Natural white color
• Weight above 185 g/sq meter.

High quality papers with the brand embossed.

Obverse and reverse

One side of the watercolor paper is more textured than the other, allowing the painter to choose different working conditions.

Both sides normally have a degree of sizing which permits them to be painted.

In the old days only one side was sized so the mark had to be visible.

Choosing the grain

The best paper on which to paint watercolor is the medium grained because it allows the color to be distributed evenly without it accumulating in the grain. Thick grained papers are suitable for special works in which the texture comes into play.

Brushes and the paper

The brushes to be used depend on the paper format. A small paper cannot be painted with a wide flat brush. Likewise it would be a drag to paint a sky on a 50 x 70 cm paper with a fine brush.

The brush used is related to the paper.

Table or easel

Watercolor is liquid so too much water on the paper means that it runs. You can paint in many different ways with watercolor, depending on what you are working on. Have a large table on which to place the support, watercolors, water jars and the brushes.

An easel is also necessary because on some occasions you will do exercises in which the supporting board will have to be vertical. Many types of easels are available in the market. The most suitable ones for watercolor are foldable and of aluminum. They can be taken outdoors, too.

There is one very practical easel which folds away to form: its legs extend out like a lectern or music stand. Inside its box you can carry all the necessary material.

The easel is one of the vital elements for a watercolor artist.

HOW TO WORK

Supporting and gripping the paper

To paint comfortably the paper must be placed that it is backed up. The support must be as least as big as the paper itself. Each painter has their own preferences, but the most commonly used support is a board. Other supports uses include a folder or a watercolor block or pad.

The paper can be gripped with drawing pins, pegs or with masking tape.

Tensing the paper

Watercolor painting is based on continuously wetting the paper. This means that the fibers give and the painter starts to see wrinkles and cocklings or bumps that make the work difficult, above all when using lightweight papers.

Heavy papers hardly wrinkle. To avoid the paper wrinkling, stretch it. We will study how to do so in the practical part of this chapter.

Unstretched and stretched paper: easy to do and saves many problems.

A table is vital for painting watercolor and for laying out the jars, brushes, etc.

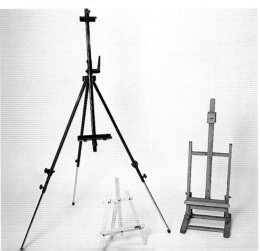

The most common supports for watercolor painting: a board, a folder and a pad.

Accessories for gripping the paper to the board: pegs, tape and drawing pins.

Boards

As can be deduced from everything explained on this page, the paper support is one of the elements to be born in mind when getting the painting materials. Have several different and same-sized boards available because it is possible that during one work session to start or finish different pictures that must dry before being taken off the support.

Tilting the support

A watercolor should be painted on a rigid support that can be tilted. The support, the board, the folder or pad, must allow you to paint flat, tilted or vertically without having to take the paper off.

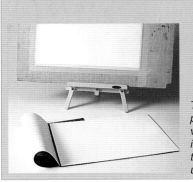

The support position can vary according to the technique used.

THE STUDIO

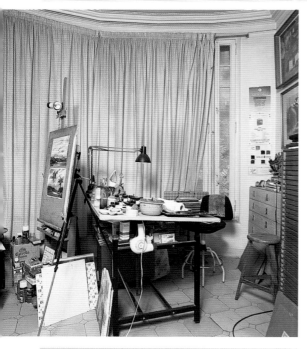

Necessary space

Watercolor requires less space than other media. However, it must be well organized. The studio space will influence decisively on the size of the works, although watercolor is not actually aimed at very large pictures.

A 2 by 3 meters room is more than big enough to set a small but practical studio. The way of laying out the elements is a personal question: comfort is what matters. A board with two trestles makes a fantastic table. You will also need a chest of drawers, shelving, an easel, a stool, support boards and a space where to store the folders.

A small room equipped as a studio.

Different sized folders.

The folders

Watercolor paper is delicate; it must never be rolled up because the fibers deteriorate. The studio must have good sized folders in which to store new papers. The different types of paper must be separated and classified, in this way the painter will always know where to find the material.

Finished pictures must be carefully classified and stored in folders. Plastic linings are a good idea, making the classification visible and practical.

A zip folder.
The work is preserved in better condition and perfectly ordered.

A drier for the studio

Although it may seem strange, a simple hair-drier greatly helps the watercolor painter's work. It accelerates the drying time in a controlled way. Of course, there must be a plug next to the work table.

A hair drier facilitates controlled drying.

Natural light

The best light for working is natural light. The enthusiast should take up a position so that they receive light indirectly, without reflections. Ideally light should fall from the other side to the painting hand. If the painter is left-handed light should come from the right.

Preserving the work

Once the painting has been finished it must be stored so that it is protected from dust, humidity, insects, and direct sunlight. The best means for doing this are special large, narrow drawers, 100 by 70 cm. This proposal is expensive so, alternatively, the pictures can be stored in large folders or in large plastic anti-dust bags. Special bags are sold in different sizes.

Additional tools

In a studio different tools are necessary, otherwise the painter would find some tasks very awkward to do.

- Jars to put water, brushes, and pencils in.
- Scissors, cutter, sponges, etc.
- A lamp, spotlight as an alternative to natural light.
- Rulers for measuring.
- A geometry set for right-angles.
- Kitchen paper to absorb water.
- Sticky tape, sellotape to hold the paper, photos, etc.
- Sponges to paint with.
- Cloths for cleaning or erasure.
- A stool.
- Pencils, felt tip pens, ball-point pens, other drawing material for the painter.
- Glue, gum Arabic for sticking the paper.
- Hair drier for controlled drying.
- Pegs and drawing pins for gripping the paper to the board.
- Alcohol to accelerate water evaporation.
- Glycerin to slow down drying.
- A dropper to measure liquids, varnishes, etc added.

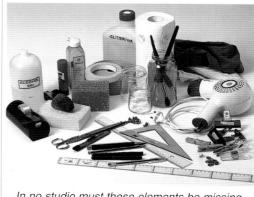

In no studio must these elements be missing.

TESTING THE PAPER

The paper used in watercolor does not always have to be checked out. However, in the beginning it is advisable that the painter knows the paper's possibilities, its texture, the sizing, degree of absorbency and sponginess.

Medium grained quality paper is the most recommended because of its versatility in accepting the brushstroke and because its texture retains its beauty without excessively accumulating paint in the pore.

Stroke tests on different grains

1 Different papers are laid out on the board. It is important to be careful in the order. In this exercise the highest grained paper is the first.

2 The papers are held by sticky tape so that the paper's response can be observed.

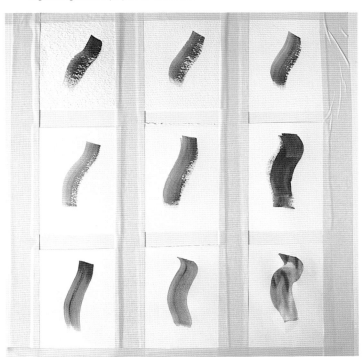

3 Try to use the same quantity of paper on each paper. Depending on the grain and the weight different results can be obtained. The fine-grained paper hardly has texture. The color has been painted easily but the shape lacks character. On the medium grained paper the paint has penetrated into the grain but it has not saturated the color excessively and the shape has been drawn fluently.

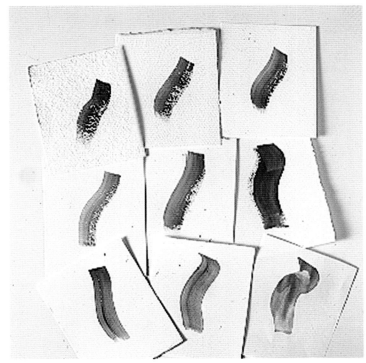

4 It has been quite difficult to outline the shape with the brush on this thick grained paper. A lot more paint has been necessary and it is less defined. Thick-grained paints respond in a different way to light and low grain papers.

Medium grained quality paper is the most recommended because of its versatility in accepting the brushstroke and because its texture retains its beauty without excessively accumulating paint in the pore.

Paper absorbency

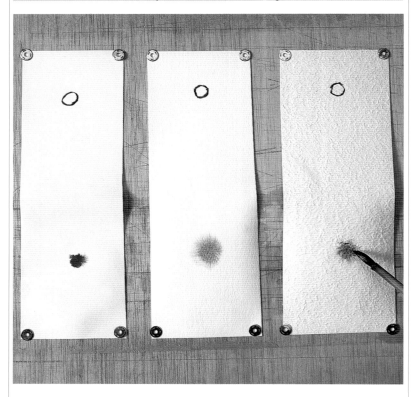

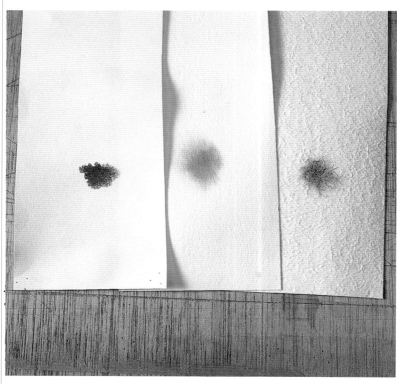

Check the sizing of the three papers. You will observe that the absorbed water has made the result perfect. On the paper with low absorbency capacity has blotted outward blending with the humidity on the surface.

The sponginess of the paper

Do a color wash on the palette; the more luminous it is, the better, to check the way the pigment accumulates in the hollow of the paper. Lay out three strips of different grained paper. Heavy paper is better because it wrinkles and cockles less. The first paper shall be fine grained, the second medium grained and the third thick grained. The paper is held to the board by drawing pins.

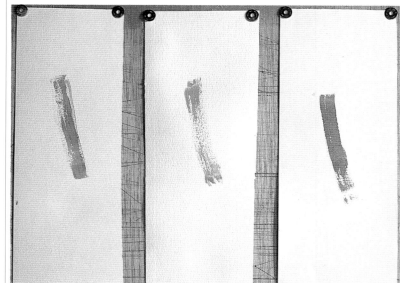

Take a thick ox-hair flat brush and wet it in watercolor, and then squeeze out excess paint on the edge of the palette. Do a stroke on the first paper until it begins to run out. Do this on all the papers. Observe that not all the papers are equally spongy. On some of them the stroke has spread out. On others the lack of sizing has resulted in the paper absorbing too much paint.

STRETCHING PAPER

The humidity of the watercolor makes the paper wrinkle, above all with lightweight papers. To get over this problem the paper can be stretched using one of two systems, both straightforward. The first used the board as a support, and the second stretches the paper over a frame, giving a paper as tense as a drumskin. The two which are going to be used in this exercise are identical, although the stretching technique can be used on any paper regardless of its weight and grain.

To take the sticky tape off the board, just wet it. Be sure to eliminate any gum left behind with a wet sponge.

Stretching over a board

1 You must have a board larger than the paper you want to stretch. You will also need water-based sticky tape, a sponge and a jar of clean water.

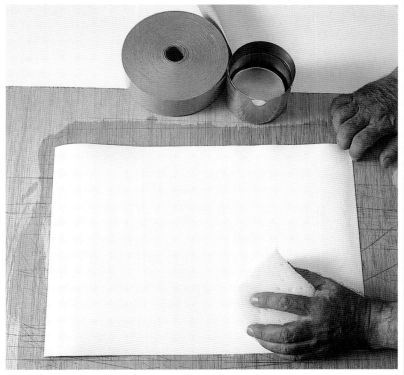

2 Wet all the paper with the sponge. The paper must be soaked in water to open the fibers up completely.

3 After a few minutes, dry the water off the paper and lay it flat over the board. Tape the four sides to the board before the paper dries out. The tape must cover at least 2 to 3 cm of the paper. The paper could also be gripped with drawing pins, but they could tear it when drying. Allow the paper to dry completely. It will now be stretched and smooth for wrinkle-free painting.

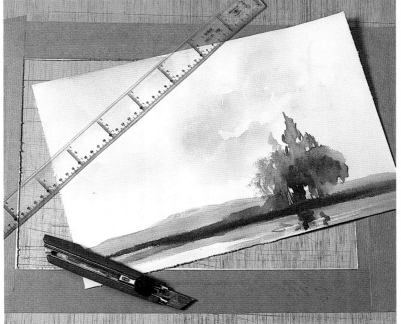

4 Once the painting has dried, use the cutter and a ruler to separate it from the board.

Stretching over a frame

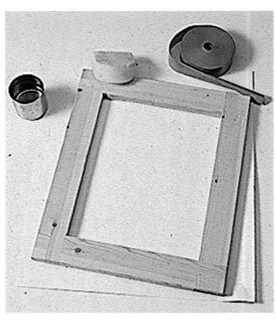

1 A wooden f3 is needed and a sheet of paper big enough to cover it with three cms to spare all round.

2 Wet the paper completely. The pores must be soaked in water.

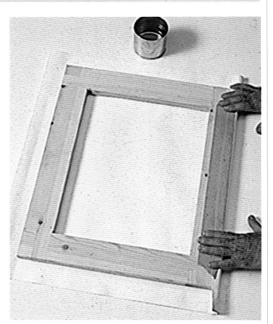

3 Place the paper over the board with the painting face downwards. On top, center the f3 with the sloping edge towards the paper. Fold one of the sides over the f3 without stretch too much to avoid tearing. Stick the side of the paper to the f3 with sticky tape.

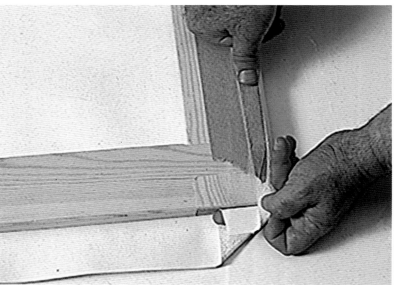

4 Do the same on the opposite side. Before folding the third side, fold the two corners so that they overlap. Note how the corners are folded.

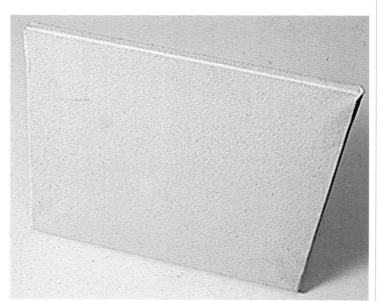

5 Allow the paper to dry and observe how it stretches. Once it is painted and dry, you can take off the paper by wetting the sticky tape with a sponge, or by cutting it. Another alternative is to leave it on the f3.

6 Finally repeat the operation on the 4th side.

TOPIC

PROCESSES (1)

TRANSPARENCY AND TONE

From light to dark

Throughout the previous chapters you have been able to appreciate that watercolor is an extremely luminous medium due to its transparency. Watercolor does not have the color white and to make the tones lighter you have to increase the water proportion. Therefore, the paint allows the white paper color to reflect more light. As it is logical to assume, if the transparency comes from watering down a color, you will never be able to make a color lighter by superimposing another color on top. However transparent the second color may be, it will always be added on to the first.

It is important that this concept is well understood before moving on. In the following pages we will study the principal characteristic of watercolor: transparency, the opaqueness of color and superimposition.

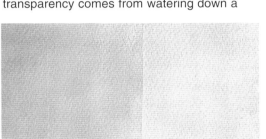

A scale of tones. The same paint mix has been used. The first strip occupies all the paper. Once it is dry, the second strip has been painted superimposed on the first.

The luminosity of the color

The darkening or gradating process in watercolor can be understood easily if you observe a dark, dense color before it is dissolved in water. Look at dark blue as it comes out of the tube. The density of the gum Arabic pigment paste blocks out the white paper support. If you take a brush and gradate the color until you get a transparent wash, the color spreads out in the watery medium. Increasing the quantity of water in which the watercolor is dissolved breaks down the density of the color and allows the white paper color to come through the pigment particles.

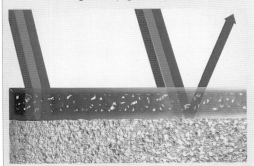

In its original state without water, watercolor paint does not let light pass. As more water is added the color density is reduced. The white of the paper reflects back light and absorbs the other colors of the spectrum.

Clarity and color saturation

The color on the paper can be lightened in several ways: a mass of color to which water is added undergoes tone dispersion. What takes place is called a washing, and it is a technique to do all types of gradations.

When water is added to a color stain, the color becomes lighter.

A wet stain can be lightened if you press down on it with an absorbent material like a sponge or a cloth. Some of the humidity is soaked up, but so too is some of the color.

A sponge can absorb color from a damp stain.

Logical process

Watercolor paint is most luminous when it is diluted with water. Different colors will have different transparencies. A color can be gradated to such an extreme that when it is on the paper it seems as if its chromatism has been dissolved in the water. If you repeat the exercise with a different color and paint a wash next to the first strip, you will be able to appreciate that each tone belongs to a different color. When the colors have dried and a new film is laid over the area, the subtle tone will be added to the first tone and despite being painted with the same film, it will slightly darken.

A color at its most transparent still marks a chromatic difference with respect to the paper background.

Just as a sponge can absorb water, a wet brush can stroke it aside to open up whites, lightening the picture. The quality of the paper plays a key role in this action.

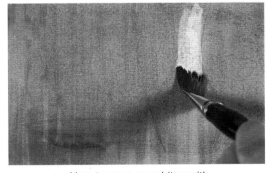

How to open up whites with a brush on wet paint.

A color painted on paper can become saturated or richer while it is wet, or when it is dry. If it is wet any addition will blend with the first color. If it is wet the second color will form a film on the already-dry color.

After allowing the color to dry, any other tone or color superimposed on top of it will enrich it and darken it.

Lightening the colors

Lightening the colors is not done with white paint, but rather by adding water to the original color and then painting on the paper. The dark colors painted can be definite, or the base of a darker tone, but they can never have a lighter color superimposed on top.

A classic example

The way Fortuny painted

It is always recommendable to study the classic painters. Marià Fortuny (1838-1874) painted this luminous landscape in which the light to dark process can be observed. First he painted a warm wash and a transparent sky. Once dry, he painted in the blue and outlined the clouds with a brush.

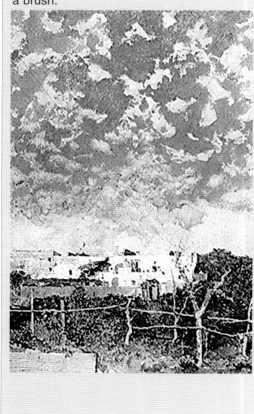

The procedure depends on the subject

Watercolor is more luminous the more transparent the wash is as it allows more light to be reflected. This property indicates how one should paint with the technique: always from light to dark. Watercolor tones and colors cannot be painted on top of darker ones. This means that if you want to paint a light color on top of a dark one, part of the dark color will have to be removed by one of the previously mentioned techniques. Then allow the paper to dry and, on top of the opened up space, paint the desired luminous color. Painting a color, as luminous as it may be, means darkening the white of the paper. The techniques of superimposing tones vary according to the work being done. In some cases the lightest tones will be painted first, and then afterwards the darker ones will outline the shapes. At other times the darkest tones will be painted first while the white spaces are left in negative from the beginning.

The process of gradually superimposing tones. Always from light to dark.

The role of water

Water is the vehicle in watercolor. Its evaporation dries and fixes the paint on the paper. In the short time period between the brush placing the wash on the paper until the watercolor dries, the paint can be manipulated in numerous ways.

A

B

C

D

Some of the most common effects on watercolor obtained from the water:

A. Absorbing with the brush.
B. Saturating the water on a color.
C. Effects from salt.
D. Washing by gradating.

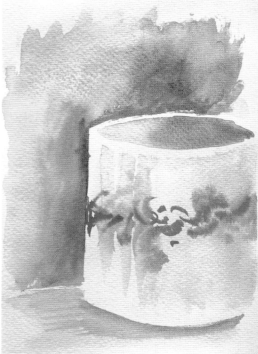

Another way of painting water color. First the dark colors were painted and the light areas were left untouched from the beginning. Finally, the tones that give nuances to the light were painted.

Intensities of the same color

One sole color has a great many tone variations. This makes possible a scale of grays as rich as those shown in the drawing. The untreated color is placed on the palette and gradated until it borders the white of the paper. This allows a wash, which is the drawing technique closest to painting, to be developed.

A practical application of the last tone scale.

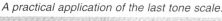
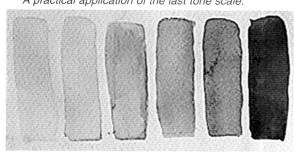

A practical application of the last tone scale.

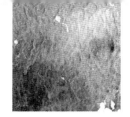

LIGHTENING

Different colors, different possibilities

The possibility to lighten depends on the luminosity of the color. The darker the original color, the greater the gradation possibilities. Just adding water to the paper is sufficient to obtain a more luminous gradation.

If you compare two colors of opposing tones, for example Prussian blue and Naples yellow, you will discover that as it comes out of the tube the blue is so dense that it is impossible to distinguish it from other dark colors. When you start to water it down, the tone range obtained going towards total transparency is very extensive compared to the gradation that the yellow offers.

Lightening with water

A color can be lightened with water but this also means increasing the luminosity. Water can be added on the palette or directly on the paper. The more water added the more luminous and transparent the color will be. On the palette the wash can make the color transparent, even if it has dried. However, when you are lightening by gradating on the paper the paint must not be dry.

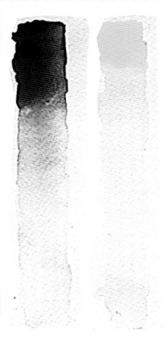

Comparing two tonally different colors. Blue gives more possibilities than yellow.

Effect of lightening on wet paint. The color must be wet so that it can be dragged by the humidity of the brush.

By going over it with a clean brush this zone has been cleaned.

Lightening and films

When the paint is watered down with water and spread over the paper a gradation is produced as the color is lightened. The transparency can be increased if you continue with the brush at the edge of the stain. Each color has a limit beyond which it cannot be lightened. This consideration is very important for doing final films or for creating certain atmospheres. The most suitable colors for doing films are the ones which allow the under color to be slightly corrected without toning them. However, obviously a yellow film on blue colors will form some greens, above all where the blue is most transparent.

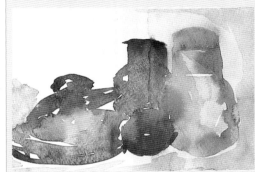

Look at this watercolor; half-way through an ochre lager was put down. It only changed the most transparent colors. On top of the others a slight saturation effect was produced.

Lightening by mixing colors on the paper

A color can be lightened by another more luminous color, always paying close attention to the effects produced by the colors in the mix. Watercolor can work like light filters. For example, adding yellow to a background stain can convert it into a greeny gray color. Dark blues can be lightened by luminous greens and even by orange. It is important to bear in mind the color that is doing the lightening because the tendency to gradate can have different chromatic effects.

Two different ways of lightening the same color, by mixing and by gradating with water. The nuances obtained are very different.

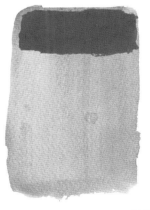

Lightening a dry color

Many experts affirm that it is impossible to change dry watercolor. This is only half-true. Just as dry watercolor can be softened up in the pan, the same can be done on the paper. Wet it by passing a clean, damp brush over the area to be corrected until the watercolor comes away. Wash and rewash the brush until the color is completely dissolved. The result depends on the color and the paper quality.

Testing on the paper

It is an interesting practice to observe the results of applying different lightening processes to colors. Try it by gradation and by mixing with lighter colors.

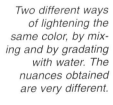

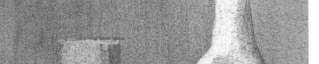

DARKENINGS

The limits of the color

On the palette a darker color version than that of the undiluted watercolor can never be obtained, unless you add a darker color. In contrast, on paper on a dry color, any addition, however luminous it may be, means that the tone increases. The pure watercolor out of the tube or pan is never the color that is actually painted as it must be diluted with water. Each color has its own darkness limit. It is very difficult to achieve total opaqueness; it is not a watercolor property, therefore try to achieve darkness through contrast rather than by using opaque colors. The variety of dark colors that can be obtained by mixing is infinite and the absence of total opacity means that the tones can acquire a whole host of warm and cold nuances.

A. Darkening process of a luminous color by superimposing layers.
B. Darkening process of a luminous color by mixing.

Homogeneous mixes

When color mixes are made they must be well done on the palette before taking the brush to the paper. If they were poorly mixed they would cause an uneven paint surface.

Using a mix to darken a color

This is the most intuitive way of darkening colors. Any tone darker than the first saturates and darkens it. However, bear in mind the possible color changes in the mix. For example, a luminous red can be darkened with a little blue, but if the proportion is increased it will turn into a violet color. Alternatively, if you use violet to darken the red many more nuances can be obtained before converting the red into violet.

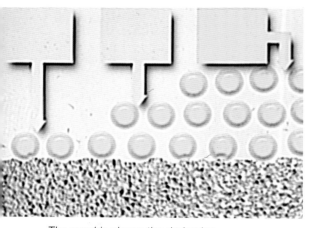

The graphic shows the darkening process of a luminous color with a color that increases its tonality.

Darkening a color without toning it

A color which has another color added to it tends to tone, to become a third, different color, unless the added color is part of the same chromatic range. When mixing, it is important to know when a color is no longer darkening but is actually becoming another color. For example, if ochre is added gradually to a luminous yellow it can be darkened without losing its tone. It can also be darkened with carmine, but it would no longer be yellow, but an orange color.

Color saturation

The range of watercolors is so wide that a color can be saturated with different tones of its own range. A color can be intensified on the palette or by superimposing layers on the paper, but only when the layers have dried completely.

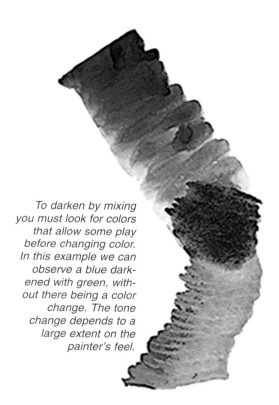

To darken by mixing you must look for colors that allow some play before changing color. In this example we can observe a blue darkened with green, without there being a color change. The tone change depends to a large extent on the painter's feel.

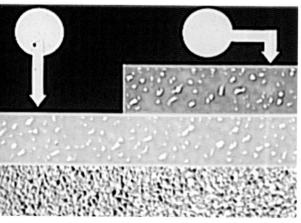

In this graphic you can see a cross-section of paper with three films of the same color and saturation. As can be seen, superimposing the layers produces a saturation of color.

From light to dark

Watercolor technique is based on a process from light to dark. A light color cannot be painted on top of a dark one; only the opposite.

Color saturation

A color can be saturated when it is painted on top of the same color, already dry.

Darkening light tones

Light colors and tones can be darkened with colors from the same chromatic range on the paper. On the paper, layers of the same color can be repeated.

Mixes

The mixes must be homogeneous and well controlled before being painted. A mix can be used to darken a color or to lighten it.

LIGHTENING EXERCICES

It is important that the painter starts to practice watercolor, using theories related to color. In watercolor the amount of water decides the light of the picture: the more water there is, the more luminous and transparent the colors are. You have to learn to distinguish between chromatic lightening, produced by mixing two different colors, and the lightening obtained from gradation by adding water.

Lightening a color by mixing

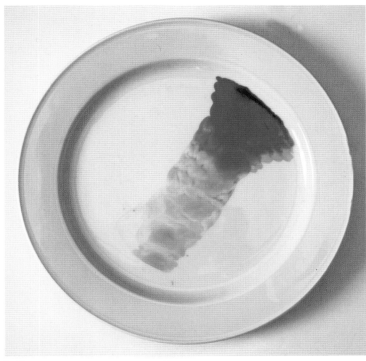

1 Spread dark blue on the white ceramic plate palette.

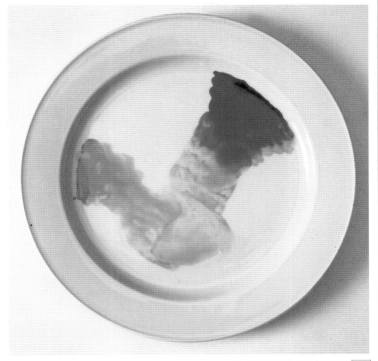

2 To lighten the color you can use a luminous green. Observe the tone obtained as the color becomes greenish.

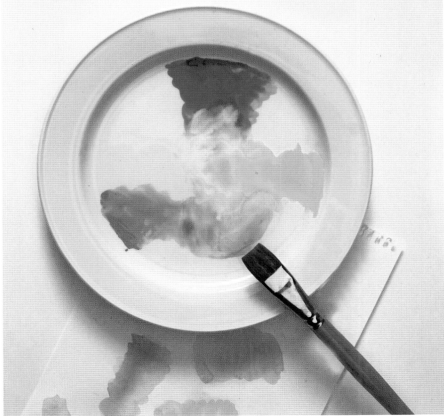

3 Observe the lightening effect produced by mixing with yellow. The tone obtained is greener than if luminous green had been used. Tests on the paper must be done to see the results of mixing.

Lightening a color by adding water

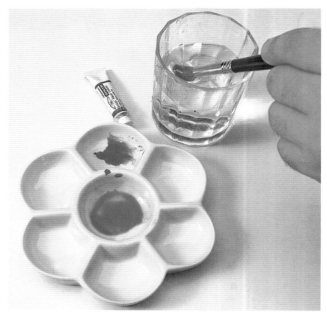

1 Place blue paint on the palette.

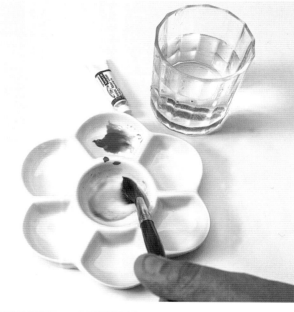

2 After washing the brush in clean water, wet the stain in the palette and thus reduce its density.

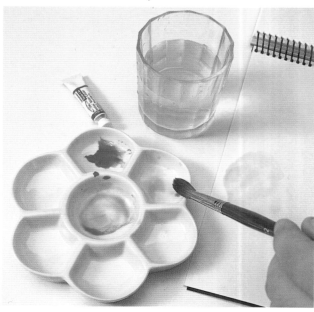

3 Do tests on the paper, checking how the color gradations perform.

Gradations of lightened colors

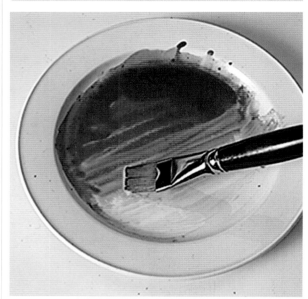

1 Do a dark wash on the palette or on a plate.

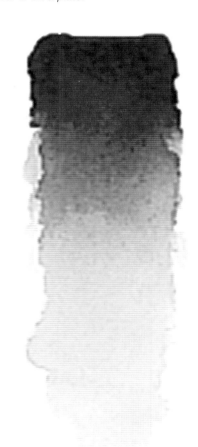

2 Do a stain stroke on the paper. At one end of the stain use the clean, wet brush to spread out the color. Repeat this until it lightens.

AN EXERCISE IN DARKENING

Watercolor paint deposited on the palette allows all sorts of gradations to be done by adding water. Thanks to this possibility the watercolor technique can be based on looking for tones by successively darkening different layers. Darkening colors, on the palette or paper, is the property that makes watercolor one of the painting media that offers most possibilities in light and chromatic terms

Darkening by saturating a color

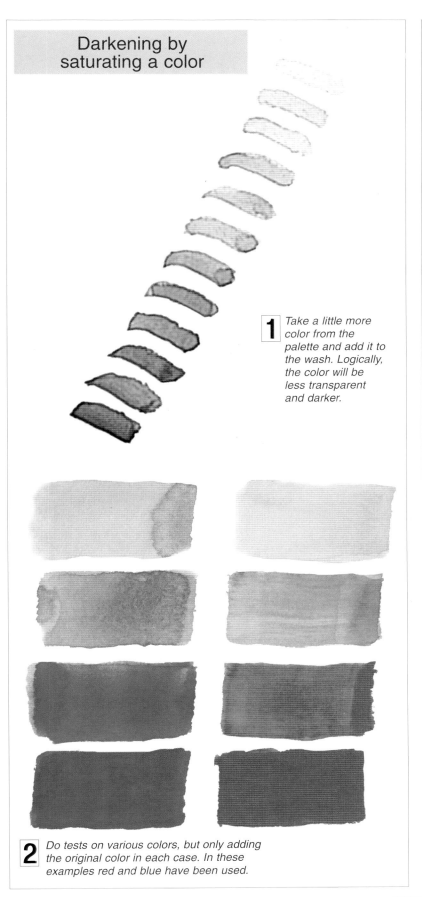

1 Take a little more color from the palette and add it to the wash. Logically, the color will be less transparent and darker.

2 Do tests on various colors, but only adding the original color in each case. In these examples red and blue have been used.

Darkening by mixing

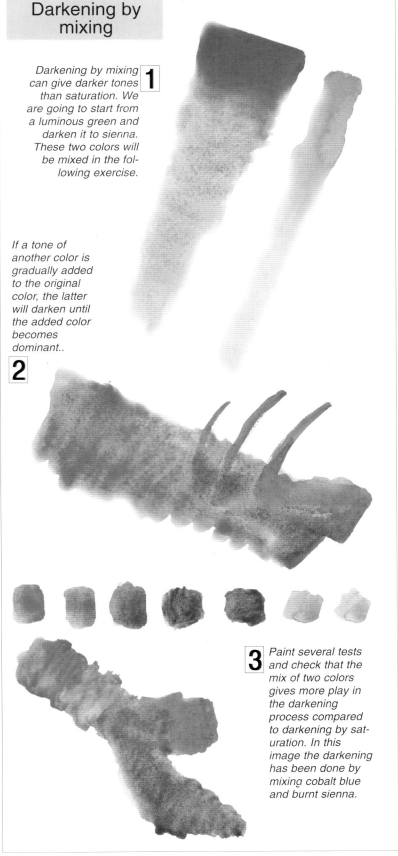

1 Darkening by mixing can give darker tones than saturation. We are going to start from a luminous green and darken it to sienna. These two colors will be mixed in the following exercise.

If a tone of another color is gradually added to the original color, the latter will darken until the added color becomes dominant..

2

3 Paint several tests and check that the mix of two colors gives more play in the darkening process compared to darkening by saturation. In this image the darkening has been done by mixing cobalt blue and burnt sienna.

Darkening by staining

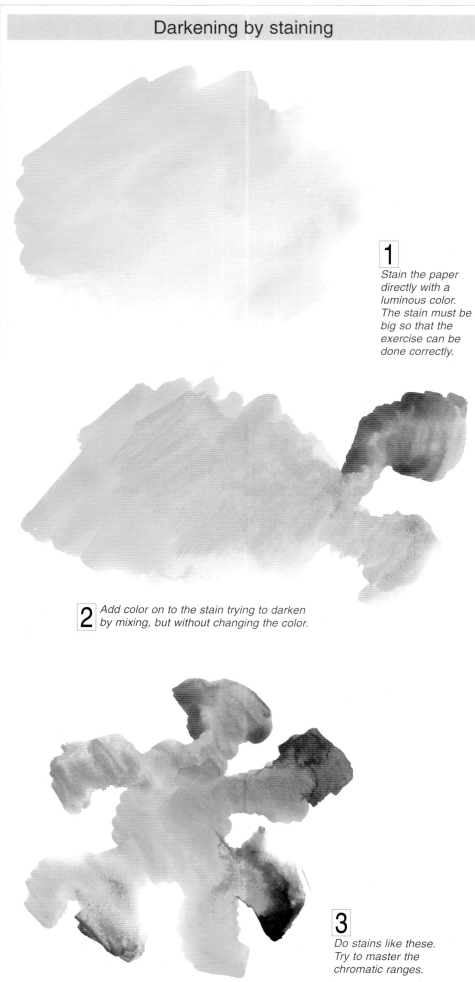

1 Stain the paper directly with a luminous color. The stain must be big so that the exercise can be done correctly.

2 Add color on to the stain trying to darken by mixing, but without changing the color.

3 Do stains like these. Try to master the chromatic ranges.

Gradating the darkened colors

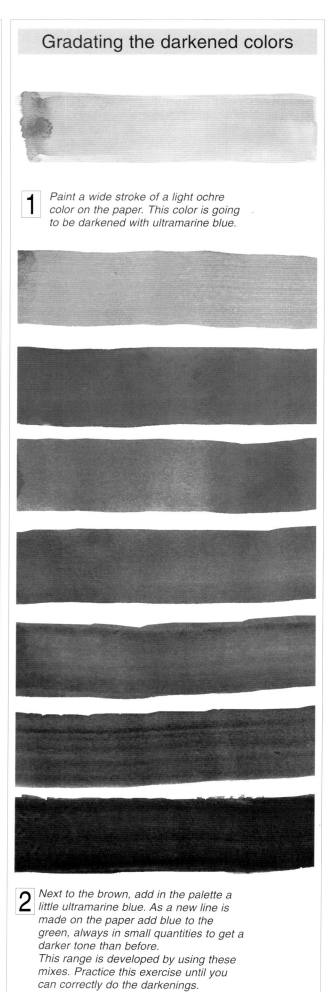

1 Paint a wide stroke of a light ochre color on the paper. This color is going to be darkened with ultramarine blue.

2 Next to the brown, add in the palette a little ultramarine blue. As a new line is made on the paper add blue to the green, always in small quantities to get a darker tone than before.
This range is developed by using these mixes. Practice this exercise until you can correctly do the darkenings.

TOPIC 6

PROCESSES (2)

When working in watercolor it is fundamental to make the most of the possibilities of the color and of the tone gradations. Watercolor facilitates the logical comprehension of color by synthesizing tones. For all enthusiasts the wash has to be the reference with which to understand the logic of the tonal process.

THE WASH (1)

The wash is one of the most interesting processes to learn and to develop. Painting with watercolor requires few materials (colors, paper, brush and water), but the wash is even more Spartan for it only uses one color so you can do away with the palette-box. This austerity has resulted in the wash becoming very popular with roaming watercolor painters.

The wash existed even before watercolor was considered a technique in its own right. In fact it was common for painters one color sketches on paper so that they could study the luminous effects in monochrome before doing the definite color planning. Watercolor is between drawing and painting, therefore doing washes enables the painter to become more familiar with watercolor. In the end watercolor is nothing more than a one-color watercolor

Dry and wet gradations

Watercolor allows a total gradation of any of the colors. This means that all types of contrasts can be obtained from one color.

A color gradation is done with water, spreading the palette color until you get the right tone. As you are only using one color looking for light or dark tones is much more straightforward than when working with many colors.

To lose one's fear of painting there is nothing better than to get familiar with how to do gradations. Just take paper and start doing a few tone ranges. It is only necessary to wet the brush in paint, apply it, wash the brush, spread the paint and then keep repeating.

A gradation can also be done on top of an already wet background. Just spread the paint and dissolve the color when a clean brush in the zones that must be more luminous.

Working with one color

A wash is done with watercolor or with ink for both of them have the necessary characteristics.

A wash is characterized by using a sole color in all its tonal variations, just like pencil or charcoal drawing. However, wash also uses watercolor techniques: layers, superimpositions, transparencies of the white paper, and above all, water to achieve the desired effects.

It is very important the watercolorist becomes familiar with the wash technique before going on to use colors. Wash is the procedure that draws painting close to drawing and is therefore more accessible, although still complex.

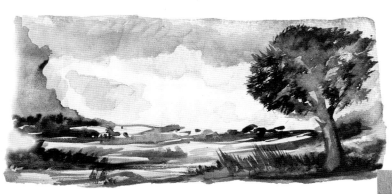

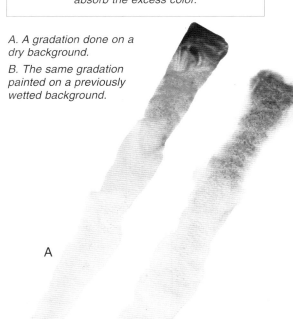

A gradation done in just one color. Wash takes advantage of the variety of tones offered by gradating a color.

Dry gradation

Doing a gradation on a dry background means that the color must be diluted in the palette. Once it is on the paper the stain is spread with the brush until the color is gradated.

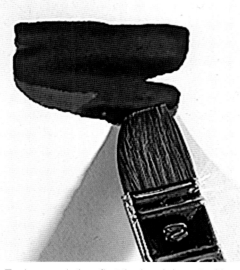

To do a gradation, first the brush is wetted in watercolor and then the paper is stained.

After washing the brush, spread the paint and absorb the excess color.

A. A gradation done on a dry background.

B. The same gradation painted on a previously wetted background.

A

B

Gradations on wet

When the paper is wetted any paint added tends to spread out over the wet zone. This effect can be taken advantage of to do gradations.

Wet the zone where the gradation is to be.

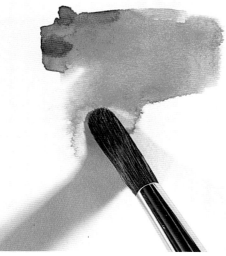

Stain the paper.

Finally, spread the color and it will blend in the humidity.

A question of water

Water is the element that regulates the transparency of the wash. All the tones in watercolor depend solely on the amount of water added and how the paint is applied.

Independently of the tone gradation, the effects that can be obtained from the wash are very varied. You can paint on top of a wet background, a dry background, take color away from a painted surface, open up white spaces, etc. All these effects can be achieved in wash and in watercolor.

The most commonly used colors in the wash are blue, sepia and sienna.

Never too light

It is important that the color chosen allows tones that contrast well with the white of the paper. Any very luminous color, like yellows, ochres, or oranges, will only offer a limited range of tones. It is always better to go without a dark tone of your own free will than to have to give up on a color because you cannot get more out of it.

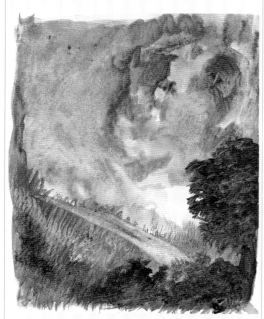

This wash was done with an originally dark color. Light tones can always be obtained from the palette. You only have to water the color to get more luminous tones.

Some of the effects produced by water in the wash.

Choosing a color

To paint a wash you can use any color, it is a question of taste. However, some colors do permit more tone and contrast possibilities than others. The colors most used for doing washes are sienna, sepia and dark blue.

From light to dark

Although wash uses the same technique as watercolor, it is very important to start from the darkest color in the palette and to do the gradations in the pans or on the palette itself. If you are doing a sepia wash, the tone limit will be determined by the least watery tone. From this base you can decide which tones will be painted on the paper.

This will be the darkest tone you can do with this color.

WASH (2)

Continuity and cut offs

Paint can be applied on a wet background or on dry paper, but one question must always be remembered: a layer of color superimposed on another not only increases the tone in the intersection area, it also produces a cut off between the two tones. This defect, which appears by mistake when the painted zone dries before painting the next one, can be avoided by painting continuously.

Tone tests

When you are going to do a wash have several identical papers handy to do tone tests. These tests must reveal how the painting will work on the paper. If you are looking for a light tone to do a first layer, and on top of this you are going to do a shadow gradation, it is a good idea to do a 'trial run' to see how it works out on the paper. Check the paper absorbency, drying time, and the effect the tones produce together, both when dry and into-wet.

Tests on identical papers enable you to foresee difficulties before they arise. In these samples the definite tone of a shadow on a wet background is being checked out

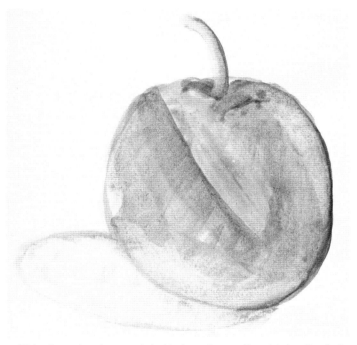

This shape has been painted in two stages. By mistake, the first stage dried before painting the second and so the cut is too visible.

A guide

Wash is on many occasions a rapid way of doing sketches that can later be developed in watercolors. Doing a monochrome wash allows many light and tone questions to be solved without going into the complexity of color. Wash is not only a useful preparation for watercolor artists, it is also used by artists who paint in other media, like acrylic or oil.

Sepia and sienna washes

Sepia and sienna are two of the most beautiful colors for doing any subject. Both colors are semi-permanent and have many tones more delicate than other shadow colors. Therefore they are widely used in washes: no other color offers so many diluted tones.

The variety of tones that sepia and sienna offer is so wide that they are the most commonly used colors in washes.

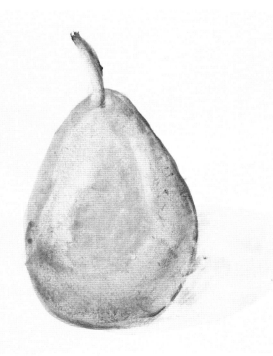

The correct way of painting: painting before the first layer dried has avoided the cut.

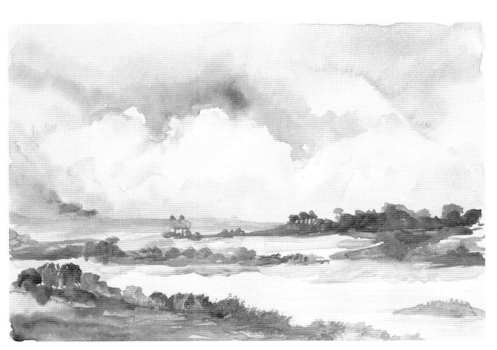

References from masterpieces

Watercolor is a quite recent painting technique. Its practice started at the beginning of the eighteenth century in England. Originally it was used to illuminate engravings but it became so widely accepted and popular that many artists took it up as a creative technique in its own right. Modern watercolor comes from gouache, there being a difference that the latter is manufactured with more agglutinate and that the pigments (normally transparent) become opaque due to the addition of inert pigments like chalk.

Before watercolor became the technique that we know today, wash was one of the recourses used by artists to sketch and prepare their important pieces. The wash had no value for the painter, it was merely a try out, somewhat similar to a drawing which offered a plastic vision of the volumes and lights. With the perspective that history affords us we can analyze some of these washes and we will observe that they have artistic value. Some are as sublime as the works that were elaborated from them.

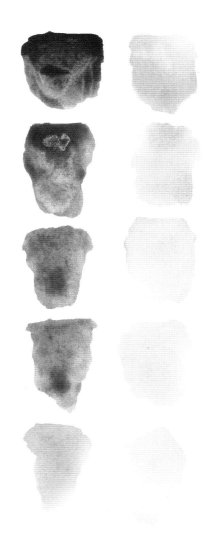

A scale of tones done in sienna.

Leonardo da Vinci (1452-1519), Sketch for the adoration of the Wise Men *(1481-82), yellow and bistre on board, 246 by 243 cm. In the Uffizi gallery, Florence. Before wash came into existence, artists used similar methods that allowed the spaces, the people, the light and the composition to be studied without elaborating colors. The semi-monochrome grisaille (a technique with two colors that allowed the tones to modeled) was used for doing the first stages of oil paintings. Or, as in this case, Leonardo used bistre (a brownish-gray yellow soot that contains wood tar) to do this sketch of 'The adoration of the Wise Men'.*

Claudio de Loreno; Landscape with satyrs*; wash on paper, 53 by 39 cm. Far from being minor art, the wash allowed artists to study imaginary landscapes and mythology, as is the case with this landscape with satyrs. The wash tones are enhanced by the luminosity of the paper in such a way that depth can be created just by reducing the color density. Of course, the most luminous tones have been painted first.*

Nicolás Poussin, Mount *Parnassus; Wash on paper, 33.3 by 16.2 cm. In this wash Poussin did not model the tones at all. He used the wash as a unique flat tone to study the differences between light and shadow. Wash allows a great deal of plasticity as it can be used as if it were drawing, the difference being that the stroke is applied with a brush. The volumes are made out much more clearly if they are approached like Poussin, without medium tones, only light areas (in negative) and darks*

Wash, basis of the watercolor

Wash is the link between drawing and watercolor. Its technique is based on monochrome tone gradations.

Water and tones

The amount of water used allows different tones of the same color.

Wash gets play out of the white paper

The technique in wash is the same as in watercolor. There is no white color, and therefore it is the white paper which allows the tones to be lightened.

The ideal color for wash

Although any color can be used, it is recommended to use originally dark colors. Sepia and sienna are the most suitable.

EXERCISE

Wash exercise: fruits

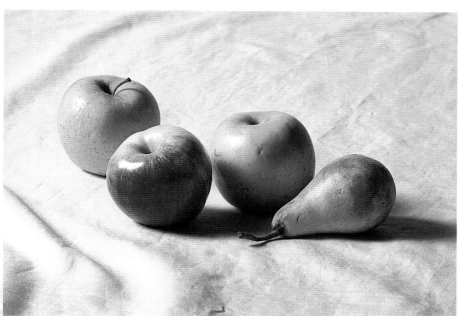

Necessary materials

- NECESSARY MATERIALS
- TUBE COLORS: SIENNA
- GRAPHITE 2B PENCIL
- 300G MEDIUM GRAINED PAPER
- WATERCOLOR BRUSH

The elements used in this exercise are available to everybody. Some fruit has been laid out on a cloth background. The simplest models tend to give the best results
Before starting the drawing on the paper, look at the light areas, the shadows and how the fruits are placed with respect to each other.

2

Place a little sienna in the center of the plate or palette. Use a wide brush loaded with water to do a light wash and paint the background. Drain off the brush and start to open up light spaces before the wash dries.

1

Start to do the basic design in pencil: Pay attention to how the fruits have been synthesized from simple geometric shapes. Once a scheme has been done, finish off the form of each fruit without thinking about the shadows.

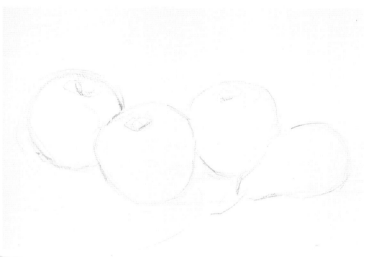

3

When the background is dry start the modeling of the apple. Paint the darkest part of the shadow with the dark color. Next use the drained off brush to stretch the tone over the surface without actually covering the light zone.

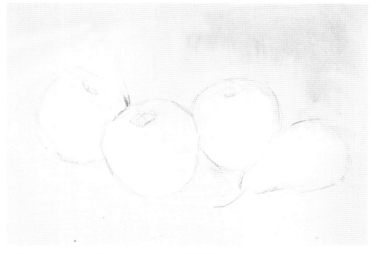

4

Using the wash done before, and adding a little water with the brush, give shape to the first apple on the left. The recently added dark tone mixes and blends with the lightest tone. The lightest tones are accentuated with a clean, wet brush.

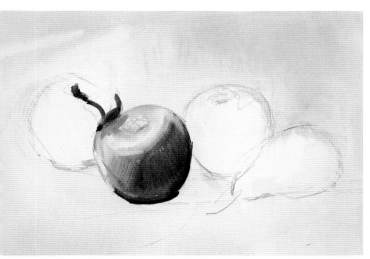

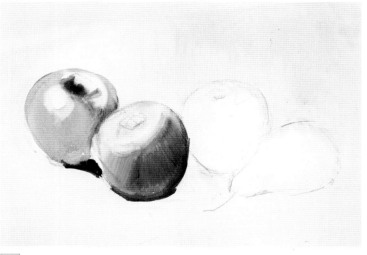

Studying wash

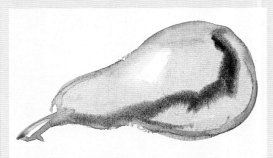

Dry the outline and with a brush loaded with a very light wash fill in the middle by dragging part of the dark color.

Do soft brushstrokes to model the shadow.

Finally, paint the darkest shadow of the fruit.

5 It is important to respect the drying times. With a new darker load intensify the shadow that gives shape to the apple on the left. Drain off the brush and finish the first fruit.

6 A very dark brushstroke intensifies the apple shadow. Outline the third apple with very light wash. It must be less defined than the others to give a depth effect.

7 The most intense shadow of the third apple contrasts with the illuminated part of the pear, with is defined when the shadow is darkened.

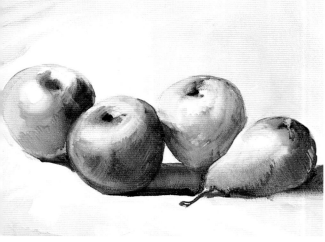

8 To finish off you only have to slightly darken the lower left-hand corner as if it were from a fold in the cloth.

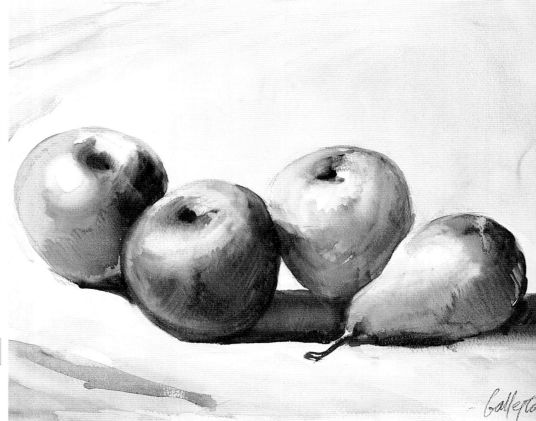

EXERCISE

Wash exercise: still life

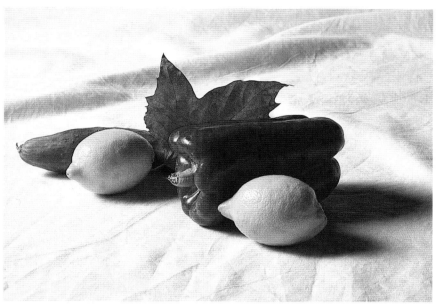

Looking for a model does not have to be a complicated task. Any everyday object can be used, for example, some lemons, a pepper or a cucumber. The model has been laid out in such a way that the lightness of the colors alternates. Finally, a leaf was added to make the composition more amusing.

Necessary materials

- TUBE COLORS: SIENNA.
- GRAPHITE 2B PENCIL
- MEDIUM GRAINED 300G PAPER
- WATERCOLOR BRUSHES

The importance of the drawing

Throughout this work we will see that the drawing is one of the vital requirements for doing a good watercolor. This is why, although the steps of the drawing are not specified, you must make an effort to make the model as accurate as possible.

1

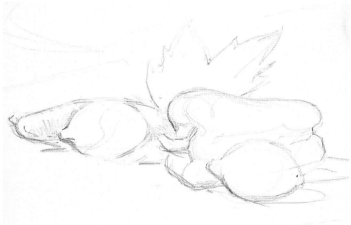

The drawing must be approached carefully and neatly. The proportions of the shapes of the model must be respected on the paper. Although a photo can be used as a model it is recommended to draw looking at the real thing.

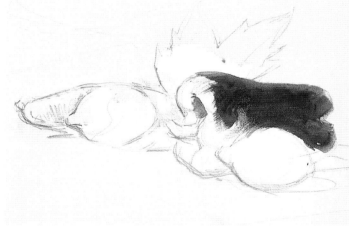

2
Firstly prepare a wash so transparent that when the paper is painted only a minimum contrast is produced. Use this color to paint all the background and to define the shape of the model. On the dry background paint the shadow zone of the pepper with the dark tone.

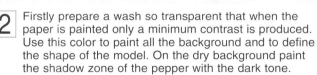

5
Go over the background with a new, very liquid wash. Use the same tone to paint the lemon on the left. Leave the shiny part unpainted, but intensify the shadow tone with a new somewhat darker layer.

3

Before the pepper wash dries go over the upper zone with a clean, wet brush. This dragging will take away part of the dark tone and will produce a wash with when you can paint a medium tone. Leave the light area blank. Paint the lemon with the same color. While it is drying paint the leaf in the background, leaving the nerve white. Use a dark tone to model the shadow of the lemon with curved strokes.

4

Observe in this close up how a dark wash has been superimposed on the still wet leaf. This has produced an interesting volume effect.

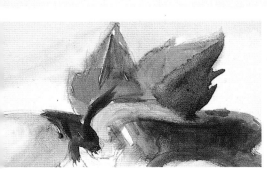

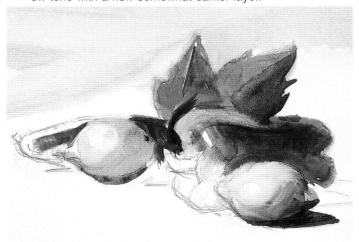

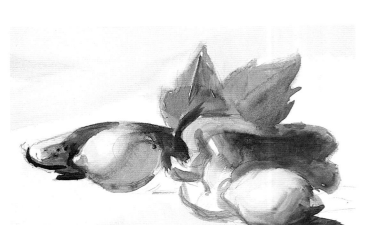

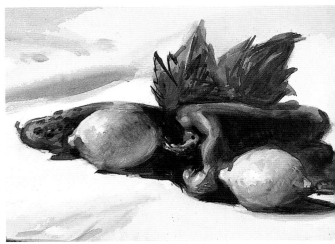

7 Finish the modeling of the lemon using a darker stroke than before around the edges of the two light zones. Blend the two tones trying to obtain a contrast between light and dark. The same wash is used to paint the luminous part of the cucumber. As the dark area is already dry the colors do not blend.

6 Before starting the lemon on the left, go over the cucumber with a dark wash thereby defining the shape of the lemon. Paint the lemon with a much more luminous wash, always using circular strokes around the light area. Before it dries intensify the tone of the lemon in the darkest part. This will increase the density of the wash q it must be blended with the last tone with soft brushstrokes.

8 The wash is now completely developed. From now on the details are done by creating contrasts. We will concentrate on the lemon, which is dry. Darker tones added now will not blend in the humidity of the paper. Increase the darkness of the shadow zones by modeling the shape with brushstrokes. Do the shadow of the lemon on the table and define the illuminated zone of the pepper.

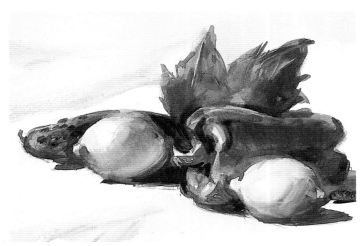

9 Work on the lower shadow of the pepper noting how the shiny spaces have been conserved. Before the leaf dries completely intensify the shadow tone.

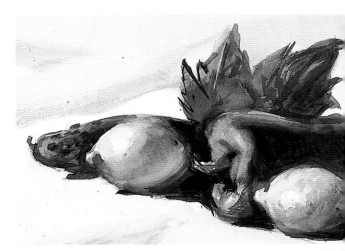

10 Finish the contrast on the edge of the tablecloth. As the background is dry a new wash can be used without the color spreading out of control.

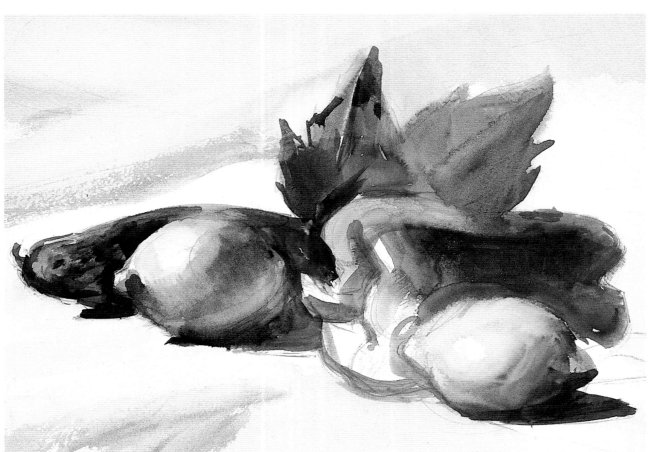

11 Wash is much more controllable when it is done with ascendant tones, that is from light to dark. These tones are the last added, and therefore the lightest tones are strong highlights. The medium tones, under the effect of the contrasts with the dark tones, have given volume to the different elements in the still life.

TOPIC 7

PROCESSES (3)

In the last chapter we saw the basic notions of the wash technique but one does not have to limit oneself to just doing monochromes and tone scales. In the following pages we will study, among other things, how to include a second color without ever neglecting the wash technique. Firstly, good mixing allows the paint to tend towards the first color or the second merely by adding more of one or the other. If the tonal possibilities and gradations are brought into play the technique becomes rich in nuances and transparencies.

Two colors will be placed on the palette and will be used both mixed together and independently. To conclude, go over the practical exercises put forward at the end of the chapter and compare the results.

Starting from a mix

To paint with wash you can be use one sole color and all its tonal gradation possibilities produced by adding water. You can also use a bi-tone composed from the two colors.

A mix is a homogeneous color compound that can tend towards either of the two colors, depending on the proportions. The variation in the mix, and the contrast and transparency possibilities can be taken advantage of to obtain a richer painting than a monochrome wash.

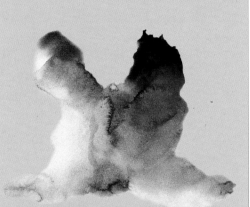

Two colors create a third color which will be closer to one or the other of the original colors depending on the mix. The tone scale can be as extensive as the watercolorist desires: they only have to play with the amount of water and the mix.

WASH: MIXING COLORS (1)

Wash allows the painting language of watercolor to get near to the synthesis of drawing. One tone or one color is sufficient to synthesize volumes, contrasts and to define shapes using drawing techniques. However, we will go further and study the possibilities from the simple mixing of two colors.

Bear in mind the following techniques throughout the chapter: gradations or the lightening of tones (how to turn a tone more opaque or transparent); and enriching a tone by adding a second one.

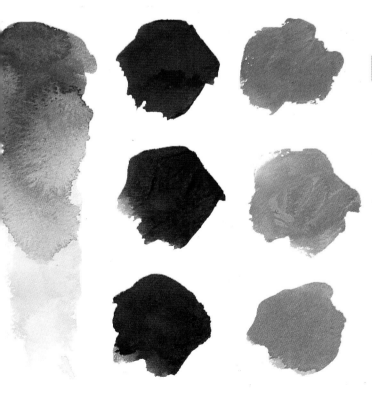

Using two colors can produce a homogeneous mix or a varied chromatic range.

Color pairs

When you are going to do a two-color wash it is important to know beforehand how they work together. Doing the mixes gives enough margin for strong, vivid contrasts. You can opt for a pair of colors from the same chromatic range. In this case the difference between the mix and the pure colors will be restrained, and the contrasts will be just rich enough to compensate for the lack of luminous of either color. For example, if you choose ochre and yellow, the two are very similar in luminosity terms.

Alternatively you could choose two complementary colors, like red (primary) and green (secondary). On mixing a broken color will be obtained with a tendency towards one of the two colors. The contrasts on the paper will have more colorist effect.

Finally, you can select two primary colors like red or magenta (they are not exactly the same) and dark blue. The mix will produce a violet color (secondary).

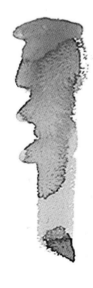

Three possibilities when choosing the mix of a two-color wash.

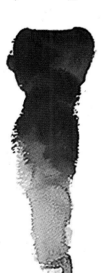

Using a sole brush

Wash is very austere in the use of color, but it can also be so in the number of brushes used. A medium, round watercolor brush allows a lot of scope because its thick, springy tuft facilitates both thick, loaded strokes and also all types of delicate, fine strokes. A sole brush can do a rich variety of strokes and a wash work can be realized with the strokes of just one brush.

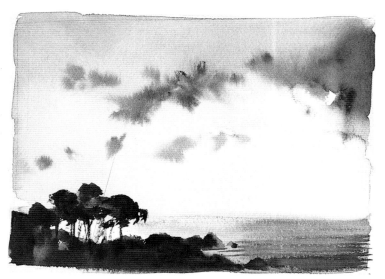

This watercolor has been done with a brush number six. Bear in mind that the paint can be spread over already wet areas while over the dry background thick or fine lines can be realized.

Brush size and strokes with the wash technique

Although a sole brush offers many possibilities, each brush size can produce different strokes. The width of the stroke can vary from the base of the tuft right through to the fine point of the hairs. The brushes which give the greatest leeway are the biggest ones, making them ideal for wash pieces.

The smaller the tuft is, the less it opens up and therefore its use is more limited: it can only do finer lines.

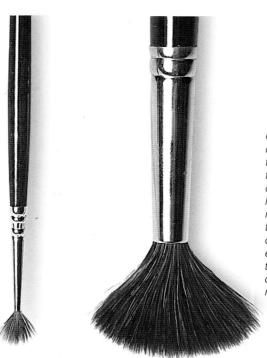

Observe the difference in the way these two brushes open up: one has a high number and the other a low one. The smaller the brush the more defined its recourses are.

The brush point

The watercolor brush point can be incredibly fine. It must only be reshaped by lightly twisting on the palette. However, it can also make a thick stain by applying an even pressure to open up the tuft over the paper.

Depending on the size of paper used it is recommended to work with a medium or large brush. Of course, if you have a small sketchbook it will be easier to use a medium to small brush (brush number relatively low).

To paint a two-color mix wash you can get by with just one brush, which should be medium or large but never small because the latter do not offer the possibilities available after brush number five.

The round brush allows a great variety of strokes.

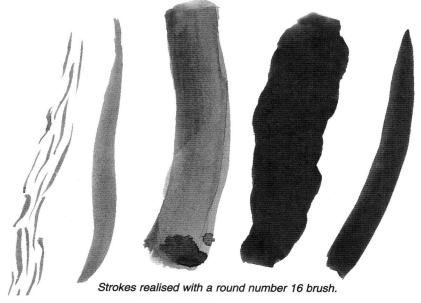

Strokes realised with a round number 16 brush.

Proportions in mixes

The quantity of color used in the mix determines its chromatic tendency. Therefore it is possible to do tone variations of one color in a stroke that mixes both colors.

The mix is started on the palette, trying to approximate one color. When you paint you can add dashes of either color for chromatic balance.

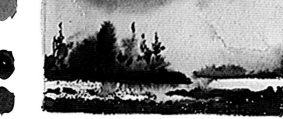

Observe in the graphic the approximate proportion of these colors in the wash.

WASH: MIXING COLORS (2)

Mixing on the palette

The wash realized with two colors can be mixed on the palette to get the right tone before taking the brush to the paper: on the palette always start from the darkest tone, gradate with water to obtain the right density for the color, and finally take it to the paper after having done a test on identical paper.

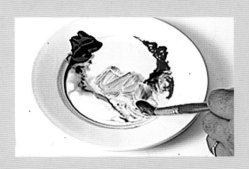

First of all place the two colors on the palette. Afterwards, in some space set aside, do the mix for the gradation.

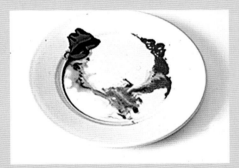

In some tones you can intensify one of the two colors.

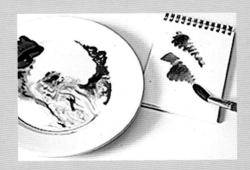

It is important to do a test on paper.

Mixing on the paper

When painting with wash the humidity of the paper is a factor in achieving some effects. The paper can be wetter with clean water or directly with a color. In both cases, while water remains on the surface any new color addition will blend, and, if the humidity was produced by a color, spread out over the background.

Two ways of blending color; the first over a background wetted with clean water, and the second over a color. In both cases the color spreads, but the results are different.

Two colors for a mix

If you are going to do a monochrome wash with the mix of two colors, or if it is going to be a two-color wash, in both cases it is recommended for the colors to be separated on the palette so that they do not contaminate each other. But, of course, they should also be easily accessible. Even if it is a monochrome wash, the product of a two color mix, it will gain in intensity if you allow there to be a tendency towards one color. To do this, drag a little paint into the mix from time to time.

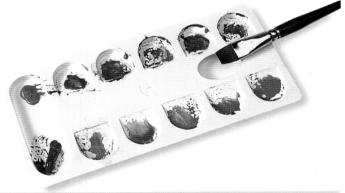

Using two colors only does not mean that the palette has to be small or untidy.

Two colors as if they were four

Another painting system for a two color wash is to make the mix so rich that you can opt for a combination of both tones, plus the two pure colors and the white of the paper as a contrast. It is judicious for the painter to get used to mixing and trying to obtain as many nuances as possible. Therefore, as well as doing a wash exercise, they can also practice mixing colors and their derivatives.

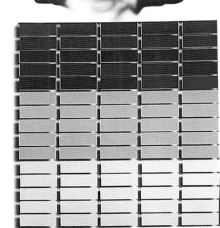

All the tones and derivatives in the image come from only two colors.

Nuances

When a pure color is developed in a monochrome wash a great variety of tones are obtained, with different luminous shades depending on the transparency of the watercolor. This tone range lacks chromatic nuances because it is made up of a sole color. However, if a second color is added the number of possibilities is multiplied. You obtain the gradation of the first color, the gradation of the second color and all the nuances produced by the mixing.

Adding colors

However little color may be added, if it is dark into light a change in the original nuance will be produced.

The dominant color

In a two-color wash one of the can be dominant and the other can be a nuance creator, working as a counter-weight to the main contrasts. The main color gets prime place on the palette, while the second color is more out of the way. When mixing the dominant color must be placed first so that the additions of the second color can be measured.

Adding a color on to the dominant tone.

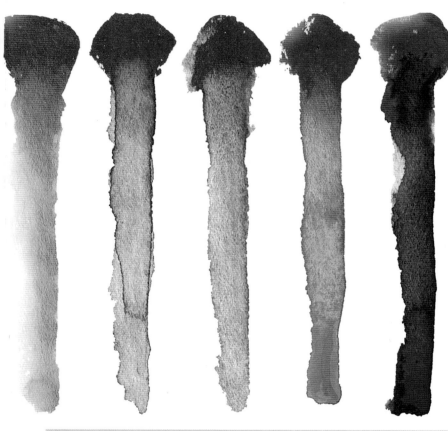

Miniscule quantities of other colors have been added to red. The nuance obtained with each color varies according to the luminous and chromatic characteristics of each.

Take advantage of the colors

Unwelcome marks are produced when one watercolor layer dries over another, then a line forms along the intersection. This tends to be one of the principal errors among learners, but it is also a recourse for drawing shapes in monochrome or bi-tone pieces.

A mark produced by mistake.

Notice how the error has been solved.

A pair of colors

The colors must be able to produce good mixes and to work together well.

The size of the brush

One brush offers many recourse possibilities. It is always recommended to use a high quality brush, the size of which depends on the paper size.

Two color wash

Two colors can be used for a wash, either for a monochrome mix or to do a two-tone piece.

Two colors as if they were four

A two-color wash can give an extensive tonal and chromatic range thanks to the gradations and combinations.

The dominant color: a classical motif

A few books can be the inspiration for starting a two-color wash in which one of them is dominant. In this case the most important color will be sienna, while blue will add a cold counter-weight. The layout of the model is crucial because the composition of the picture will be based on it. Study the shadows and the spotlight careful-ly. If you can, com-pose your own model with a similar look to here.

Necessary materials

- TUBE COLORS: BLUE AND SIENNA
- 2B GRAPHITE PENCIL
- 250 G. MEDIUM GRAINED PAPER
- WATERCOLOR BRUSHES

3

Add a dash of blue to paint the book spine. Water the color down and paint the grayish tones of the pages. Add a little more blue without chang-ing the dominance of sien-na. Paint the block of pages of the upper book. The strokes go in the same direction as the shapes. With a very lumi-nous blue paint the curve of the opened page.

1 The drawing is a fundamental base in watercolor. Without hurrying start the scheme and do not start to paint until the composition is completely finished. Erase unnecessary lines and go over the lines that drawing the shapes: Do not shadow them.

4

Use a somewhat watery pure blue to paint the shadow cast by the open book and the background on the right. While it is dry-ing, go over in very dark sienna the edges of the covers and define the cover of the upper book.

The first wash painted is very transparent sienna to fill out homogeneously all the background. Wait for it to dry before painting the book cover in very dark **2** sienna. Observe how the shine on the edge of the book has been left unpainted.

5

First, with a very transparent wash paint the spine. You must wait for it to dry and then darken the same wash before repainting. Leave the decoration the same color as before. Do some markings on the lower book. Use a bluish wash to paint the shadow part of the open book and the table edge.

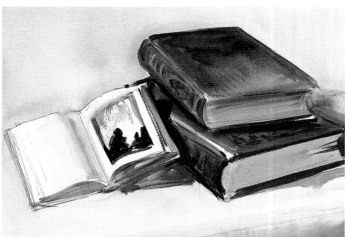

6

Use the wet brush to spread the stain on the book cover. When you come to the most illuminated zone, take the excess paint off the brush. Use a very dense mixture of blue and sienna to paint the figure illustration on the book.

Do a lighter wash than the dense color used to paint the illustration. This tone is used to paint the dark margin of the open page. Notice how the most luminous zone is left unpainted.

7

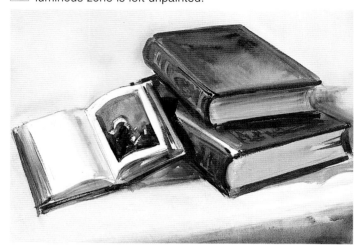

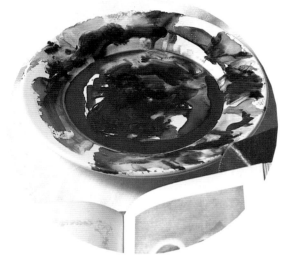

This is the palette used through all the process: a plain ceramic plate.

8

Use a very watery sienna, lightly stained with blue, to paint the shadow zones in the background. As the background wash is now completely dry, adding this layer will darken the first layer, but always very controlled by the brushstrokes. Paint in dark sienna the arabesques on the cover.

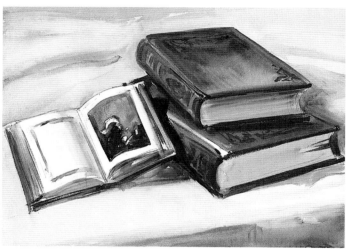

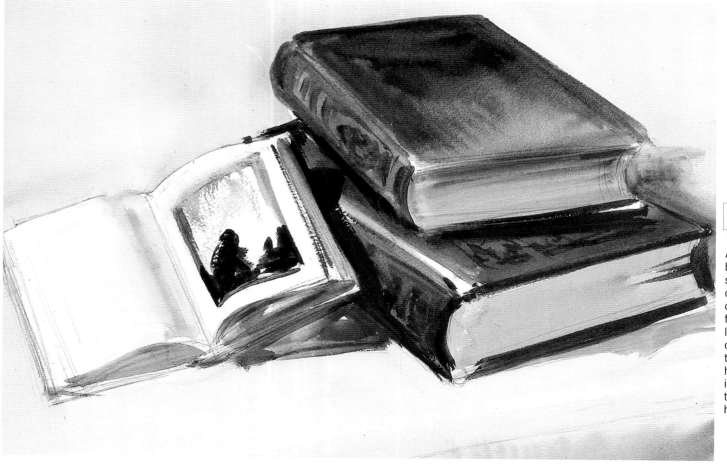

9

All that remains to be done is some small adjustment of the background contrasts and to finish painting the left page of the open book. This two-color wash has now been finished. Throughout the dominant color has been sienna.

EXERCISE

Watercolor in two colors: still life

Two apples, an onion, and a bottle of wine are going to be the model for the next wash exercise. It is important to compare the process and the result of this wash compared to the last one, which had a dominant color. Now, despite also using two colors, the mixing gives a wide chromatic and tonal range.

Necessary Materials

- TUBE COLORS: CARMINE AND DARK HOOKER'S GREEN
- 2B GRAPHITE PENCIL
- 250G MEDIUM GRAINED PAPER
- WATERCOLOR BRUSHES

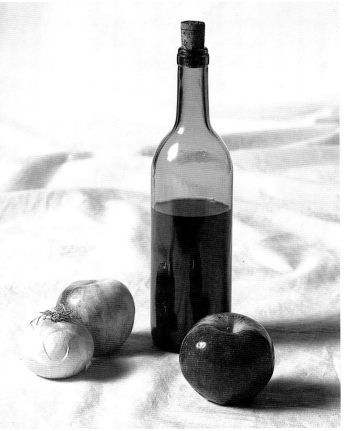

1 Observe carefully the way to do the basic design and drawing. Together all the elements can fit into a triangle. Within this figure, share out the space into concrete simple shapes. A drawing done on a well-designed scheme is much easier.

3 Start the bottleneck with vertical green strokes. The highlights must be left untouched. Use a much more watery green to transform the last tone into a luminous layer that defines the body of the bottle. A carmine and green mix gives the tone of the wine in the bottle.

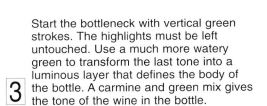

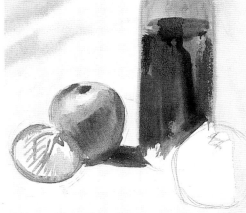

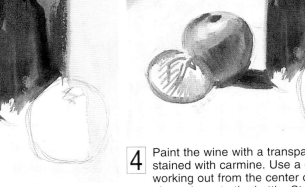

2 Mix green and carmine to obtain a brownish tone and use it to do a faint wash in the background that defines the main elements. Once the background is dry, do a greenish layer to define the folds of the cloth.

4 Paint the wine with a transparent green stained with carmine. Use a dark tone, working out from the center of the wine to give volume to the bottle. Stain the shadow with brownish green. When it is dry you can then paint the apple in carmine.

How to paint an apple in two colors

Mix green with carmine to obtain this gray tone. Do the basic design of the apple.

With the same mix color as before stain the most illuminated part. Leave the highlight blank. Before this color dries, paint the limit of the light zone and of the shadow.

Drag the brush over the surface of the apple. Add dark tones from the darkened mix and model the shape.

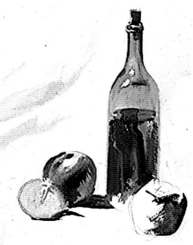

5 Before the apple dries, do a green layer that converts the mix into a reddish gray. Take advantage of the green tone to water it down on the palette and paint the onion with a transparent color.

6 Use a flat brush and very dark carmine wash to paint the apple with the same stroke. Observe how the highlight of this fruit is resolved: curved strokes comb the zone. Afterwards the strokes of the flat brush reserve the white in the background. The highlight has been taken care of.

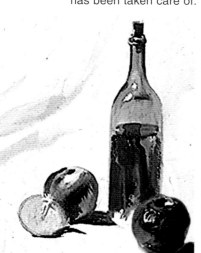

7 Use a wide, clean, wet brush to blend the different gray tones of the apple on the left, always following the surface curve. It is very important not to stain the white highlight that has been reserved since the beginning. Once the tone modeling is dry, paint a very dark layer (a mixture of both colors) on the onion shadow above the apple. The same color and thin brushstrokes are used to draw the fine lines that define the onionskin.

8 Finish this wash by increasing the contrast of the apple on the right. Do a very transparent wash in the background around the bottle.

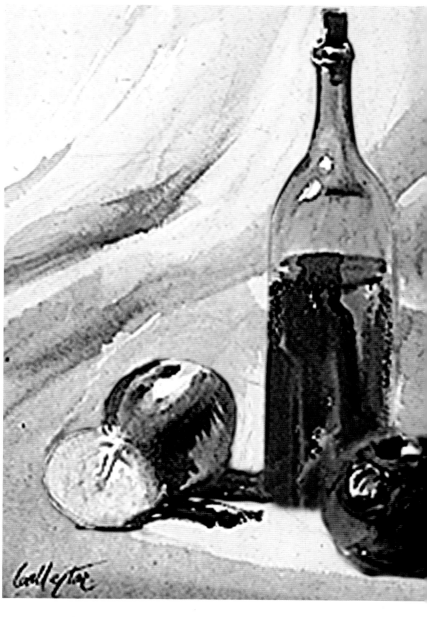

TOPIC 8

WET WATERCOLOR

Watercolor can be painted in two ways that we will now study: watercolor on dry and watercolor into wet. Although in practice both techniques are constantly combined when working, in the following two chapters we will concentrate on each one separately.

Water is the base of watercolor. In it, the paint dissolves and flows: a charged brush when in contact with clean water unloads its charge and you can see a cloud of color that ends up staining the entire container. If this operation is repeated the water becomes more opaque until it is no longer

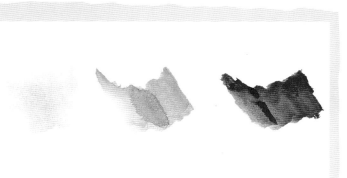

The transparency of the water diminishes as more watercolor paint is added.

transparent. This effect, added to the absorbency and whiteness of the paper, allows us to paint very fluently, but the stain will be limited just to the wet zone

WET ONTO WET

When the paper dries

After wetting the paper and painting, when the starts to dry it will wrinkle and form waves on the surface which, will obstruct your painting. To avoid this the paper must be held or stretched. The heavier the paper, the less it will wrinkle.

An untensed wet, light paper will wrinkle as it dries, complicating posterior work.

Wetting the paper

To start any piece on wet, the paper has to be thoroughly damp. Watercolor papers have to stand up to any degree of humidity including total immersion in water.

Each artist has his or her preferences as to wetting the paper, which also depend on the piece to be realized. The paper can be placed under the tap, a spray, wetted with a sponge or with a flat brush loaded with water.

Blendings

Blending colors on wet paper happens naturally as the load spreads away from the tuft on the wet surface. The blending takes place when the color load enters into contact with the humidity: its edges are not controlled. The surface does not have to be wetted with clean water: it could be a mix or a wash.

Gradated color blendings on a background wetted with clean water and on a still wet color base.

Rapid wetting

The most usual way to wet the paper is with a flat brush or a sponge. Both methods allow the humidity to be spread evenly over the painting surface. To wet the paper the brush or sponge must be loaded generously and then passed over in long strokes. Special sponges with handles, like brushes, are available. They speed up the wetting process.

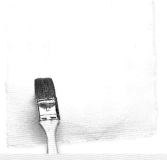

The paper can be wetted with a flat brush or a sponge.

A beveled sponge with handle.

Controlling blendings

The paint spreads easily over the wetted zone until the color comes up against the end of the humidity: it is a barrier that cannot be passed, unless you push it back with the brush. The color can be manipulated on the wet area without danger of it going beyond.

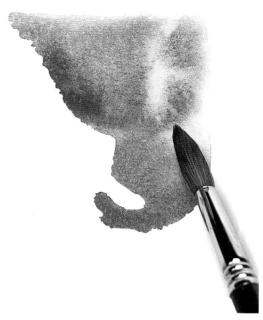

The humid zone retains the color added.

Gradations on wet and losing outline definition

A gradation on a wet background is much more easily obtained than on a dry background, although the results are quite different. On a wet surface add a brushstroke of color which will then spread out losing its defined outline. After washing the brush and stretching the paint, the color disperses and gradates. The wet background facilities the color fusion but does not allow the brussh stroke to be well defined.

Going for a tone in direct mixing

One of the advantages that working onto wet has the ease of color blending. A light tone can be darkened with a denser tone. This can even be done with the same color for saturation reduces the transparency. While the paint is still wet on the paper it can be manipulated effortlessly: colors can be mixed and the tones played with just by adding color. In the same way that a color can be saturated on a wet surface, it is also possible to take away color by absorbing paint with a clean, dry brush or with a sponge.

Controlling the humidity

The degree of humidity of the paper determines if the paint spreads over all the paper or if it gently blends in the zone marked off by the brush. When you want to cover a large surface, like a sky or all the background, brush or sponge water over the surface before doing the color wash. The humidity of the paper must be controlled before adding the color. Too much water only gets in the way. It will suffice for the paper surface to be lightly humid so that the wash flows freely.

Wetting by zones

The work done on wet may appear to be an uncontrolled process as the color spreads over the entire wet surface, but when you do the work by zones the diffusion of the color can be controlled. What is important when working on wet is to allow the zones you do not want to blend with any added color to dry. Only in this way can the painted zones be well defined.

Each painted zone has been wetted and painted when the others were completely dry. This preserved all the edges.

The tone on the wet background can be intensified by adding color; or it can be reduced by absorbing paint with a dry brush.

A classic example

The way Emil Nolde painted

The work of Emil Hansen Nolde (1867-1956) forms part of the first vanguards of German expressionism in the twentieth century, the so-called Dresde group formed by Kirchner, Bley and Nolde. The name came from 'dresde Die Brücke' (the bridge). The gesture and the stain possible with watercolor facilitated the plastic expressiveness of Nolde's work.

Emil Nolde, Sunflowers, *34 by 47.7 cm.*

Wet all the painting and start the most luminous colors stains.

The densest flowers outline the shape of the flowers.

As he was working on a wet background the paint could be manipulated on the paper, modeling the shapes with the brush.

DRY ONTO WET

Discontinuous strokes

The control of wet into dry watercolor painting can be total: discontinuous strokes which do not lose their expression can be made on an already painted and dry surface. Discontinuous strokes open up the door to all sorts of plastic effects like reflections in the water, the texture of numerous materials, etc.

The common method

The most versatile way of working with watercolor allows the work to be fluid and controlled at the same time. For this to be so the drying times of every layer must be controlled. some layers can be worked on while the background is completely dry; others will need the painted background to still be wet. These color layers will darken the first ones and therefore the tones that must remain luminous will have to be reserved from the beginning. On top of the dry colors, washes can be done using the same techniques when painting on a wet background. The new washes will not alter the stability of the already dry colors.

On top of a dry color new transparencies can be added without mixing the color of the layers below.

Effects achieved with discontinuous strokes on a dry background.

Transparencies

The watercolor technique is based on the creation of layers or films. They are called transparencies. When they are applied the colors can be lightly nuanced in tone or completely covered by other denser and darker colors. Any color, however opaque it may be, can be gradated on the palette or on the paper until it produces a subtle transparency: if underneath there is an already dry layer, this will not mix, rather it will come through the new color.

Do not drag too much with the brush

The paper surface is delicate and even more so when it is wet, therefore never insist too much with the brush. A mistake should not be corrected by adding color and water: the best method is to absorb as much paint as possible with a sponge or clean brush and allow the zone to dry. Then redo the area. Watercolor errors can be corrected but, to avoid deformations, do not drag the brush.

Dark on light and light on dark

As watercolor is completely transparent it is necessary to know how the tones are going to behave before they are painted. A light, luminous tone over a wide surface is a good base, once dry, to receive any other darker color. In contrast, if the base is dark any luminous colors added on top will be no more than tone nuances.

The quality of the paper

To obtain good results in watercolor painting it is vital that the paper is high grade. The degree of sizing must regulate the absorbency and impede sagging. The paper must have body and be medium grained. The main brands meet these requirements.

How to define an edge

Watercolor when worked wet onto dry allows the artist to perfectly define the edges they are painting. Watercolor flows accurately on an already wet zone; in this way you can paint a watery surface in which the edges are neat and perfectly outlined against the background color. If the background had not dried out it would not be stable.

The effect of using a light tone as the base for a saturated dark one when the upper layer is lighter than the base.

Washes

To work on a wet background it is recommended to be able to master the wash technique in all parts of the picture. Firstly study the widest zones: these will be done with light, luminous colors, and then do the densest, most opaque color washes, controlling the mix produced in the contact zones. To avoid an unnecessary dispersion from one zone to another, the color has to be denser than the wash added before.

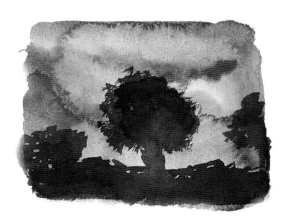

On top of a dry background washes with perfectly defined edges can be painted.

Calculating effects

The effects that can be achieved with wet watercolor can be varied, but one must be careful when working into wet. It is easy to go too far. Watercolor painting does not progress like clockwork. With practice it is possible to get the feel of the effects likely to be produced by color and the humidity of the paper.

Testing effects

It is important that the watercolorist is familiar with the principal effects produced when working onto wet, whether the base is white or if there is another color. To avoid possible surprises, it is not a bad idea to do tests on pieces of paper similar to the ones to be used. Tests are never the real thing, and that is why they offer a lot of margin to try out new ideas without committing yourself. Often thanks to trial and error many plastic effects that otherwise would have been impossible to foresee are achieved.

Testing effects can help to decide the way you work.

Working on details

Watercolor allows a lot of detailed work when working in wet on already dry layers. Detailism with watercolor is used normally by naturalists who paint flowers or fauna. Any stroke, however delicate it may be, while it is still wet can be nuanced by tones of other colors, thus making it possible to paint all sorts of textures.

Many illustrators used watercolor as their principal pictorial method because wet-into-dry allows color transparencies to be superimposed with great precision. The quality of the paper is very important in this type of work: very detailed work requires fine grained, heavy paper.

To achieve work with this finish the superimposition of layers is fundamental. First the most luminous and extensive tones have been applied. As these have dried new color layers have been added to define the shapes. Finally, thin strokes have given the necessary texture.

The effects of pointillism

Pointillism is a painting method based on theories of color of Georges Seurat (1859-1891). It is also called Divisionism because it breaks a color down into its elements. The pointillism technique is very dramatic: the colors are not painted with brushstrokes but with small points of pure color that are mixed on the viewer's retina. For example, if you want to paint a green surface, paint small blue dots alternated with yellow ones. From a certain distance the eye merges the two colors into one. This pointillism effect can be practiced both with a dry color background and with a wet one. The results are completely different.

A sample of pointillism work in pure color which mixes on the retina and provokes compound colors.

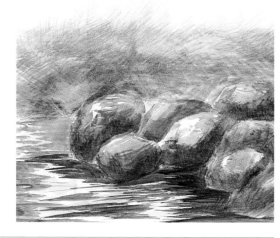

Wet the paper before painting

Some of the watercolor techniques require that the paper be wetted beforehand with a sponge or a flat brush.

Wetting and gradating

On wet paper interesting gradation effects can be obtained as the watercolor color spreads over the damp zone.

Mixing on the paper

There are two ways to mix on paper: mixing the wet colors directly or superimposing one color on top of another.

Color into dry

On top of a dry color transparencies or perfectly controlled strokes can be realized.

The way Turner painted

One of the principal techniques that Joseph Mallord William Turner (1775-1851) used to create his magnificent watercolors was wet onto a dry background. This is how he obtained dynamic, strongly natural clouds.

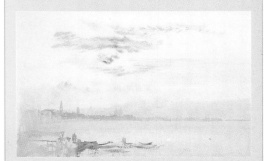

Turner, Looking east from Giudecca: early morning *(1819), watercolor on paper, 28.6 by 22.4 cm. British Museum, London.*

Just as Turner did, completely wet the background. Do a yellowish transparency and on top the horizon and clouds blue.

On the somewhat drier paper do the orange stain of the clouds and allow it to mix with the transparency of the background. Go over the blue strip, gently blending it with the strip underneath.

Finish with some small burnt umber stains on the almost dry background.

Landscape: wet onto wet

Necessary materials

- TUBE COLORS: ULTRAMARINE BLUE AND SIENNA.
- 2B GRAPHITE PENCIL.
- 250G MEDIUM GRAINED PAPER
- WATERCOLOR BRUSHES AND FLAT BRUSH
- STICKY TAPE.

Wet watercolor blends easily when it is painted onto a wet background because the vehicle of watercolor is the water itself. The fluidity of watercolor is very suitable for doing landscapes and other types of diaphanous textures. The model that we have chosen is not very complex. However, it will offer the enthusiast the opportunity to study in detail the fluidity of color on a wet background. Theme, a cloudy landscape with the light coming from behind, is suitable for putting this technique, one of the most common in watercolor, into practice.

1

After fixing the paper with sticky tape draw the horizon line and quickly sketch the lightest clouds. Remember that luminous colors and pure whites must be reserved from the beginning.

2

We are going to paint with the paper vertical. Load the flat brush well so as to wet all the paper surface. To wet the paper homogeneously do neat, horizontal strokes. It is not necessary to soak the paper, nor to make it drip.

3

On the palette do a gray colored mix from the blue and the sienna, the only two colors we have. All the work is going to be done onto wet. Start to stain the sky area with the flat brush. Observe that color accumulates unevenly. These patches can have the excess paint absorbed by passing the flat brush over, if they are to be lighter zones.

4

Use crossed-brushstrokes to spread the color of the clouds, and add blue in the darker areas. The colors blend together because of the humidity and the edges of the stains diffuse when they come into contact with white of the paper.

5

Use fan-shaped brushstrokes to give depth to the sky in the lower part, which can be manipulated because it is still wet. The clouds on the right are painted with a very luminous blue wash. On top of these stain brown some of the storms.

6

Take advantage of the fact that the paint tends to spread over all wet area to work on the shape of the clouds and to intensify the fan strokes of the horizon.

7

Once the sky wash has been done we will be able to observe how the very liquid color responds on a practically dry background. The edges of the horizon tend to blend and lose their definition.

8

Again we are working on a wet background so as not to allow the freshly painted horizon background to dry. Do a pure blue stroke on which of paint again with sienna, but this time with very dense watercolor so that the color does not spread beyond its limits.

9

When doing a light from behind the color must be as dense as possible to contrast with the different sky nuances. The color of the strip of earth is painted almost without being diluted. The density of the strokes is held constant on the wet background, even the limits softly blend and lose their definition.

10

The darkest tones of the horizon establish different planes with respect to the much more transparent first wash. Now this watercolor in which wet-into-wet work dominates has been finished.

Landscape: wet onto dry

Necessary materials

- TUBE COLORS: COBALT BLUE, DARK GREEN AND SIENNA
- 2B GRAPHITE PENCIL
- 250G MEDIUM GRAINED PAPER
- WATERCOLOR BRUSHES AND FLAT BRUSH
- STICKY TAPE

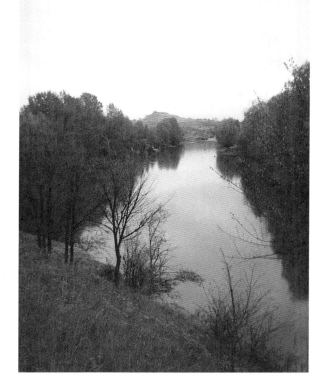

As a landscape has so many forms and color masses it is one of the most rewarding theme with which to put into practice the technique. In the last exercise we will practice dry onto wet; in this one we will let the color layers dry before adding new ones. Note the differences between the two techniques.

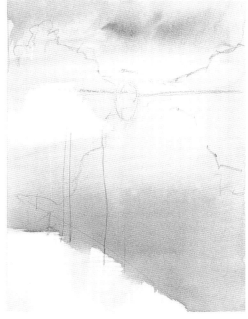

1

A good drawing is one of the main supports for a watercolor artist. Sometimes it will have to be detailed and accurate, and at other times, as is the case here, it will be a composition guide. On top of a sketch of the principal landscape shapes, do an uneven sienna wash in the river and cloud zone.

2

Allow the last transparency to dry completely before starting to paint a new color. Firstly, paint the mountains in the background with a faint blue wash. Allow it to dry for a few moments and start to paint the trees in a darker blue. Note the way the strokes go.

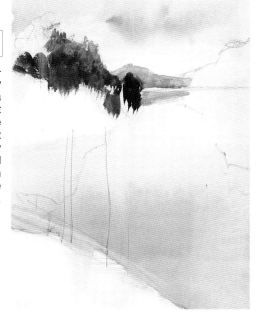

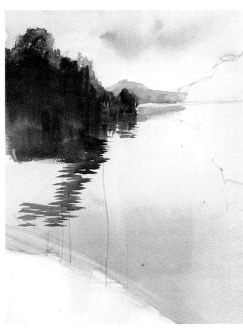

3

The aim is to do an unbroken, even color stain in the left part of the river, so continue painting in blue before the last stain dries. As the color is still humid it flows and blends, but as the background is dry it allows us to paint accurately the strokes for the reflections.

4

Finish painting the left riverbank in a monotone color. Start the right bank with blue in the background. When it is dry, paint the rest in dark green mixed with blue.

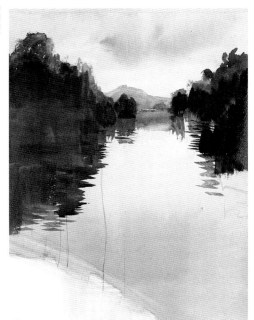

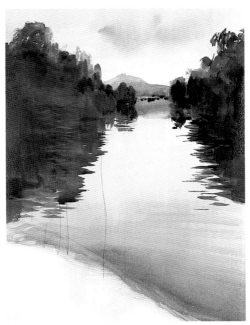

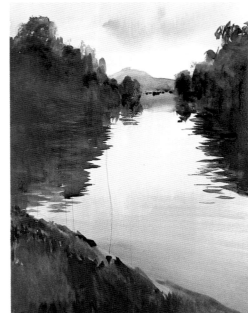

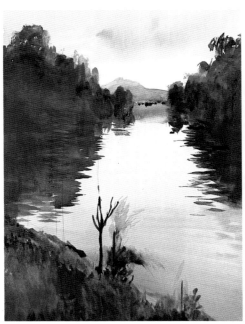

5 We finish the right bank with a mix of green and blue, taking advantage to paint the reflections in the water. Meanwhile the color of the left bank has dried and so we can paint again in blue without blending the color. Observe that in the lower zone a very faint gradation in blue has taken place, made possible by the background being dry.

6 The color of the last gradation could seem unpleasant. However, when we put in the other colors the whole chromatic context will be established, increasing the colors' attractiveness. Paint the shore with vertical strokes in blue, green and sienna.

7 The principal color masses of the landscape have been set out. We will allow the last interventions in the lower area to dry, and we will start to paint the trees along the bank. Firstly do the bush in a very transparent wash. Once it is dry start to draw the trees.

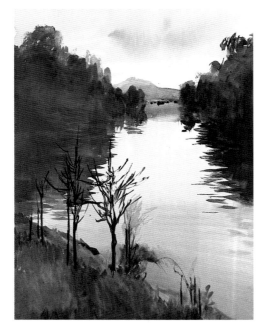

8 Concentrate your attention on the drawing of the dry trees. If you look at the model, you will see that it is very graphic. Draw first the trunks, and after the branches with finer strokes.

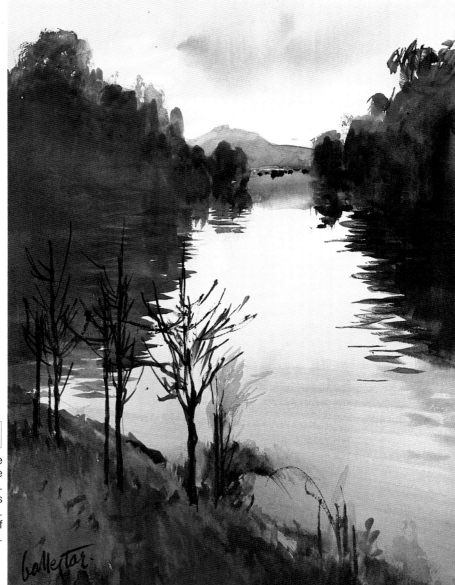

9

Continue the work on the trees. As the background is completely dry the fine brushstrokes do not swell out or blend. This will round off the exercise, but it is very useful to practice with other models. Always respect and take advantage of the drying times of each layer.

TOPIC 9

THE DRY BRUSH TECHNIQUE

Watercolor allows a rich variety of plastic effects. When working on a wet background blendings of tones and colors abound. However, when the background is dry there is no tone blending on the paper but instead superimposed strokes and defined outlines.

In the last chapter we studied wet into wet watercolor and wet into dry. These two different options enable you to work with all the technique possibilities of the medium.

The watercolor loaded onto the brush also has a degree of humidity that effects the characteristics of the strokes and therefore the painting style. An almost dry brush (were it completely dry it would not paint at all) opens up new creative horizons going from new textures right through to painting in almost photographic detail.

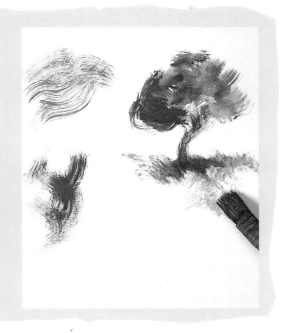

The right grade of humidity

The humidity of watercolor is what allows it to be applied on the paper. When painting the three factors that come into play -paper, brush and paint- can all have different degrees of humidity. The dry brush technique requires getting the combination right.

Any addition of color onto paper means that the edges of the stroke are unstable as the color tends to spread out over the wet background. A brush just slightly humid can drag part of the color, and if you work quickly allows the creation of textures by dragging. When only the watercolor on the paper is humid tests must be done to get the right **cover capacity of the brush.**

The brush must be loaded with just enough color to do the stain required.

A SPECIAL TECHNIQUE

When watercolor painting we have an option: to apply the watery medium on a humid base or on a dry one. At the same time the paint load of the brush can also be determinant in the resulting stroke, which can be continuous and fluid, or short and hard. In this chapter we will analyze the possibilities with a variety of styles and loads.

One of the questions which we will go into will be textures from dry strokes. Texture, in fact, comes from a continuous superimposition of different strokes.

The dry brush technique is not the most commonly used by watercolor painters, although it is one of the most dramatic. Although it may seem strange, a medium that flows over the paper like water can have similarities with oil painting or even dry painting (pastel). However, it loses some of its freshness and transparency characteristics that are so typical of watercolor.

On the next pages we will explain how textures can be realized with the dry brush technique. The most hard-hitting results require a great deal of elaboration. Firstly, a tonal base is done with soft washes, then selective darkening to establish the highlights, and, finally, the texture work that is done with the almost dry brush.

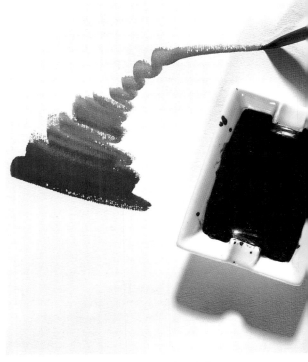

Work done with a dry brush allows heavy detail textures and finishes to be obtained. This close up has been left unfinished to show the drag of the brush.

The brush must be unloaded before taking it to the paper where you are working.

The humidity of the brush

The brush cannot be 100% dry, not even when using tube paint which is not very humid. The gum Arabic, the principal agglutinin of watercolor, tends to dry rapidly therefore permitting color to be added as if it were dry.

When using the dry brush technique it is recommended to have absorbent paper available for the excess humidity of the brush so that you can obtain the right degree of humidity for the textures and retouches. The drier the brush the shorter and more interrupted the stroke will be.

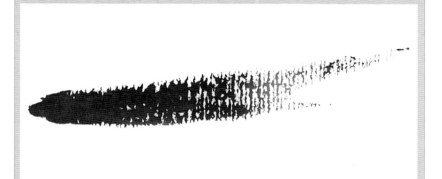

A dry brush allows you to work taking advantage of the paper texture.

Kate Greenwa (1846-1901) Study of rocks and moss (1855), watercolor with white relieves, 33 by 18.7 cm. The Ruskin Gallery, Sheffield.

Note the fine details of this piece done with a dry brush.

Which watercolors should be used?

All types of watercolors can be used with a dry brush but the best are tube paints because their pastiness facilitates dry working. When you take watercolor from a tube onto a dry brush the color impregnates the hairs even though they are not wet. The performance of the paint is very limited because the color adherence increases with the dryness. Watercolor in pans can also be used, although, of course, the color must be in a creamy state. To turn the watercolor in a pan creamy you have to wet it with a little water until it dissolves. Insist with the brush until there is creamy watercolor in the pan. Once it is softened using it is identical to watercolor from a tube: always with a dry brush.

Watercolor from a tube is very versatile because it allows immediate mixes, both onto dry and onto wet.

The brush size

In the last chapters we saw that high number brushes allow more effects than lower numbered ones. Working with a dry brush means there are small nuances which reduce the brush options: sometimes it must be low numbered and sometimes high, depending on the use to which it is being put. Doing a texture on a wide surface calls for a thick brush to obtain a uniform surface with the right tone. An almost dry brush can cover a large area, and if you repeat the stroke you can increase the tone to achieve the texture desired. The thinnest brush is useful for little details where thick brushes cannot reach.

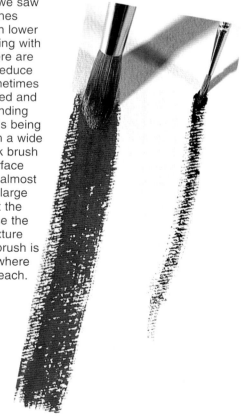

A wide brush always offers more possibilities. However, when working with a dry brush a thin one allows you to do very textured lines.

DRAGGING WITH A DRY BRUSH

The paper grain

The results when working with a dry brush depend a great deal on the grain and the degree of absorption of the support. An almost dry brush hardly has a vehicle (water) with which to slide across the paper. This makes it possible to do broken strokes dragging the color, or very fine details. The heavier the paper grain is, the more it will impede the brush passing. However, there are many techniques which can be used to obtain a multitude of effects on thick-grained paper but only if beforehand it has been gone over with a wash. In this case the dry brush will only stain the relief of the grain making the paper texture stand out. If the work requires close up detail it is recommended to use fine-grained paper for on this surface the almost dry brush will have no resistance other than the watercolor as it dries out.

Drawing with a dry brush

The dry brush technique is not limited to the creation of textures or detailed finishes: a slightly loaded, almost dry brush can be used to do highly expressive strokes. This means that it is an ideal medium for sketches and drawings. The line from an almost dry brush is not uniform. Drawing with a dry brush takes advantage of the marks made as the paint begins to run out to draw shadows or to do tone valuation. Once the paint is out and the brush is reloaded, get rid of any excess paint with a sponge or paper. Continue drawing until the paint is semi-used up and medium tones can be done.

Strokes done on thick grained paper always bring out the texture.
A brushstroke on medium grained paper has greater covering capacity.

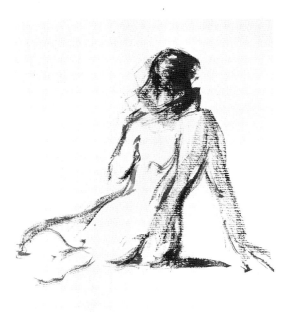

A dry brush allows drawing with textured strokes.

Alfred Joseph Moore (1841-1893).
Study of a tree trunk (1857), watercolor with white reliefs, 22.9 by 30.3 cm. Ashmolean Museum, Oxford, England. Details are one of the possibilities of the dry brush as it allows the painting of opaque tones.

Paper for watercolor comes in many formats and with a wide variety of grains.

Strokes

It is important that the watercolorist is familiar with the dry brush possibilities because the effects can be applied to all types of works to obtain relief, volume or texture. When a dry brush is passed over the paper, depending on its thickness, load and the pressure, it can leave a trace that can be superimposed in various ways to give different textures. The brush discharges paint according to the way it is pressed. If the strokes are zigzagged, a crossed texture forms that becomes denser as you insist. Parallel strokes give a wood-grain like texture.

Different possibilities with strokes realized with a dry brush on a dry background.

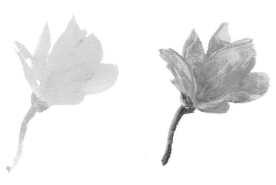

This flower has been painted in two stages: first a very light wash without tone additions; afterwards, on the dry background a slightly loaded brush has incorporated new tones.

Stains

Not only fine details but also wide textured areas can be done with the dry brush. This is very practical to get atmospheric or texture effects.

When wide stains are going to be done with a dry brush it is recommended to clearly define the zone to be covered because the stroke gesture makes it easy for the color to go beyond the planned space. Gestural painting is also possible when staining with a dry brush. You do not have to do details. Staining can even be used as a base for a piece that will later be elaborated with more detail.

Strokes that together form different textures. The superimposed strokes create different textures.

The dry brush and details

Watercolor is a medium that allows all sorts of finishes: it depends on the artist and the degree of accuracy he is looking for. Generally the details are done at the end when darker tones or colors make the forms sought after since the beginning more concrete, or defined.

Details with a dry brush can also be worked from the beginning, provided that they are realized with dark colors. Successive layers will gives transparencies of the tones used.

Textures

Texture is the external expression of the things that surround us. Depending on its surface and the material an object reflects more or less light. The shininess determines its light reflecting capacity. The more the light is diffused over the surface, the glossier the latter is. A dry brush offers all types of textured possibilities from dragging mottling or blending.

A B

A. On an even stain a series of strokes form a texture.
B. A texture realized by dragging an almost dry brush.

A classic example
The way Andrew Wyeth painted

The american realist painters developed very refined dry brush techniques. This work by Andrew Wyeth is a fine example. The density of the dry stroke allowed him to paint luminous colors on a dark background.

Andrew Wyeth (1917), The rope, watercolor on paper (32.1 by 52.7 cm). Weintramb Gallery, New York.

Do not rub with a completely dry brush

Although the dry brush technique requires the tuft to be almost dry it is unadvisable to rub if there is no water at all for the brush can easily be spoilt.

For these techniques it is necessary to have a little humidity in the paint, at least enough to preserve the hairs. If the brush is quite dry, at least take the precaution of not pressing too hard.

The dry brush technique

When the brush is almost dry, detail techniques and spectacular textures can be obtained.

Humidity in the brush

Dragging the brush over the paper depends on the humidity of the brush and of the paint.

The grain and a dry brush

The paper grain, of which there are many variations, is determinant in the dry brush stroke.

Details and texture

To achieve a detailed finish and to create a particular texture the dry brush technique must be applied.

Flowers with a dry brush

Necessary Materials

- TUBE COLORS
- 2B GRAPHITE PENCIL
- 250G MEDIUM GRAINED PAPER
- FLAT, ROUND WATERCOLOR BRUSHES, PREFERABLY SABLE HAIR
- STICKY TAPE.

The dry brush technique allow surprising effects to be obtained. Applying watercolor onto dry, by dragging the brush, is especially suitable to get marked textures. The choice of paper is very important because if the grain is too marked it will impede the drag of the brush. The model for this exercise are some flowers with strong contrasts. The flower textures are clearly defined by zones so it will not be excessively complicated to do.

2 Although we are going to work with a dry brush it is recommended to establish the tones that will be the base for the darker paint. Dragging the brush makes the paper texture stand out. So that the luminous background does not come through where undesired, paint these zones. Paint all the background with sienna and ochre. The color will outline the shape of the flowers.

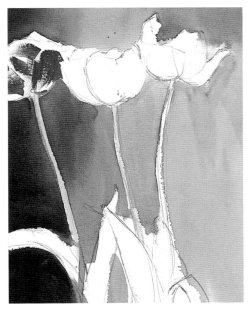

3 It is important to plan for the zones in which the background white will play a role. After looking at the shininess of the petals we have decided that the white of the paper is a good background for the first dry strokes. Take carmine and violet from the palette and apply them with the brush very drained out. The first strokes of the petals are done without wash. Dragging the brush brings out the paper texture and allows the white to gradate the color. Also paint the luminous green of the stems.

1 As always with watercolor the drawing is a fundamental part of the process. Pay close attention to the model and try to do a succinct but detailed sketch of the forms. Do not rush the drawing because without it the painting will come to nothing.

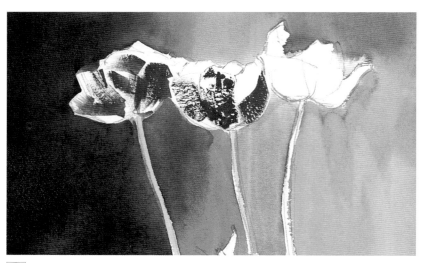

4

With a dry brush the watercolors are much more opaque because the lack of water means the paint is dense, but this does not rule out doing a transparency with a dry brush. A transparent color can be applied by dragging with a dry brush: a wash is made from the color, the brush picks it up and drags it over the paper until the right texture is obtained. In this way different tones can be achieved. Observe that in the new red strokes the opacity varies.

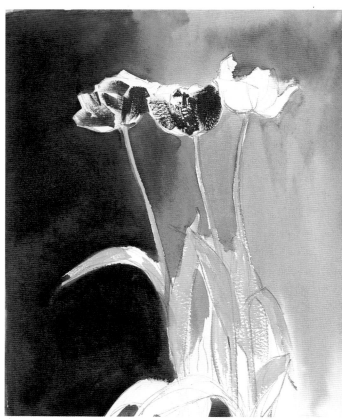

5

Start to paint the grain leaves of the flowers. On the palette green and yellow until you get a very luminous tone. The brush used must correspond to the zone being painted. The paint on the stem will not be the same as on the leaves. Here the dry brush is not as versatile as the wet brush.

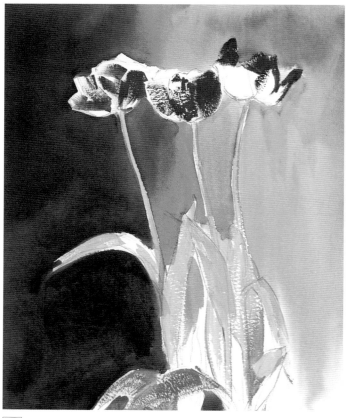

6

Add a bit more green to the last mix to obtain a darker tone with which to paint the shadow of the leaves. While the lower area is drying, go back to working on the flowers. Use a dense, dark carmine to stain the shadiest part of the petals. Lighten the color with a vivid red and outline the flower and its petals.

7

Finish the flower on the right with a rich variety of tones. Observe that the shiny whites, highlights, are the product of dragging the dry brush over the paper. Use a luminous green, darker than the background, to give volume to the flower stem. Now start to look for shadow tones in the leaves. Paint with a very dark green, always onto dry and in such a way that the brush is dragged over the surface.

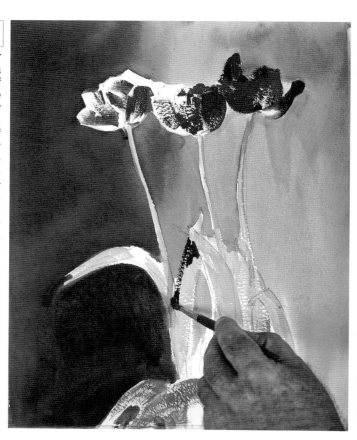

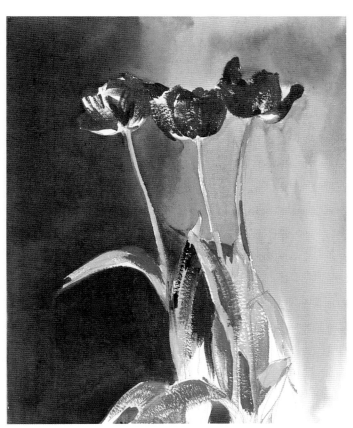

8

It is recommended to allow the zones on top of which we want to paint new tones to dry so that the colors do not mix together. Finish the shadowing of the green leaf tones. Dragging the dry brush allows the tones below to show through the texture. Paint strokes to give the final touch to the flowers. Introduce a purple tone. The highlights are now outlined. The texture left by the dry brushstroke gives relief to the luminosity of the petals.

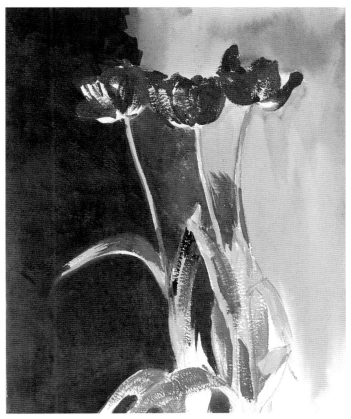

9

Let's focus our attention on the picture background. It is now completely dry so the colors will not blend together. Start to darken the upper zone and drag the color down. Outline the flowers and the stems. The highlights seem to stand out much more due to the dark tone contrast effects. Take advantage of the brush load to start dragging the paint in background zones that were more luminous before.

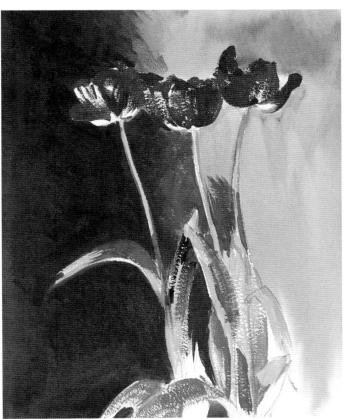

10

As the upper zone has been painted generously we can now spread the color with rapid strokes. The humidity of the paint allows the blending between of the dark this and the background. Take advantage of the brown on the palette to mix it lightly with green. The resulting tone can nuance the arched leaf.

11

Use a dry brush to finish the background with shadowy mixes of sienna and ochre. The tone gradation will be done by superimposing strokes. In some zones we will blend the colors. Dragging the brush over the lightest background tones produces an interesting texture effect. Work on the leaves in two ways: darken them with somewhat wet dark brushstrokes, then wait until they are dry and on top paint a very dry, luminous, dense color.

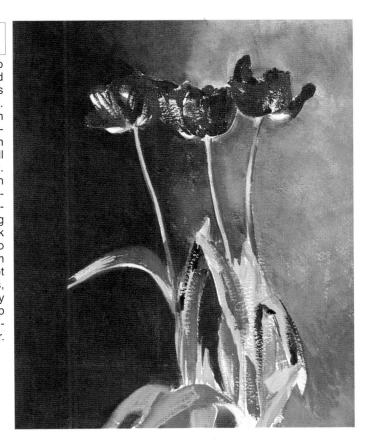

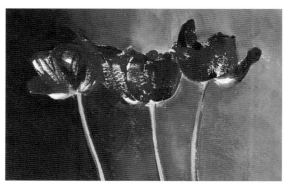

12
When working with a dry brush the texture left on the paper depends on the background and on the grain. Here, the medium grain allows very versatile work for it is easy to give relief to the texture and highlights. The details do not only come from the small strokes. Texture also creates detail. What is of primary importance is the contrast between different points of the picture. Compare the effect that is produced by the contrast between the dark, dense background and the luminosity of the flowers.

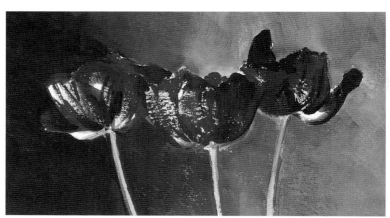

13 The volume of the flowers can still be further increased; it is only necessary to add a small contrast in the most shadowy zones, still using the dry brush but insisting on the shadow until it is completely covered. Also do a few loose strokes on the petals of the flower on the right. One important point: a very watery gray is used to nuance discretely the shadow on the lower part of the central flower. The white highlight will still be able to show through.

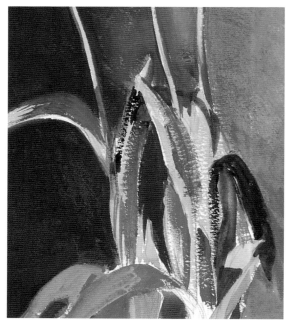

14 Focus on the greens of the leaves. Enrich the mix on the palette with blue tones and start to paint and draw the darkest tones. These final contrasts will give definition to the leaves and relief to the highlights. This time do not use the brush excessively dry so that you can isolate zones and create contrasts between textures.

15
Now we have finished this laborious but rewarding piece. It has been a demanding task: dry strokes, superimposition of transparencies and alternating techniques. What must remain with us are the conclusions that we can apply to other works in the future.

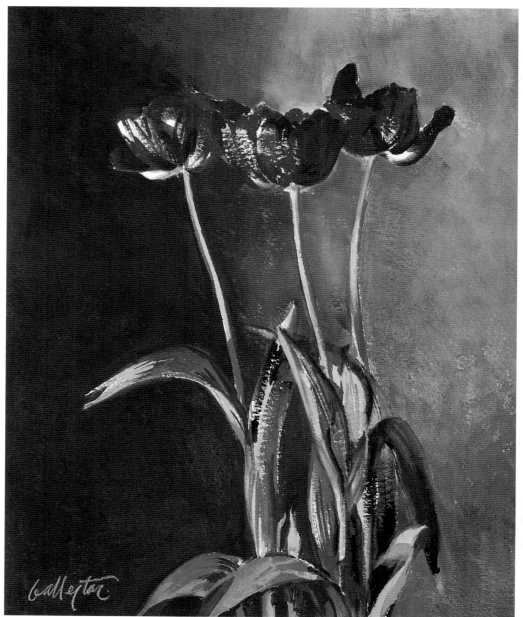

TOPIC 10

COMBINED TECHNIQUES

Watercolor offers endless possible effects which can be achieved after study and practice. The exercises put forward on these pages will allow the enthusiast to become familiar with theoretical questions explained in other chapters. The primary aim of the exercises is not for the learner to get the best results, although this is always satisfying, but for them to begin to understand how a watercolor artist paints and creates. Of course, the more they understand through the practical examples, the greater their progress will be: Go over the last exercises and do not throw away any pictures. They will be a good yardstick during the learning process. In this chapter we are going to practice wet watercolor and finishes with the dry brush. This combination demands a great deal of skill from a watercolor artist.

Modeling with the light

On already dry paint different techniques can give different types of modeling. In the artists' jargon modeling means all the characteristics that enable a three dimensional object to be represented on paper by exploiting the tones.

A transparency can be darkened while it is still wet by adding the same color. This produces a blending of the two wet tones and the modeling of the darker tones is produced by the saturation of the first.

TEXTURES

One of the possibilities offered us by watercolor is the transparency and doing textures on a dry or wet background. Starting from these two basic techniques, the combinations can be infinite. Watercolor allows all the representations and painting tendencies.

We will study in detail alternating the techniques learnt in the previous chapters and apply them in the forthcoming pages.

The transparency of watercolor allows the superimposition of very luminous layers that increase in tone as they are laid down. This plastic possibility means that rich, realistic textures can be created, or the picture enriched with light effects.

Textures can be realized by imitating natural textures or by simple mechanical effects with the brush on the paper. Imitating natural textures is done by superimposing different transparencies with different degrees of density. On top of these the finish is very important because it is what gives the appearance sought after. Textures achieved mechanically rely on different recourses like the pressure of the brush and the humidity of the paper.

Another way to model the color is to add another color. Painting into wet also produces blending, although it does imply the color changing due to the mix.

A dry transparency can be superimposed onto another. This can either be the same color or distinct.

Combining mechanical and manual textures enables us to give distinct finishes to the surface. The rock texture has been obtained by pressing with the sponge, and the grass texture by taking advantage of the brushstrokes.

The dry brush process on a wet surface allows the form to be modeled by superimposing textures or lines.

A dry brush for the final touch

On top of a texture created either by imitation or by mechanical methods, the different color layers allow different finishes to be done, provided that the techniques are combined carefully. If you allow sufficient drying time between the different layers the superimposition will be clean. A dry brush is necessary to finish the texture, putting in lines, contrasts and the limits between the forms of the texture.

Insisting on the dry background

After doing a work based on washes we can do one based on combining tones, that is transparencies of the same tone on top of each other successively darkening the original tone.

The dry background can be just as easily manipulated pictorially as the white paper. The difference is that you are working on a previously prepared chromatic base. It is recommended that the colors added are darker than the base colors, unless you are painting with a dry brush. If you paint a light tone on it, the color below will be darkened.

Modifications on dry paint

On a dry background the appearance of a watercolor stain can be modified, either as part of the technical process or as a change of plan, rectifying a mistake made during the work.

Despite the popular belief, watercolor is quite easy to correct. It depends on the quality of the paper and the color being used. The modifications can be done immediately on wet paint. However, if the paint is dry you will have to insist with the wet brush to open up precise forms in areas which were previously painted in color.

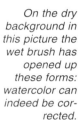

On the dry background in this picture the wet brush has opened up these forms: watercolor can indeed be corrected.

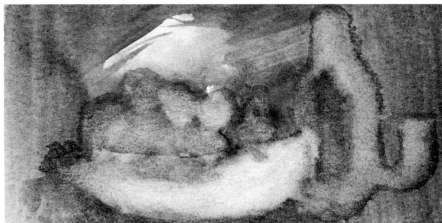

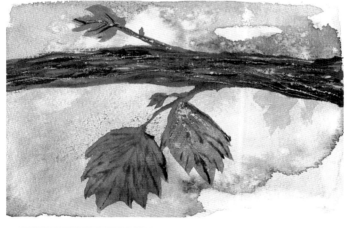

When working on a dry background very detailed elements can be painted in stages. First the background has been painted, next the trunk and, finally, the darkest tones of the lines and the textures.

Tones and textures

Combining wet and dry techniques gives a rich variety of plastic effects. Practicing on different paints different combinations is a very rewarding exercise. Sometimes you can use an almost dry brush, which on a wet surface will produce a combing effect. In other cases tone variations will be obtained from wet and dry layers and dragging of the wet brush over the completely dry background. These experiments carried out almost like a game should not be thrown away; they will be useful for later works.

Transparencies on dry paint

A completely dry background is also useful to create atmospheric effects with transparencies of the same tone or even of very dark colors. A transparency can be so extreme that its effect is only noted on the lightest tones. For example, if a yellow transparency is done on a well contrasted picture only the most luminous colors and the previously white spaces will be changed.

An ochre transparency has been done in the middle of this sketch. It has only had an impact on the most luminous tones.

A landscape sketch realized by combining wet (in the sky) and dry techniques (the strokes superimposed over the rest). This sketch could later be worked on for a full-blown piece.

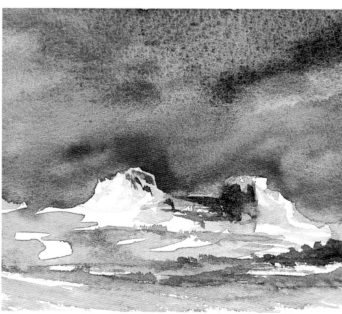

PLASTIC EFFECTS

Stumping the stroke

For a watercolor painter there are many small details that make this medium a passionate challenge. The stroke of a brush can be a line that defines a shape or in its wake it can leave a colored stain.

Sometimes the line will be pure and hard. To achieve this it is only necessary to paint on the dry background and to wait until the stroke is dry again. However, when creating a texture often a highly contrasting stroke has to be blended on an already dry background. The process to stump the stroke is the following:

1 On top of the already dry wash, paint a stroke loaded with color.

2 Clean the brush and spread the part of the stroke that you want to diffuse. If it is necessary you will have to absorb the excess paint, then clean the brush again and continue the gradation.

3 Insisting with the wet, clean brush on the paper will blend the stroke into the background. If you drag too much with the brush, the color below will fade away and highlights will be opened.

The stroke can be blended on the background and become a transparency.

The top of the tree has received quite dense, green dashes, and in this way they have not totally blended with the background.

Diffuse or blend

Do not confuse diffusing a stroke with blending a color. A stroke can be gradated on a wet or dry background until it is completely integrated; this is diffusing or stumping.

Color blending refers to zones wider than a stroke. A gradation is of a color while blending involves various colors.

Take advantage of worn brushes

When combining different plastic languages, the use of the brush is a fundamental question. When practicing the learner will discover that the different hardnesses and brush shapes allow a great variety of strokes. Over time, or by accident, brushes get deformed, worn out or break. Old brushes should not be thrown away. Although they may have lost their springiness or some hairs, old brushes allow effects that are very difficult to do with new ones. Many artists buy cheap brushes and deliberately spoil them to obtain a tool for dragging textures with a dry brush.

Details, painting on wet

On a dry background it is possible to do a highly detailed piece if very dense layers are applied. This will not prevent the stroke from spreading slightly when it comes into contact with humidity. As it dries out it will accept new dry color additions that define forms and details. The wet background absorbs part of the dry color added to it, but when this color is somewhat dense defined shapes can easily be obtained.

In this landscape realized on a wet background some zones (the dark horizon color and the reddish stains) were painted denser than the others to avoid total blending.

The freshness of the original stroke

The stroke is a key consideration for watercolor painters and all artists in general. It is not recommended to insist too much on a stroke because it makes it look unsteady and takes away freshness. This is one of the reasons why a good drawing base is necessary. The stroke always looks steadier on a clearly defined scheme.

You must be careful with the stroke even in a sketch. A skilled drawer pays as much attention to the result as to the technique.

Practice exercises like this one: paint a background, wait for it to dry and then do brushstrokes. Note the effects of the different strokes.

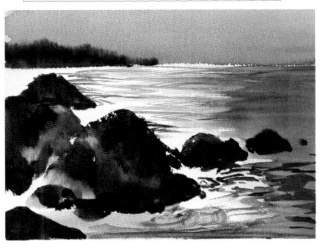

Light and texture

The texture painted with watercolor can never be so 'material-like' as with other painting mediums. However, it is possible to do textures based on the luminosity ffects on the objects. As color layers are superimposed the luminosity of the stain decreases; the white paper becomes less visible. To take advantage of the luminosity of watercolor, above all when doing different textures with superimposed layers, it is important that the most luminous zones are left in negative (unpainted) so that light enters.

Look at this piece carefully. The artist has combined all the watercolor possibilities: transparencies by superimposing layers, white spaces in the dark background, superimposing opaque strokes on the dry background to do the feather details.

Combining transparency and opacity

When considering watercolor techniques it is necessary to emphasize the importance that combining opaque and transparent techniques has. A transparency is similar to a film and although opacity is not the most distinctive watercolor characteristic, it can be done with a dense color. Combining both techniques in a picture gives atmosphere and depth. An opaque color can be clouded with other transparent colors without excessively altering the original tone. However, when a transparency is painted over a luminous color, although it is opaque, the nuance can be altered.

Conclusion:

1 Dark colors can be covered by other more luminous ones without their shape being hidden.

2 Opaque luminous colors can be altered by transparent colors that change their tone.
An opaque color can always be painted over a transparent film, wet or dry, although in the two cases the results will be completely different.

The transparency of the watercolor decreases when the proportion of color in the water is increased.

Strokes and stains

Just as transparencies and opacity can be combined, in watercolor strokes and stains can be continuously alternated to obtain all types of pictorial textures right through from small, realistic details to the most expressionist combinations. Strokes and stains can be combined in wet or dry. In the first case the color added to the wet stain will blend according to the density of the paint. When dry strokes are added to a dry stain, the stroke control is total so they can be superimposed without any danger of mixing.

This exercise combines stains and superimpositions. It is important to respect the drying times before putting down fresh layers so that the colors do not mix and the limits are defined.

The way John Ruskin painted

Ruskin understood perfectly the plastic possibilities of watercolor. In this piece you can appreciate his mastery of light and different textures. Firstly he did a perfect, precise drawing of the forms, without going into the shadows but defining every detail. Over the drawing he added very transparent films which he allowed to dry before insisting so as to model the forms. When the color masses were already dry he started to use the dry brush to define the textures and details. Finally, he finished the contrasts with dark ink and the highlights with white tempera reliefs.

John Ruskin (1819-1900). In the pass of Killiecrankie (1857), watercolor and tempera with pencil and ink, 24.8 by 28.2 cm. Fitzwilliam Museum, Cambridge.

Textures and layers

Certain textures can be obtained by superimposing layers on top of already dry ones.

Insisting on a dry background

On a dry background the brush can drag and blend color. A texture is made to stand out when worked on with a dry brush.

Details on a wet background

To do details on a wet background the strokes must be made with a bit of diluted color, preferably tube watercolors.

Combining transparency and opacity

The combination of different techniques facilitates the creation of textures.

A portal: dry brush on wash

Necessary Materials

- TUBE COLORS
- 2B GRAPHITE PENCIL
- 250G MEDIUM GRAINED PAPER
- FLAT, ROUND WATERCOLOR BRUSHES
- A FLAT BRUSH AND AN OLD BRUSH TO PAINT TEXTURES
- RAZOR BLADE OR CUTTER
- STICKY TAPE

It is not always easy to find the right model, and therefore sometimes you will have to fall back on photos. Many painters have files with photos which they use when they are looking for a particular theme. This is the advantage of following the exercises we propose: for the time being you do not have to look for a model. Our proposals are sufficiently varied and interesting. In the following pages we are going to do an exercise full of textures that combines the techniques of transparent watercolor and the superimposition of dry strokes.

1 As always, pay attention to the drawing. A model like this one does not require honed drawing skills but you must know how to synthesize the circles of the doorknob. Once the knocker has been drawn, do a scheme of the shadow that falls on the door.

2 Do a first wash over the background. Use very transparent, totally liquid colors on a wide flat brush as it allows you to cover the paper easily. Start the color stain with an orange ochre and while the paint is still wet add some blue stains that blend with the background.

3 Wait for the background wash to dry. Now in the upper left zone, intensify the tone with big sienna strokes. Observe that with this new color addition we outline with the brush the metal piece on the door. Take advantage of the same color to paint the knocker very transparently.

4 Pay special attention to the process in this step. The previous layers must have dried completely before adding new colors. The background color will be a base for the new layers that will be applied with a medium sized brush to have greater control of the stroke. The most diffused colors were painted on the previously wetted background (on the left). We have painted the shadow of the knocker but observe that part of the color has blended with the new strokes. Do long sienna strokes to start the texture of the wood. Finally, paint the contrast of the shadow of the knocker in very dark burnt umber.

5 Again wait for the last step to dry and then intensify the contrast in the lower right corner. First use a reddish transparency mixed with burnt umber and then darken the background in a controlled fashion with sienna and blue. Wait for this last addition to dry and then use fine brush to depict the wood grain.

6 The application of new layers must be made foreseeing the effects they can have on the colors underneath. Do a few strokes of ochre mixed with sienna on the left zone. This will effect all the light tones and will also drag part of the shadow on the knocker. Start to work on the forged iron. The shadow of the embossed metal is painted as a point.

7 Before we painted the shadow of the embossed metal of the knocker as a point. Now we are going to use the same color but much more watery to go round the shape. We will leave the highlight zone unpainted; the background color will come through. Darken the shadow and the contrasts with very dark burnt umber. When it is dry paint a new layer of burnt umber on all the left side of the picture. On top of it go over some of the wood grains.

8

Observe in this close up how we enrich the texture of the door not only with long strokes and stains. Paint the marks on the wood in green on top of the completely dry background. The stroke must be dense and wet so that the paper is saturated with the color. The marks we made at the beginning have not disappeared.

9

The work will now be centered on the use of the dry brush. Firstly finish the points on the knocker. Paint the fine lines dividing the iron into triangles. These lines must not have a monotonous stroke and the humidity must vary because such variety will give a rich texture. Be careful when painting these zones so that no part of the picture which has to be luminous is stained with dark paint.

Revise all of the pictorial process developed until now and study the superimposition of the different layers and transparencies. First the colors that form part of the background were painted, after the contrasts were defined, and, finally, the details which contrast the color additions were added.

10

When the points on the iron have dried completely, use sienna diluted in water to start to paint the final color of the knocker. Leave unpainted the highlights that are produced on both sides of each shadow point. The quantity of paint on the brush must be controlled because the zone being painted is not too wide and we must spread the color accurately so that it does not block out light points.

11

Use the dry brush stained with burnt umber to start the detailed work on the wood texture. Small lines and stains provoke subtle contrasts with all the zone textured before. They do not have to be large stains. Small strokes will enrich the grains and the knots in the wood.

12

Enrich the texture in the background in specific zones. Watercolor work, like any other painting representation, requires the artist to interpret the model. Although the work we do stems from a photo it has to avoid being a copy. Do not limit yourself to the colors of the photo, they are just a reference. In this zone work with very dry colors, some warmer than others. Increase the contrast between the reddish tones and add some new, almost black contrasts. Over these new colors work with the wet brush to stimulate the blending between the faded tones and the background resoftened by the humidity of the brush.

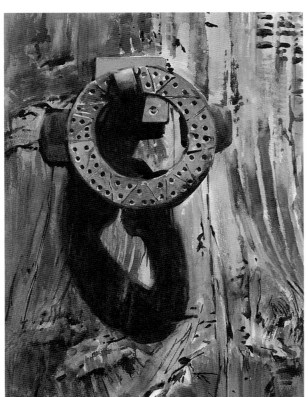

13 Finish the knocker zone with a burnt umber wash. The wash has to be applied very rapidly and without insisting with the brush so as not to drag the dry paint. The work on the knocker is finished and we will now concentrate on the door texture doing some sienna and English red strokes. The strokes must go with the texture we have been creating throughout the session, but we must not cover all the zones completely. Remember that the different layers must show through the spaces we leave between the strokes.

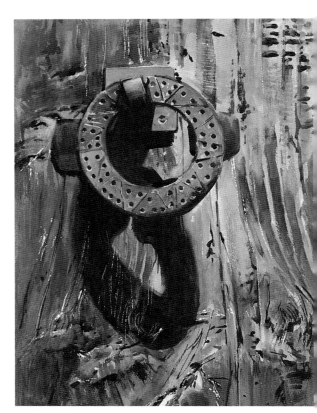

14 On top of the surface of the completely dry picture we are going to open up highlights to intensify the old wood texture. We can use a razor blade or cutter (be careful to avoid accidents). The light spaces and textures are done by scratching the paper with the blade crosswise, otherwise we would cut the paper. It is important to work on heavy paper: light paper does not stand up to this treatment.

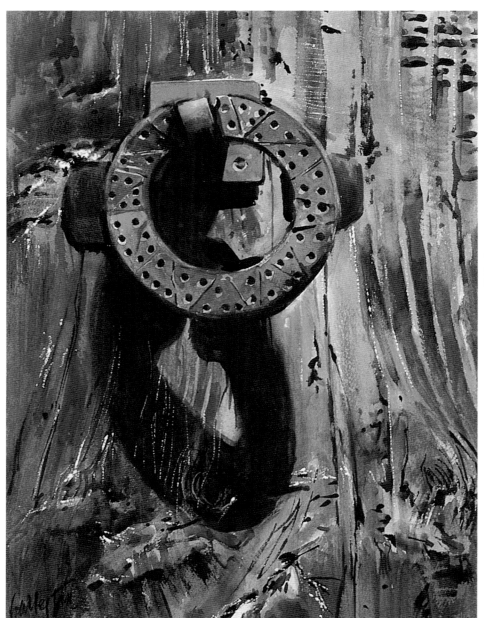

15 By using the blade we finish off this piece in which different techniques related to the humidity of the color on the paper and dry brush texture techniques have been put into practice.

TOPIC 11

WHITE IN WATERCOLOR

As we have seen in all the previous chapters watercolor allows a wide range of technical and chromatic possibilities, however, it lacks white.

The way we treat color is intuitive. The lightest tones are pure colors watered down but when the color in question is white, or a light color among dark color, painting is more complex. No mix gives white. This color does not exist in watercolor: it is produced by the absence of tones on the paper. Something similar occurs with grays, light tones and highlights: they are all represented by exploiting the contrasts between the most luminous areas and the white spaces left untouched. In this chapter we are going to study whites and medium tones. The notions explained in the following pages will be vital for all the technical applications in this watercolor course.

Reserving the form

Drawing always plays a role in watercolor, as we have been repeating since the beginning. It is a guide which enables us to observe each of the zones and the color that is to fill it.

The shapes are drawn and then the color is put in, or, if they can be left in negative, also called 'reserved' if they are for the most luminous forms. The reserved forms do not all have to be for whites: the highlights within a dark zone are also reserved.

Purism and plastic expression

The purist watercolorists defend not using white paint because of the existence of the white paper. This is a respectable opinion but, remember, plastic expression is the principal objective of painting. Moreover, great artists like Rubens did not hesitate before using white tempera to correct or to do highlights.

However, abusing easy recourses, like adding opaque white, does end up limiting a technique that on its own is very rich and takes away some of its special flavor.

RESERVING WHITES

Reserving whites

White is obtained in watercolor by leaving the paper support untouched

The highlights and the lightest forms have to be decided on from the beginning: We call the spaces left open for whites or for light tones among dark ones reserves. They must be kept clean through all the work process because a light color cannot be painted over a darker one.

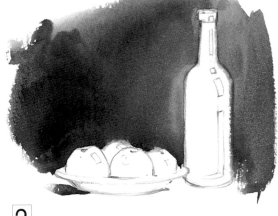

2

The reserve is marked off by the drawing. The dark tones must not penetrate into spaces destined for light tones.

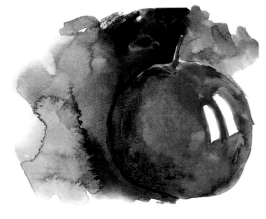

The highlights and lightest tones must be respected from the beginning of the painting. White comes from the paper color.

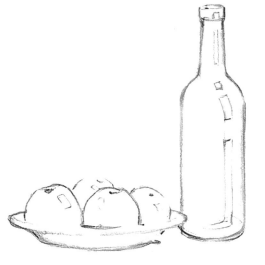

1

The forms of the most luminous zones have to be reserved before painting. The drawing must be sufficiently explicit and clean.

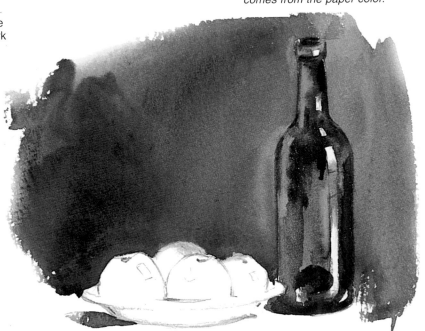

3

When the wash was laid down the spaces to be occupied by whites were left untouched.

Negative painting

To understand the way the reserve works in watercolor think of it as a photo-negative. Imagine a definite shape, for example a still life. Draw the still life in the traditional way, the lines defining the objects and the shadows. First paint the darkest tones outlining the light forms of the objects in the still life. Once the background has been painted, do the next darkest tones. The highlights and lightest points are left reserved.

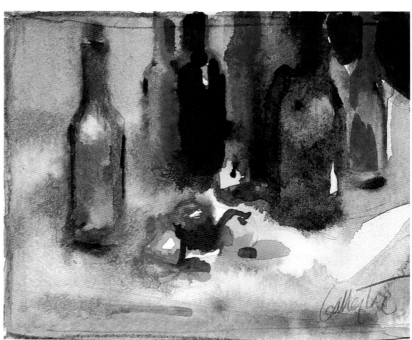

Vicenç Ballestar, Still life, watercolor on paper. The artist's private collection, Barcelona. In this work the lightest zones have been reserved since the beginning.

The dark tones outline the most luminous shapes. In reality, the flowers are not painted; it is the darkness that defines them.

Maximum light

The highlights must be established from the beginning of the picture, even if we have painted a transparent staining. The points of maximum light depend on the outlining tones. Remember the optical law of simultaneous contrasts: a tone is more luminous when it is surrounded by darker colors. A grayish color can appear as a luminous white tone if the surrounding colors are sufficiently contrasted.

A classic example

The way Giovan Battista Tiepolo painted

Giovan Battista Tiepolo, one of the most important painters of the Venetian school of the 18th century was one of the best decorators of his time. Reserving whites was one of his principal recourses. In this wash you can observe how the highlights have been intensified by the surrounding medium tones. The gray wash plays a key role in describing the volumes.

Masking fluids

Reserves can be done mechanically putting something between the color and the paper to avoid staining. Artists commonly use masking fluid or templates. The former is applied with a brush. When it is dry it forms an impermeable plastic film that accurately covers any reserve. Once the painting is finished the masking fluid can be rubbed off with an eraser or a finger. Wax, too, is waterproof. Candle wax or white wax can be used. However, the wax cannot be taken off, something which makes it different to masking fluid. It remains soft throughout all the painting process. If you play with the paper grain and the wax pressure you can achieve multiple effects with the reserve. Templates are another possibility: they can be sticky or simply be paper or cardboard shapes cut out. Their use depends on the zone to be masked.

Reserve effects realized with masking fluid. It can be removed with an eraser.

A wax reserve impedes the color penetrating in the reserved zone.

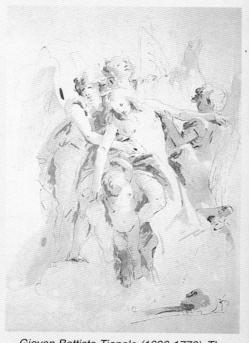

Giovan Battista Tiepolo (1696-1770), The ascencion of Mary Magdalena, wash on paper, 33.5 by 26.1 cm. Woodner collection.

OPENING UP WHITES

Opening whites on a dry background

The base of watercolor is gum arabic, a resin totally soluble in water. The brush deposits on the paper a load of water, pigment and gum Arabic. Once the water has evaporated the gum Arabic acts as a agglutinin and pigment fixative. As the watercolor is liquid it penetrates in the pores and remains stable when dry. However, opposite to what many enthusiasts think, watercolor is reversible. If the paper is well gelatin-sized, and not too thin, if the watercolor is wetted again it softens and can be removed for white spaces. Opening up whites enriches the watercolor technique. It offers the possibility to do highlights and corrections.

On a dry surface pass a wet brush over repeatedly. This will open up a white space.

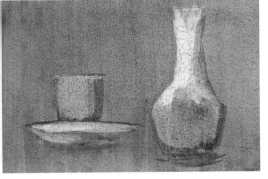

In the same way as you open up a white space you can obtain medium tones in this still life.

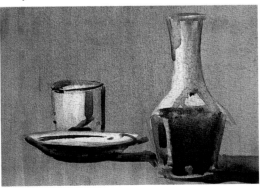

Once the opened up spaces have dried you can finish the picture with darker tones.

The size of the reserve

You can correct provided that the paper is suitable. Some colors are more resistant to wet brush corrections, and therefore it is important that the zones of the picture are clearly defined. However, when choosing the reserve zones (for the most luminous colors) consider the possibility that the background color could invade part of the zone. You are still in time to correct. As watercolor can be corrected, you do not always have to reserve the entire space for a light object. It is important to reserve the spaces where the purest highlights will go but bear in mind that these highlights are minimum compared to the whole picture. Other highlights can be light or luminous colors that are different to the white of the paper.

When we painted the background we penetrated in the reserved zone. Once it was dry we could restore the luminosity and the outline of the object using a wet brush.

Absorption

One of the most usual ways of opening up whites is by absorbing the wet color. Any absorbent material can be used to soak up the newly added color. Some materials absorb more than others. Also the humidity of the paint plays a role in the whiteness of the space opened up.

Correcting the watercolor

The fact that wet or dry watercolor can be corrected is a great help to the artist who changes their mind. Something which can happen often during the work process.

If the paint is wet just absorbing it is sufficient. When it is already dry you will have to insist with a wet brush until the zone is cleaned up.

After painting the still life we decided to place another object in front of it. The space was opened up by using a clean, wet brush.

With a sponge

A sponge is a vital tool for any watercolorist. Some prefer it to be natural, others opt for a synthetic one; it is a question of tastes. When watercolor paint is still wet it can easily be removed with a wet sponge. To open up a white space on dry paint, rub softly and repeatedly with the wet sponge.

Effects produced on similar stains with different absorbent materials:

Absorption by pressing with a dry sponge has hardly provoked a medium tone.

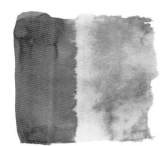

Absorption by lightly pressing with a wet sponge.

Absorption by dragging a wet sponge.

Color absorption with kitchen paper.

Color absorption with a wet, clean brush.

Removing color with a finger.

Applications of opening up white spaces

Absorbing color or tone from a surface offers many possibilities, from simply opening up highlights to the construction of new shapes where previously there was a mass of color. Generally a watercolorist does not need to open up white space constantly, but on some occasions it will allow them to solve a painting problem, redo elements or change tones.

In this example you can appreciate how a light space has been opened up in a previously dark zone.

White reliefs

The highlights of white paint can be used to give volume. This is not very orthodox for some watercolorists. However, since watercolor was first used to prepare sketches this technique has been common. Using white tempera or China white allows papers which have a non-white tone to be used. Do not go too far with opaque white paint, but remember that it can be used for certain works.

Another way of intensifying the highlights is with white reliefs. This is done with white tempera or China white. Giovan Battista Tiepolo, The Ressurection of Tabita, wash on colored paper with white reliefs, 37.7 by 48.7 cm. Woodner collection.

White reserves

As watercolor has no white the painter must foresee which areas will be white. They are then left unpainted.

Maximum light

When the highlights are established, analyze which shall be the points of maximum light. A reserved zone can have medium tones and completely white spots.

Opening up whites on a dry background

A watercolor can be corrected. A clean, wet brush can open up white spaces in a painted zone.

Absorption

Absorbing wet color with a sponge, paper or a brush allows you to open up very luminous white spaces.

Whites with bleach

A white space cannot always be opened up by dragging a wet brush over the paper. Sometimes a radical method must be used. A 50% concentrated bleach solution completely removes watercolor from the paper with the help of a brush. Do not use high quality brushes because they could be spoiled.

With a brush

A clean, wet brush is one of the most effective ways to open up very pure white spaces on just painted surfaces. It is easy to use: just pass the brush over the area, wash it, drain it and then repeat the action. In this way you can draw, open up white spaces, etc.

EXERCISE

Ceramic: white reserves

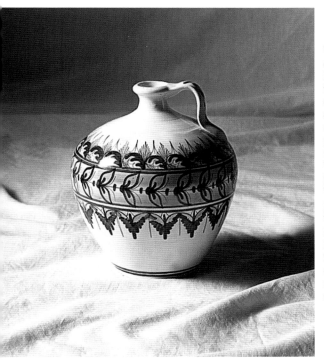

White is the most important color in watercolor. However, despite its ubiquitous presence it is neither on the palette nor in the color box. This paradox is explained when the transparency of the watercolor medium is considered. White is present because it is the color of the paper. When the watercolorist is painting they are removing with color part of the luminosity from the paper. In the next exercise we are going to practice two important questions: reserves and modeling tones on a white ceramic surface.

Necessary Materials

- TUBE COLORS SIENNA AND COBALT BLUE
- 2B GRAPHITE PENCIL
- 250G MEDIUM GRAINED PAPER
- FLAT AND ROUND WATERCOLOR BRUSHES (PREFERABLY SABLE)
- STICKY TAPE

1

It is important to define the white zone before starting to paint on the paper. The drawing of the principal forms allows us to establish clearly the limits between the background and the figure. In this exercise it is fundamental to clarify the zones to be painted because the dark tones will outline the lighter tones.

2

The ceramic is white. Use a dark mainly sienna colored wash to paint all the background: paint in negative. Note that the shape of the vase is outlined although it seems to be painted white. When painting the background be careful not to enter the reserved zone. Add a little blue to the wash to darken it. Paint the shadow in the background.

3

Wait for the background to dry to avoid the risk of touching the vase zone. Do a very light wash, almost transparent, with which to paint the inside of the vase. The highlights have once again been left reserved. Before it dries out, use a darker tone to go over the shadow on the right. The brushstroke direction is very important. It must be inclined and cover all the shadow. Before it dries out open up the luminous strip on the right with a clean, wet brush.

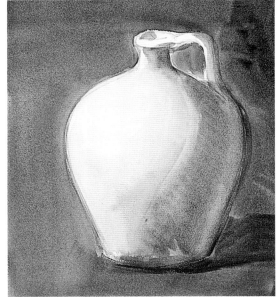

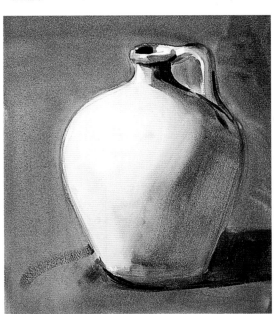

4

Use a wide brush to unify the shadow zone with soft strokes. Take advantage of this to intensify the gray tones. It is relatively easy to darken the tone on the palette. Just add a bit of color, but be careful you do not make it too dark. To do the grays on the vase use blue hues, but we do not want to repeat the brownish tone of the background. When this layer is dry paint the shadows on the neck. Adding these dark tones will produce a strong volume effect: We now have three tones.

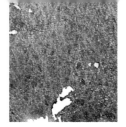

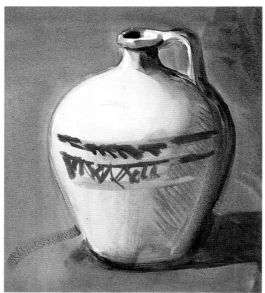

5

When the tone modeling is completely defined and dry, we have a good base on which to work on the grays. The work we will now do is rapid and will take advantage of the humidity of the paint to unify zones. Use a gray layer, somewhat darker than the last one, to quickly go over the shadow. Just as we did before, finish off the shadow zone with long strokes to darken all the right side. Use light blue to draw the frieze and on top add a new blue tone, this time much darker and purer.

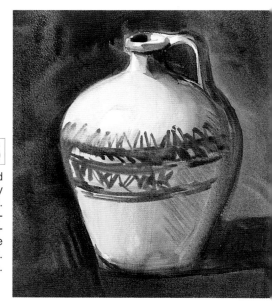

6

The decoration on the vase is finish with rapid strokes. For the time being, do not insist any more. Prepare a sienna wash with a little blue. The tone obtained will be darker than the original one. Paint the background again and outline the vase carefully. Observe that as the background gets darker the contrast increases. The whites appear much more luminous.

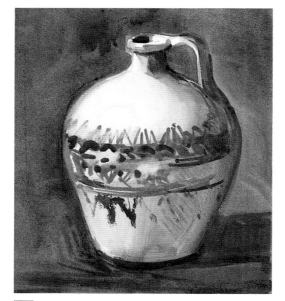

7

Focus on the vase decoration: Alternate transparent and opaque strokes to get a glazed ceramic effect. Observe how we have corrected a small error right in the middle of the shape. This white space was opened up with a clean, wet brush, doing repeated little dragging movements in the zone.

8

When the ceramic decoration has been finished wait for it to dry and then make some dark strokes to the contrasts in the shadow zone. This exercise has now be finished. However, if we are trying to reflect the mood, why not put down a transparent layer?. This transparency gives atmosphere, although note that a few pure whites are still reserved.

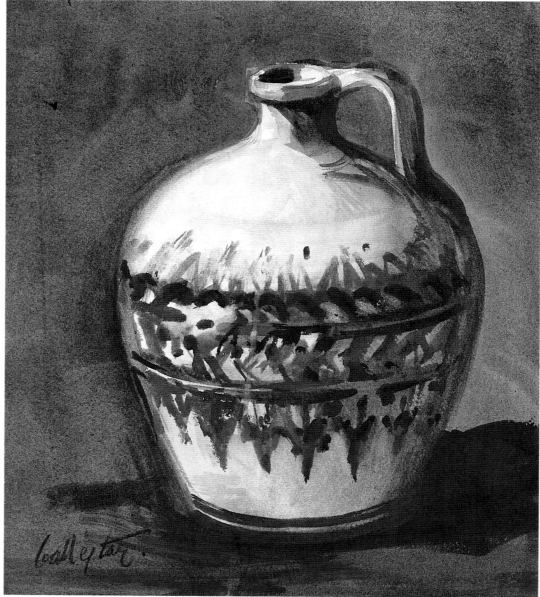

EXERCISE

EXERCISE

Leaves on a tree: darkness to define the form

Whites are not only reserved in watercolor to develop highlights. They are also applied in all sorts of work to combine dark and light tones. In the next exercise we are going to paint a very straightforward theme, one that is often right in front of us. This is a very important question: our themes do not have to be complex, nor difficult to find. Let's focus on these leaves: the contrast between the dominant tones is fascinating.

Necessary Materials

- TUBE COLORS
- 2B GRAPHITE PENCIL
- 250G MEDIUM GRAINED PAPER
- FLAT AND ROUND WATERCOLOR BRUSHES (PREFERABLY SABLE)
- STICKY TAPE.

Use the same wash with which the reservation of the luminous tones was started to finish the background. Define the edges of the leaves and the branches. Intensify the tone and paint the arch behind. Use a wet brush to drag part of the color to define the architectural column. Do not insist too much so as not to open up a perfect white **3** space. Finish this step with a blue stain to insinuate the darkest leaves.

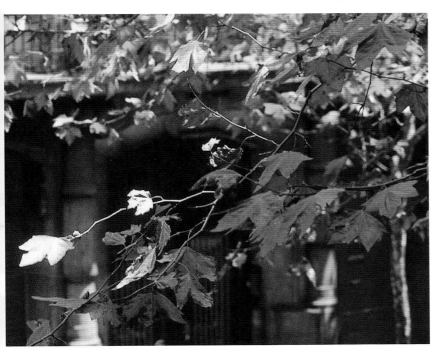

1

This theme could become chaotic if it is not carefully planned. The drawing of the main forms guides the color staining and will allow us to establish the reserves. Note that we have selected a very concrete part of the image. The basic design always plays a determinant role in the piece. The drawing, although schematic, is very accurate. We must always draw synthetic shapes.

Start to mark off the reserves on the right side of the picture using a blue and sienna dark wash. Note how some branches have been perfectly defined by the dark background. Start the staining of the leaves in a very luminous green. **4**

2

We want to reserve the most luminous zone. Start on the background, painting carefully near the limits of the leaves and the main branch. In this zone we use two types of strokes, one wide and generous and the other much more detailed to outline the forms. The density of the wash varies in different background zones. In the upper part it is much darker and the drag it downwards using a brush.

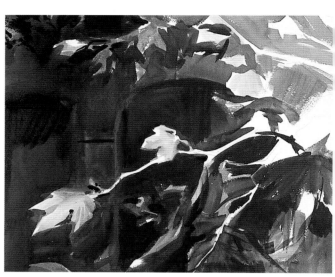

5 We have now reserved the greater part of the spaces destined to white. Now we will give a better finish to the background, and do some new reserves on the shadow transparency that we have just done. Wait for the background to dry before starting to intervene again. This time the wash must be much darker than the last one. As we are using tube colors we can get much denser tones. Paint the inside of the arches in very dark burnt umber and outline the leaves and branches again.

6 When the last color layer has completely dried, we can start to paint the leaves. On top of the green transparency of the main leaf do some dark strokes to draw in negative the lines on the leaf. Add some green and brown to the palette to obtain an olive tone. Paint the leaves in the upper zone, setting aside some reserves for highlights. Use a clean, wet brush to take some color away from the doorway on the left.

7 Prepare another dark wash. Now we are going to paint the dark colors that reserve the leaves on the right of the picture. Go round the largest forms with the brush and take advantage of this color to correct any leaves that were left poorly defined at the beginning. Once the background is dry, paint the leaves on the right with sienna and blue. First do a blue layer, and when it is dry darken it with sienna.

8 Finish the reserving of the branches and leaves. As the dark background surrounds them they appear light to our eyes. Let's give the necessary volume to the branches. Put in some green color spots in the upper right corner of the picture. Dark stains outline and give shape to the lightest tones. All that remains to be done are a few red stains. As the surrounding color is much darker the red strokes will not modify the reserved form.

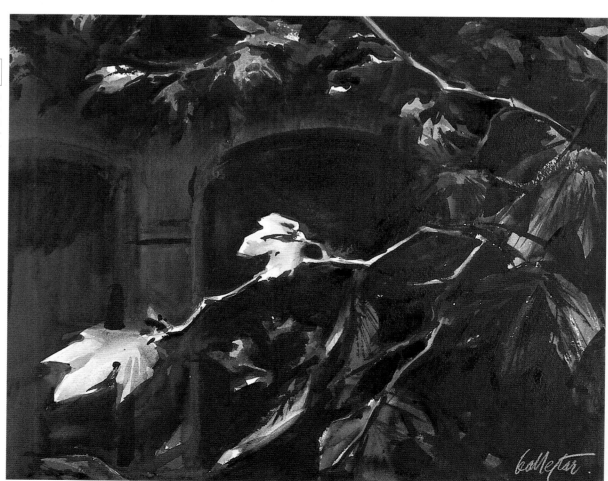

OTHER TECHNICAL POSSIBILITIES

So far we have studied many technical recourses for watercolor, but this medium offers an even more extensive range of possibilities.

Material textures cannot be done with watercolor because the watercolor finish is so thin that it hardly alters the texture of the paper. However, this limitation does not imply a lack of other types of optical effects.

Watercolor has as many plastic recourses as the artist's imagination can think up. In this chapter we will go to the limits of the medium, testing ideas so as to obtain a range of effects that will be practically useful. Pay attention to the effects shown in the theoretical part and look for their practical application in this chapter.

MARCS AND TEXTURES

The texture of watercolor is extremely thin; it is not material. This does not mean that plastic effects cannot be obtained. Watercolor is a delicate pictorial medium. Its transparency makes it especially vulnerable to any external aggression. It is this vulnerability which makes pòssible so many plastic effects.

Scratching the paper means that the paint accumulates in the furrow. A wax stain makes the area impermeable. A few grains of salt make the water and color stick together. All of these are marks and textures, new and practical possibilities to create a rich pictorial language.

Applying special recourses

Watercolor is completely liquid when applied although in the palette it can have different densities. When it is placed on the paper its properties depend on the degree of absorption, the humidity and the way it has been painted, with a dry brush, an old one, a sponge, etc.

Once on the paper, and before drying, the color is susceptible to physical forces. Just blowing could move the paint. What could be an accident can become a plastic recourse: drying stimulus, scratching, blotting the color,

absorbing, splashes, etc. You only have to know how to provoke the effects and how to do controlled 'accidents'.

The texture of these stones in the foreground has been done with small drops of clean water while the color was still wet.

Tools and accessories to do the special recourses.

Scratching

Freshly painted watercolor softens the surface of the paper. Any pressure on the paper while it is wet increases the concentration of paint in the area. While the paper is drying this pressed area absorbs more pigment than the flat surface. When the wash is dry there will be marks where you pressed. Pressing or scratching can be done with any object: the sharper it is the finer the mark will be. To scratch normally the artist uses the brush handle, a knife or a nail.

Scratches done with the brush handle.

Reserves with sticky tape

In previous chapters we have studied how reserves avoid staining zones that must be left intact. There are many ways of isolating a reserve. Doing it freehand is effective when it can be well-controlled, but if you are going to paint a wide zone in a gestural way it is best to tape over the area to be protected. Sticky tape is a good reserve method but the shapes must not be too complicated. Be careful when taking the tape off: do not rip the paper.

Sticky tape is a good reserve, but the forms it can adopt are limited.

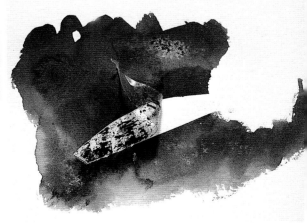

Marks and reserves with wax

Wax is a good water repellent. Many watercolorists use it to get texture effects from reserves. A stick of white wax or a candle can be used. The former is colored and is applied before starting to paint. The latter is transparent and can be used in any moment during the painting of the picture. It does not cover the color of the watercolor but it isolates the new color addition.

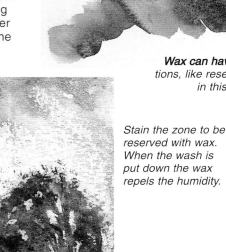

Wax can have multiple applica- *tions, like reserving white spaces in this landscape sketch.*

Stain the zone to be reserved with wax. When the wash is put down the wax repels the humidity.

Salt

One of the most attractive effects possible with watercolor are produced when salt is sprinkled over the wet wash surface. The salt grains absorb the humidity of the paint. A grain of salt concentrates the watercolor. While the rest of the surface is drying the point where the salt is remains wet because of the greater pigment density. When the entire zone is dry there will be a rich variety of textures.

Salt on wet watercolor produces interesting effects, like this.

Masking fluid

We have already seen masking fluid before. It is the most versatile mask for watercolor. It is used as if it were paint. It is gray; you know when it has been applied. Put it on with a brush and watch how it can take any shape. It dries out quickly and is removed easily: with just an eraser or a finger. When the plastic film is taken off the unpainted form is revealed.

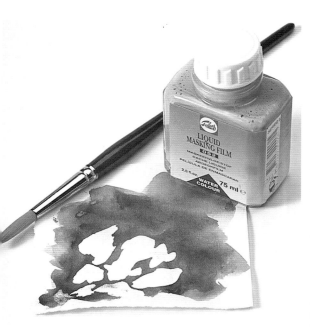

The stains on the paper are the product of being reserved with masking fluid.

EFFECTS AND TEXTURES

White wax

Watercolor paper is normally white meaning that the colors come through the transparent medium. When water touches the wax it goes around the area forming a reserve. When white wax is used corrections or reserves on the finished paint can be made. White wax can be difficult to see against the paper background so a color mass can receive new light areas which in turn will be reserves when new layers are put down.

White wax also allows reliefs to be done on zones that have been finished: they will not receive any more color when they are covered. If the paper is quite thick-grained wax can be used to emphasize the texture of the paper. You only have to rub the wax stick without pressing.

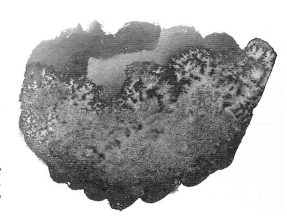

The way to apply white wax to get a textured surface.

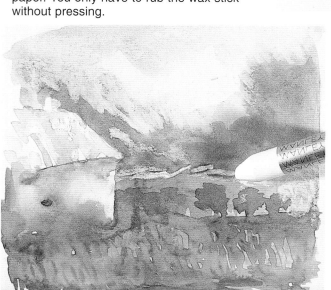

A white relief done with white wax.

Turpentine

Some materials which have nothing to do with watercolor and are much closer to other painting media are useful to elaborate plastic effects and textures.

Pure turpentine disperses the water, as if it were oil. When turpentine and watercolor is mixed on the paper curious texture effects are created: iridescence, gradations, etc. Sometimes these effects are fortuitous.

Although the results of the effect of turpentine on the paper can be unforeseeable, it is possible to control the zone effected by using reserves. These effects are not difficult to apply but you must control the area from the beginning. This can be done in two ways: firstly, apply drops of turpentine onto the wet watercolor. Or, secondly, cover the zone to be textured with turpentine brushstrokes. Then apply the watercolor and model the effect with the brush.

The effect produced by putting turpentine onto wet watercolor.

The effect produced by painting with watercolor onto a zone stained with turpentine.

Gouache as a texture

Some dense paints can be used with watercolor. A thick paint like gouache can be used in some zones to modify the paper texture. When a wash is painted on different surfaces, in this case paper and gouache, two very different drying effects are created. Part of the wash comes into contact with the gouache and blends with it. Tone differences are formed and these, in turn, come into contact with the virgin paper.

The most suitable gouache for these effects is white because it permits a complete blending between the base color texture and the paper background.

Before applying gouache as a background texture, you must first study the drawing so that you make the strokes in the right place. Do not create homogeneous zones or wide ones. Once the gouache is dry, do a watercolor layer without insisting so as not to blend the background paint.

First white gouache has been painted. After it has dried, color has been added without insisting too much with the brush.

Material plastic effects

Just as gouache can be used to do a texture for a watercolor background, in the same way other recourses like latex or acrylic can be used.

Plastic media have the advantage that they dry rapidly and are very resistant to the brush being passed over. A zone reserved for a texture with acrylic or latex can be wetted without softening. The latex is applied directly onto the paper. Do not do make homogeneous surfaces if you want to do a varied texture. To get a material texture with acrylic it is necessary to add a catalyst which does not thicken. You can buy one in Fine Arts shops. Both latex and acrylic are applied with brush and both are soluble in water while they are moist.

In stationary shops and in Fine Arts shops they sell relief paste, a plastic product similar to latex, which is applied with the brush onto the paper.

When the background has dried, paint tranquilly with watercolor. The support texture is ideal for all types of work.

First the background that is going to be used for the texture is prepared.

After priming textures with plastics

Straight after painting with latex, acrylic or relief paste, the brush must be washed to get rid of all resins. Otherwise it would dry out and become matty. It is better to use a brush you do not use for watercolor; they do not need to be quality brushes. In this way you can lengthen the life of the watercolor brushes, which are always more delicate and expensive.

An example of the recourses used

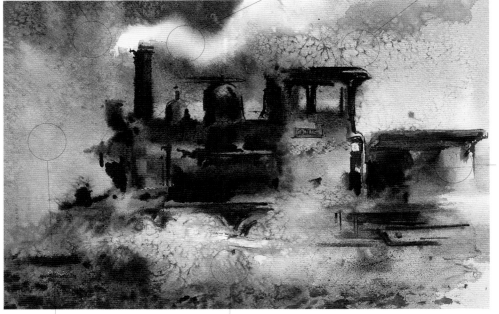

reserve *expanding color onto wet* *salt effect*

reserve

water splashes *color saturation*

The fresh color can be dragged with a sponge which will be used as a brush to manipulate the stain on the paper. The sponge allows a great many possibilities with the stain, direct mixing or stroke work.

You can cut the sponge to give it the form you want. It is going to be used to open up white spaces that will lighten the color in some zones or correct mistakes, or simply as a complement for some texture.

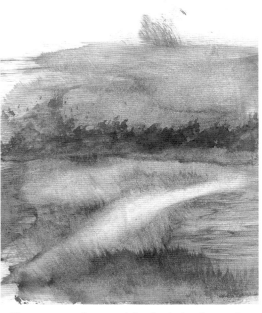

The sponge allows moist color to be dragged or white spaces to be opened up. In this example only a sponge has been used. No brush has been used.

Textures realized with a sponge. On a moist background and on a dry background.

Textures with a sponge

A simple sponge can be a splendid tool for doing all types of watercolor effects. The sponge allows you to absorb, put down textures by pressing, drag colors or open up white spaces. To absorb color the sponge must be clean and slightly moist. Do not drag the sponge, rather press it against the color. You can repeat the operation until you get the desired effect, but wash it after every application.

To prime a texture by pressing, first stain the sponge with the brush or directly on the palette. Do not soak the sponge with color, just enough to stain the paper. The background can be painted or not, it does not matter, but the degree of humidity will have an impact on the texture definition that you want to make. If the background is moist the color from the sponge will spread and blend with the background. If the background is dry you will be able to apply a texture with a regular application.

Observe how the color has been gradated by absorption with the sponge. The sponge must be slightly wet.

Scratchings

Paper is easily scratched. Interesting textures can be obtained by scratching the wet or dry surface.

Marks and wax reserves

Wax isolates the paper surface. Transparent wax can be used to isolate reserved zones. White wax is uses to do corrections, reliefs or effects on the already painted paper surface.

Material plastic effects

The paper surface can be primed with a gouache texture, relief paste, latex or acrylic.

Textures with sponges

A sponge allows a great variety of plastic recourses: absorptions, textures and dragging colors.

EXERCISE

A still life with rusty materials: textures

There is nothing better than a still life of old, rusty padlocks to put into practice effects to create textures and surfaces looking like materials. In this exercise we will demonstrate that a medium as transparent as watercolor offers a great deal of recourses, from chiaroscuro to texture creation, that are highly realistic. The plastic recourses of the present chapter are going to explore in depth this complex but fun work.

Necessary Materials

- TUBE COLORS
- 2B GRAPHITE PENCIL
- 250G MEDIUM GRAINED PAPER
- FLAT AND ROUND WATERCOLOR BRUSHES (PREFERABLY SABLE)
- STICKY TAPE
- MASKING FLUID
- RAZOR BLADE
- WHITE WAX
- SAND PAPER
- SALT

1 It is important to learn how to synthesize the main forms of the model with crystal clear lines. Synthesizing the forms is not only important to start painting; it also enables you to set up the composition correctly. First the drawing is done with general lines leaving aside confusing shapes. Focus your attention on the principal elements. When the forms have been correctly fitted you can finish them more accurately. Finally, erase all the guidelines: you no longer need them.

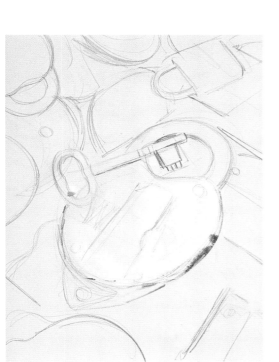

2 The color painting has to start in some place. As watercolor does not allow the superimposition of light colors on dark ones, you should start with the most luminous tones that will be the background for the later color interventions. An ochre wash gives a first tone to the principal element. However, be careful for some zones must keep the white of the paper, like the shine of the key. Do a few dark green strokes around the lock. Before both washes dry, sprinkle a few grains of salt in the wet zones.

3 You will see how the salt starts to make an effect on the wetted watercolor. The color is absorbed in the zones where there is salt. Use a somewhat more diluted green to finish the staining of the locks. In the darkest zones use sepia. The color of the transparency does not completely cover the original drawing. The warm zones are painted with large strokes, and then again sprinkle salt over the moist area. When the color is dry, draw some zones to outline the shadow of the main lock.

4 The masking fluid allows you to make reserves impermeable to the color totally controlled by the brush. Apply it over zones that must be left unstained. It dries out very quickly. Look at the zones that have been covered (the masking fluid is gray). Focus your attention on the most luminous shiny reserve and on the lock in the upper right corner.

6 Add contrasts that define the forms using shadows. If you insist with the brush in waxed zones you can cover it completely allowing you to play with the rusty metal texture. The darkest shadows are done with a dark mixture of green and sepia. Also add some carmine tones to give warmth. Use the dark colors to make precise shapes in the background. The piece below the center lock has been perfectly defined by the just painted dark tone. Finish it with a razor.

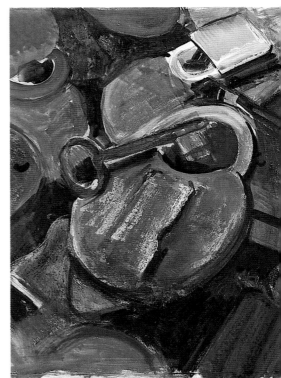

5 After applying the masking fluid, make a few touches of wax on the surface of the lock. It is necessary to control the pressure of the wax on the paper so that you do not close the pore completely. To avoid a permanent wax stain it is recommended to do a test on another paper beforehand.
Wax can be applied in two ways: with the point to do controlled strokes, or flat to give a homogeneous surface in a defined zone. In the zone reserved by the wax paint with oranges, greens and sienna. Start to darken the zones that surround the locks with wide strokes in the background.

7 Paint the key with dense burnt sienna and reddish ochre brushstrokes, but leave the highlights in the lower zone. Remember that the masking fluid is still on the paper. Paint the lower, right section with red mixed with sienna. To give volume, do a dark gradation on top of the still fresh color and define this piece with the dark color. It will blend with the background tone. The lower part had been painted in dark tones: now darken it further with a sienna and cobalt blue mix. Use the same color to paint the sloping line on the right.

8 Use an orangy, green, rusty color to paint the ironwork in the upper part. Paint carefully respecting the most luminous zones and increasing the contrasts by the shadows. Once the picture is completely stained, draw the forms in dark tones. The composition is nearly complete. Now the work will be to do the finishes and the definition of the objects. An important note: a picture must be painted as a whole so that you have a global vision of it.

9 The drying time of each zone is important because it allows the forms to be defined. If two moist zones come into contact they will blend. To avoid this the dark strokes should be denser. Take off the masking fluid put down at the beginning, using an eraser or your fingers. The paper must be completely dry or it will be smudged by the dragging finger or eraser.

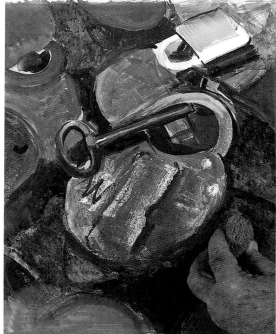

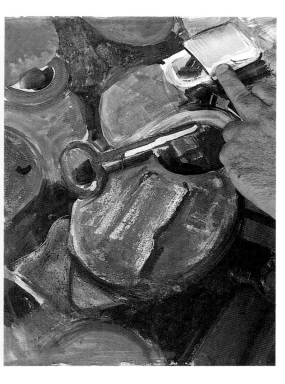

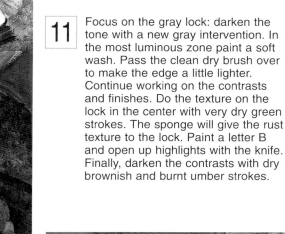

10 Start the details on each part of the picture, starting with the key. Make the shadow zones stand out with a dark tone. The contrast created will make the lightest tones more shiny. The points of maximum light are left reserved. Finish the form of the key and, at the same time, do the shadow on the lock with very dark brownish strokes. Draw the letter W on the left of the lock. The wax put down at the beginning will help you. Use a knife to open up white spaces for the rivets. Use a stained, almost dry sponge to do very dirty, dark tones in the background.

11 Focus on the gray lock: darken the tone with a new gray intervention. In the most luminous zone paint a soft wash. Pass the clean dry brush over to make the edge a little lighter. Continue working on the contrasts and finishes. Do the texture on the lock in the center with very dry green strokes. The sponge will give the rust texture to the lock. Paint a letter B and open up highlights with the knife. Finally, darken the contrasts with dry brownish and burnt umber strokes.

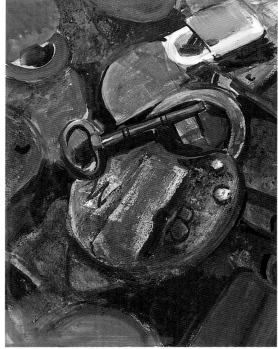

12 Paint the shadow of the screws with a fine brush. Note that the dark indicates the way the light falls. The knife work is very important for it allows you to open up small highlights and to scratch texture wide areas. Gently scrape off small areas using the knife tip. Be careful not to tear the paper. Always drag the knife with the blade perpendicular to the way you drag it.

13 Paint the most contrasted zones of the forms with brown and burnt umber. Now each piece stands out on its own. In the lower part of the drawing enrich the shadow zone with dark green. Make the object more real by working on the forms. Stain the sponge in orange and do a few texture touches in the lower part.

15

Do a dark wash. Apply it with wide strokes over the dry background to finish the darkening of the pieces in the lower zone. For the first time black is used to do the darkest parts of the shadow. Use the sponge with the mix of colors in the palette to give texture to the lock on the left of the composition. Use the knife, without scratching too hard, to lighten some zones.

14

All the elements of the picture are correctly placed and defined by the shadows. Once the entire picture is dry (speed it up with a hair dryer) use the sandpaper to enhance some textures. Do not rub too hard so that you do not go through the paper. Throughout this work many aggressive actions have been realized on the paper so it should be thick so that it will stand up to them.

16

Increase the definition of the locks by going round the shadow edges. Pay attention to the small details. Finally, retouch the color of the lock in the center: violet on the arch, orange on the body, etc. Open up new highlights with the knife, above all on the rivets and screws to make them more realistic. The work is now finished. Although it has been laborious it has enabled us to practice textures and direct interventions on the watercolor.

TOPIC 13

DRAWING AND WATERCOLOR

The transparency of watercolor is often combined with very evident lines. Drawing is an important plastic supplement in watercolor. In previous chapters we have studied the basic of watercolor but we preferred not too introduce drawing until later, although, in fact, it is a straightforward technique. This was because we did not want to distract the learner's attention from watercolor itself. However, throughout the chapters we have emphasized the important of drawing in this transparent medium, even though the line has been covered by the color. We will now deal with the line as part of the creative process.

Synthesis and conjunction: learn how to see

The synthesis of lines helps to understand the forms better than just looking at the details of the model. Forget for a moment that the shapes have color.

When looking at any model, be it landscape, still life or figure, bear in mind the following points to understand its shape:

• Fit the model into an imaginary frame to mark off the limits. You can make a cardboard frame as a viewfinder.

• Have clear in your mind's eye the lines that border the shapes. Reduce the shapes to the most basic.

• Once the general form is clear you can start to draw on the paper.

WATERCOLOR PRACTICE

Color on engravings

Line and color (or line and wash) can be combined in the way the English illustrators did in the engravings of the 17th century. In fact, this is how watercolor won its reputation in the artistic world. As time went by landscape illustrations went on to become commercially and artistically important. In 1703 Lucas Carlevari published a collection of 103 engravings in black and sepia. Later, engravings for tourists came into fashion and colors (watercolors) were introduced. Eventually a high technical level was reached.

Some artists went as far as developing their own techniques, no longer using the engraving as the base. Drawing and color are evident in many of the techniques used by watercolorists.

Omitting details

A piece in which drawing is going to play a key role must be approached carefully, planning the details of the forms. The treatment given to a purely lineal or one value drawing (modeling the tones with a monochrome gradation) is different to the treatment given to a drawing which is going to be painted in transparent watercolor. The latter must have all unnecessary detail removed.

An interesting exercise is to draw the same model in two different ways, firstly using tone values and not painting any color. Secondly, just do a very simple drawing designed to receive color strokes. The line, in this case, will only be to contain the color.

Rafael, The Athens school, *detail of the sketch for the definitive work painted in watercolor. Although watercolor became important as a medium in the 18th century by then it already had forerunners among the great artists. Here Rafael used a wash and line technique.*

How to join the forms

Once you have fitted the model forms into the surrounding space, you can do the more detailed lines.

You have to analyze the internal elements of the model just as we did in the beginning with the general forms. Structure the most complex forms with general lines that later we will join together.

The original scheme turns complex elements into simple forms.

Once the simple forms have been finished, work on their structure.

The drawing must not have double lines that could cause confusion.

Two different ways of understanding the figure: through drawing and through color.

The pre-drawing and drawing directly

The drawing before the final work can be done as part of a planned, structured process or it can be done directly in an off-the-cuff style. The two techniques offer different results. The first gives a structured finish, in which errors can be corrected as you go along. Drawing directly requires more creativity from the artist and less propensity to make mistakes, above all when using an ink pen.

In this type of work the errors can be corrected: they must be skillfully incorporated into the drawing by the artist. To do a direct drawing one must know how to draw very well. Nevertheless, it is a good way for the enthusiast to learn.

Direct sketches realized with an ink pen.

Provisional drawing

A provisional drawing is used as a support for a later drawing. The lines do not have to be so careful but they must be structured.

The provisional drawing does not have to be definite: it is only a structure of lines which are a guide for more definite lines later on. Therefore it will no longer be necessary when the definitive drawing is done.

Many artists are not bothered if the provisional drawing lines are visible through the final watercolor. Other, more purist, prefer to erase the lines once the work has been finished.

The tip of the brush

One can draw with pencil, pure graphite, wax, quill or cane, and likewise there are many options for brush points, varying in form, material and hardness.

You can draw with Chinese brushes. These are soft and have a good paint carrying capacity. The stroke is versatile. Low numbered and high quality brushes facilitate a thin, homogeneous stroke, ideal for details.

This drawing is a good example of working with value and modeling.

The pencil type

The type of pencil used depends on the result you are after. Graphite pencils are classified according to their hardness. Pencils for artistic works have a letter B. The higher the number that goes with the letter, the softer the pencil lead and the blacker the line. Therefore it can offer more gradations of gray.

Letter H pencils are hard. They can have a fine, strong point and are suitable for precise technical works. The higher the number, the harder they are. Hard pencils are more difficult to rub out and hardly allow gradations of gray.

These commentaries about hardness can also be applied to pure graphite sticks. They come wrapped in plastic film and offer wide or fine lines, depending how you drag the point over the paper.

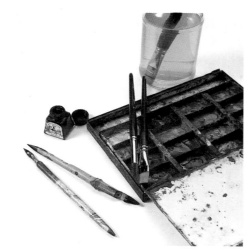

The tools for drawing with watercolor are not limited to just the pencil: ink, cane and the quill facilitate a gestural and contrasted line.

What to avoid

Problems of drawing with watercolor

• Do not use hard pencils that leave marks on the paper. The hardness is indicated on the pencil. It is better to use soft pencils (classified with a number and the letter B). The line is denser and easier to erase the higher the number is. A 2B pencil is good enough for doing a sketch.

• Do not press too hard with the eraser because you could spoil the paper surface. The softer the eraser the better; never use hard ink erasers.

• Avoid double lines, above all in the definitive drawings. The line should be continuous and uninterrupted, at least if this is the effect you are after.

• Do not value grays and tones that you can resolve with color.

Lines realized with pencils of different hardnesses.

Combining ink and watercolor is perfect for doing sketches.

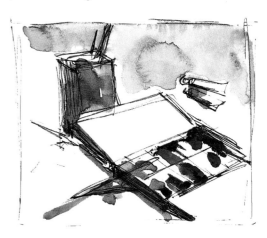

DRAWING TECHNIQUES

The line

At the beginning, unless you master technical drawing or are doing it to achieve a specific effect, the line must not stand out too much. The drawing process must always go from the general to specific. This means that firstly the general forms are drawn inside the scheme in straightforward lines, without great detail. As the forms begin to take shape, the lines become more definitive and precise. The initial sketch gives way to a drawing with firmer lines.

Synthesis

A drawing is easier to understand the less lines it has: define the forms only with necessary lines.

On top of the initial scheme it is easier to draw the definitive lines. The drawing must be precise and avoid unnecessary details. Get rid of all superfluous lines. Remember the object of the drawing is not to be the final artistic expression: it is going to form part of the color of the watercolor so it does not have to be a finished drawing. The color and the brushstrokes will enable the work to be completed.

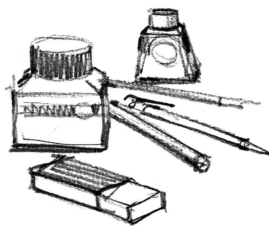

The lines are made firmer until he forms are completed.

A quill and ink

A drawing can be done with different media. One of the most common is the metal quill. It has a very versatile line. Its tip definition depends on the pressure applied: the line can be thick or fine. Black, sepia, sienna and blue are all colors that work well in ink. The intensity of the color depends on the amount of water in the wash.

If the quill is hard it will make a rigid line. In the Art shops there is a great range of models which vary in quality and price.

A splendid example of how to master line. The synthesis of lines facilitates understanding the forms.

Different lines realized with a quill.

Alternative lines

Many media can be used to draw the structure that is going to be painted in watercolor. Some media interact directly with the color. The drawing of an ink pen gradates with the water and tends to disappear over time. Some pens give a stable line that fades away when it comes into contact with the moist watercolor. A fountain pen offers a similar line to a hard quill but does not have to loaded with ink every time.

Different drawing media: ball-point pen, pencil and felt-tip pen.

The cane stroke

A drawing medium rich in possibilities is a sharpened bamboo stick dipped in ink or in watercolor wash. All the important Fine Arts shops sell bamboo sticks, the points of which can have different thicknesses. It gives a strong line which can vary greatly: continuous when well-loaded and similar to a pencil when the ink is running out.

Bamboo cane allows a rich range of possibilities. To do this image (below) only one stick has been used.

When doing sketches, the ink line can be the base for the color scheme.

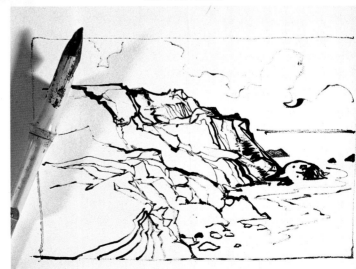

The lithograph pencil

The lithograph is oily and therefore its line will not be covered by the watercolor as it is contrasted throughout the process. It will not lose its intensity. The lithograph pencil allows the paper to be completely sealed and to make a perfect black stain. Despite its oily point it flows over all types of papers. The continuous line comes freely. The pencil is not made of wood. Instead it is wrapped in rolled paper. The point does not have to be sharpened. Just pull on a little thread that unwraps the paper around the stick.

A lithograph is ideal for doing sketches and continuous lines. The drawing can be done before applying the color or on top of the wash. It does not matter if it is dry or not.

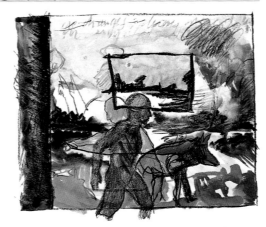

In this example first all the black lines were drawn; afterwards the color was put down. The lithograph line has been a barrier to the color.

Drawing effects

There are many drawing effects that van be achieved with the different media. The line can be perfectly reserved with a lithograph pencil. Or alternatively, if a watercolor crayon is used the line can be integrated into the wash blending both pictorial languages. A stick of Chinese ink can be used as a drawing medium: by just moistening it in water you can draw directly on the paper.

A. Lines from a lithograph pencil. The color does not penetrate into the line.
B. Blending the line from a watercolor crayon with a watercolor wash.
C. Lines from a China ink stick in watercolor.

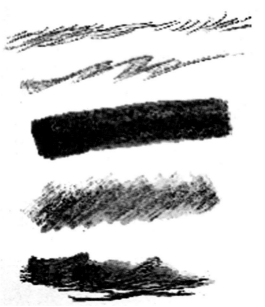

Various lines made with a China ink stick: the modeling of the form depends on the way the wet bar is held against the paper.

A

B

C

A classic example

The way Paul Sandy, the father of English watercolor, painted

Paul Sandy and his brother Thomas were founder members of the English school of landscapist watercolorists. Sandy developed a splendid technique as a watercolorist which made him a worthy forerunner of Constable and of Turner. He decided to go beyond the technique of illuminating engravings and elaborate a technique for watercolor in its own right. In 1752 he painted a series of landscapes of the forests of Windsor, in which he combined his mastery of perfectly drawn lines with the characteristics of watercolor. The foregrounds are much more defined than the rest of the pictures because of the line intensity. Line combines with color, but they do not blend. Sandy achieved this effect by letting the first wash dry. Some lines were drawn before painting the color. The details of the trees in the background were drawn once the color was dry.

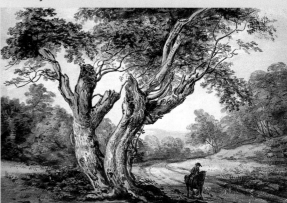

Paul Sandy (1725-1809), A walk through Windsor forest, watercolor and sienna drawing on paper, Victoria and Albert Museum, London.

Mastering drawing

The mastery of drawing is an important question. It must be an aim of the watercolorist, above all when color is a complement. To achieve a perfect technique it is fundamental to practice constantly with all the media we can find. Keep drawing, whatever theme. The right feel with color will come on its own.

Line and color

A rich plastic language enables a clear drawing to be blended with the color of watercolor.

Schemes and sketches

You have to distinguish between a scheme and a sketch. The former is much more synthetic. A sketch, although it must be simple and synthetic, offers more information, but always synthesizing and without excessive detail.

The line of cane

Among the different drawing media, cane stands out for its stroke versatility which facilitates different intensities of grays, and other graphic effects.

Drawing effects

A drawing that is to be painted in watercolor offers many possibilities, from a lithograph pencil drawing right through to the line of a watercolor crayon.

EXERCISE

Pencil and color: a studied drawing

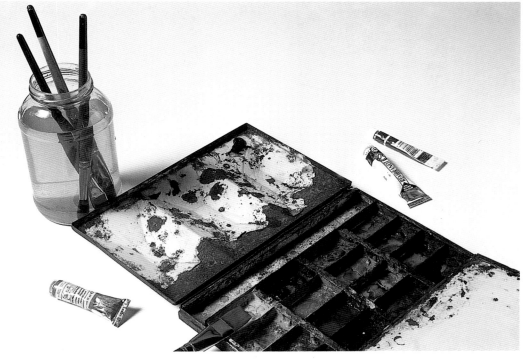

Necessary Materials

- TUBE COLORS
- 2B AND 6B GRAPHITE PENCILS
- 250G MEDIUM GRAINED PAPER
- SOFT ERASER
- FLAT AND ROUND WATERCOLOR BRUSHES (PREFERABLY SABLE)
- STICKY TAPE

Any theme can make an interesting model. Do not resort to the worn out excuse 'I don't paint because I don't have an interesting model'. We are surrounded by things to be represented which are great for plastic expression. As can be seen this exercise is based on common articles for any watercolorist. They must set up a challenging composition. A diagonal form always works well. To break the excessive rigidity of the basic design, place a few watercolor tubes on both sides of the paint box and use a brush to construct a diagonal in the opposite direction.

2 On top of the perfectly defined scheme, use the 6B pencil to go over the structural lines that strengthen the form. Note that as well as going over the lines, you also have to shade the darkest planes of the box gray. Be careful with the grays. In fact, only the darkest zones will be marked. The medium tones will be left blank.

1 Do the first lines in a very general way. Firstly situate the space that the open box is going to occupy and select the parts of the model that you want to fit in. Do not choose the whole model, just a part of it. When doing the first lines bear in mind the proportions between the different forms of the composition. Once the basic structural lines have been drawn, go over those which are definitive.

3 Go over the forms of the composition to define them. Use a dark tone to define the shadow zones. The most luminous highlights are left unpainted. Draw a firm line to mark the different compartments of the palette-box. The watercolor tubes have been synthesized with the lines: we are only going to do the principal lines. Now that the drawing is completely defined, increase the contrast in the darkest zones of the palette-box and the brush handle.

4 When the drawing is finished the necessary color can be applied. There are two ways of working: one, using washes to reflect the luminosity of the paper. The second is using pure and dense colors to focus the eye on the palette-box. Intensify the darkest zones with a brush loaded with black watercolor. Paint the darks of the palette with a very luminous burnt sienna wash, and the background violet. The most luminous highlights are left in reserve. Do loose brushstrokes of very diluted cobalt blue on the jar and the brushes.

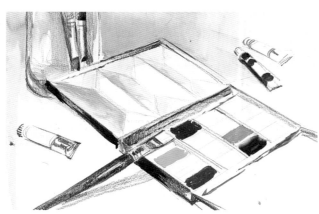

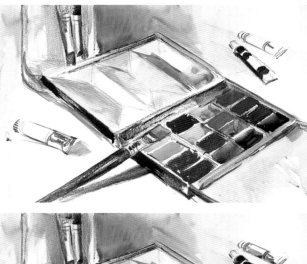

6

Before continuing with the palette colors, darken the background with the dirty tone produced from mixing in the palette. Paint the zone around the jar darker and gradate the tone on the right side of the picture, around the tubes. The latter will appear more luminous because of the effect of the simultaneous contrast. Mix the background color with blue and paint the cavity on the right of the palette-box.

Wait for the last layer to dry while painting the central cavity of the palette-box and the lower right part of the composition in sienna mixed with very luminous violet. Finally, paint the rest of the colors on the palette.

5 Use brown and blue to paint the stripes on the watercolor tube in the upper corner. We are working with tube colors which permits us to paint strong, luminous colors without hardly diluting them. Start to paint the colors of the palette. Do not stain the cavities. When you want to paint a color with a highlight, leave the zone unpainted. Note how the red and carmine highlights have been done.

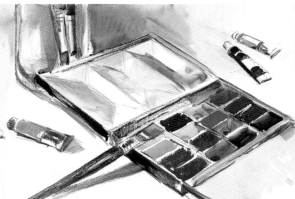

7

Paint an ochre-yellow shadow on the left side of the palette-box and under the tube on the left. Use a dark gray to intensify the shadow of the pencil on the table. There is an interesting equilibrium between drawing and watercolor: in some areas the drawing is more developed than in others. On the jar give a few strokes of wash the same color as the background but leave unpainted the most luminous zones.

Blacken the handle of the brush on the palette-box. The brush head was too dense in color. Drag a clean, wet brush over to take away part of the already dry color.
The color interventions are now finished. Once they are completely dry, use the 6B to intensify the darks around the jar to empha-
8 size the shininess of the brush.

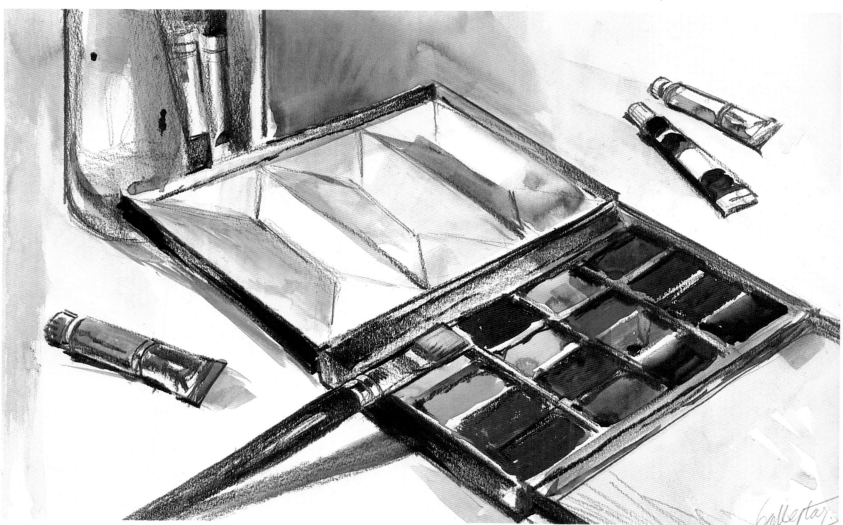

Ink and watercolor: a direct drawing

Necessary Materials

- TUBE COLORS
- BAMBOO STICK SHARPENED FOR DRAWING
- 250G MEDIUM GRAINED PAPER
- CHINESE INK IN A POT
- RAZOR BLADE
- FLAT AND ROUND WATERCOLOR BRUSHES, PREFERABLY SABLE HAIR
- STICKY TAPE.

This exercise is different to the ones done before. In the last exercise we used graphite pencil to do the base for watercolor. The work was divided into stages: planning, going over the darks, finishing the drawing and putting in the color. In this piece the drawing, flowers in a metal vase, is going to be done directly with ink and a stick. It is not realistic to assume that the enthusiast will draw freehand as well as an experienced professional. If it is too risky to start in ink, draw a few guidelines in pencil to get going.

Mentally situate the forms on the paper. Start drawing directly with ink. First dip the stick in the inkpot, making sure it does not drip and start to draw the leaves on the left. As the stick is still loaded with ink do the darkest lines that will form a triangular structure on which to construct the drawing. In this initial drawing only the most evident lines and darkest zones are drawn. When the ink runs out, use the faint line to **1** insinuate more subtle lines around the vase and some flower forms.

2 Now that the principal lines are down, define the forms of the petals of the flowers. Control, or measure, the ink you take from the inkpot to avoid excessively thick lines. Unload the ink on a test paper before. Although the stick can be versatile in its stroke, sometimes it drips on to a zone that should remain white, obliging you to modify the stain due to accidental dripping. Use an almost inkless stick to do the luminous part of the vase.

3 Now all that has to be done is to increase the dark contrasts. As you can see, the darkest zones define others. The contrast makes them lighter. The lines around these luminous zones are faint, almost invisible. Do not forget that it is a drawing for watercolor. The color will give the final definition to the forms.

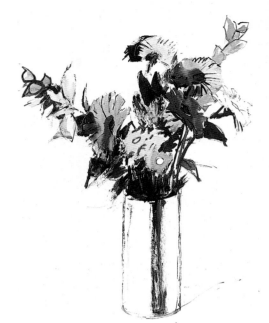

5 Before the first flowers dry, do little, not very watery color dashes. These will blend with the still moist background. Paint the leaves green in a wide variety of tones and gradations according to the light zone that each one occupies. Use a very luminous wash for the upper leaves. The leaves at the base of the jar, as they are in the shadow, are done with a dark, not very watery green. Once the green has dried, you can paint the flowers yellow.

When all the flower colors are dry, give more outline to the stains that define them, above all in the middle of the flowers. On the middle upper carnation the black stain is too bold. Scratch it carefully with the razor blade to correct it. Finish the flower off with an almost transparent wash of carmine and green. To complete the picture, paint the vase. Make the central highlight darker with ink. When this is dry, paint cream colored stripes to reserve the highlights. Once the color is dry, you can paint the gray metal reflection.

7

4 You have to wait for the ink to dry completely before applying the color, otherwise the ink will be dragged, smudging the paper. When dry no watercolor wash will make the ink run. Start the green tone of the leaves. As in the previous works, the most luminous tones are going to remain reserved. Do light washes, with which to paint the light leaves, in the palette. However, do not paint all the leaf: the highlights are left white for now. Start with the two lightest flowers first. Afterwards, using a much denser color, paint the flower in the middle.

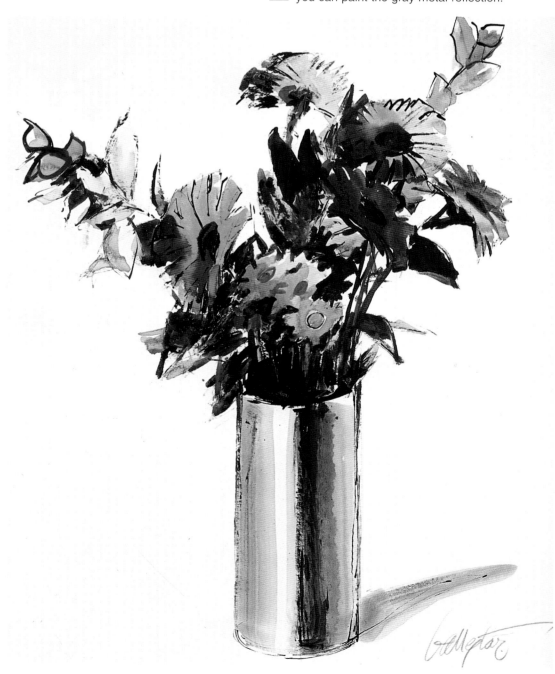

6 The painting process of this still life can be divided into three clearly different stages. First, the ink drawing. Second, staining the colors on the dry background. Third, the shades of the wet tones as they are modified by blending with new interventions. Paint some carmine and light green strokes on the still moist flowers. Once this is dry paint the center luminous green. Paint the flowers on the right in the same way: firstly, a light yellow tone and then, on top, in the darkest zone a reddish stain. Finally, go over the blue cobalt of the darkest leaves and let the color blend subtly with the white background.

TOPIC 14

THE STAIN

A brushstroke has to control the line. If you compare watercolor with other media you will appreciate that the painter must continuously control the brush to get the right forms. It is an 'evasive' medium. The color is in the water which can freely expand over the paper, distributing its intensity and gradations.

A stroke can draw or stain. Drawing is based on lines that define the forms. With staining the form is within the stain. In this chapter we will study different staining processes and we will explore in theory and in practice two interesting exercises based on backlight. One way of correctly understanding the model is through its drawing synthesis, or through its stain synthesis.

Color and what surrounds it

As watercolor is a medium which relies on the luminosity of the paper, the color must be treated always remembering that it will be effected by, and will effect, tones of other layers and the tones around it. When we stain paper we must not only focus on the strokes that make up the principal elements, we must look around. Which colors turn a yellow reflection into green? We must look for the background tones that complement and transform the tones of the principal elements. The colors surrounding an object condition its cromatism. Never paint without reflecting on the overall color effect.

Practice exercises like this one. Each of the colors is conditioned by the adjacent ones.

STAINING SYNTHESIS

Synthesis and forms

In previous chapters we have seen the meaning and the importance of synthesis in drawing, how to be economical in the stroke and how the latter interacts with the watercolor. However, the form is not only defined by the drawing line. The stain, through the stroke, is one of the main recourses for transmitting the characteristics of the model being represented.

Knowing how to look

Real objects and model have very complex forms. They are made up of many different elements. If you look at a landscape your eyes can focus on a unique object, isolating it from everything that is around it. It will then appear as a stain among others. Its color and form complexity increase the more we concentrate on it. If our gaze becomes lost in the horizon, the objects lose their forms and lines. The whole view leads us to synthesis. This is what we must understand when we look at any model: always analyze it going from a general level to a detailed level. The form is not only defined by the space it occupies but also by the stains around it.

Understanding the form

The form of any object can be depicted by stains. It is not necessary that the color be descriptive. One must be able to understand and to describe a shape, and to master the drawing of it.

On top of a synthetic drawing, do the staining that insinuates the shadows.

After the staining, define the line with subtle strokes.

Observe how in this drawing line and staining are in equilibrium and are not overstated. Neither encroaches on the other. The definition of the form and the shadows are insinuated, but all the fig is clear.

In this tree the line is only partly evident; the color stain finishes off defining the rest of the form.

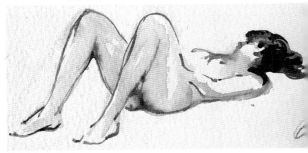

Starting from the staining, go over the lines with faint strokes.

A useful exercise

A good exercise to practice your understanding of form is take an object and to abstract its internal and external forms, observing in the process that both are complementary as they divide up the space. Do the experiment with different models: objects, people and landscapes. You can try representing forms based on the space that surrounds them. In this way a tree leaf is defined not by its mass but all that lies around it.

Accidents

Experimenting is a stimulus that can lead to lucky discoveries in a pictorial medium. In previous chapters we have dealt with texture experiments, but there is another way of learning techniques. Take advantage of errors. Sometimes when painting with stains these will blend with other colors still moist or will be superimposed on completely dry colors. More often than once we will see that an error offers a solution to another problem we would not have found. For example, when painting a landscape first the sky is stained and then the foreground is put in. If the horizon line is painted, mistakenly believing the background to be dry, it will blend with the sky blue and will finally spread in an unexpected way. It may have been an error but it has produced a plastic effect. Chance errors can become common recourses over time, with the advantage that the next time you will have more control.

Respect watercolor stains

When doing a watercolor sketch it is possible to make small errors due to accidental stains. Learn how to take advantage of these chance happenings integrating them into the overall effect… provided that they do not stand out too much.

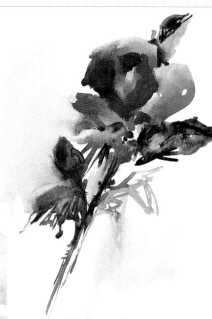

When you learn to master an 'accident' it can become another recourse of watercolor.

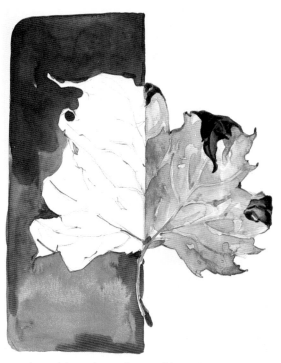

A model can be understood from the internal form and the color masses around it.

By mistake part of the ochre color of the horizon has blended with the blue of the sky giving the landscape a very satisfactory atmospheric effect.

WORKING OUT STAINS BEFOREHAND

Intended stains

Staining in watercolor can be easily manipulated which means that the work can be immediate and fresh. In this painting medium the masses of the forms are done with staining. The drawing is linked to the stain, never at random. Immediately after its application the brush is used to define its form.

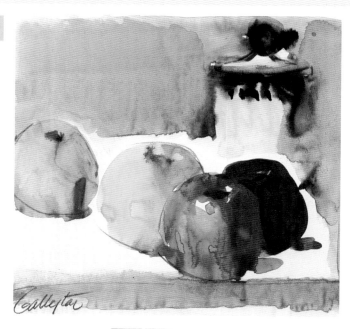

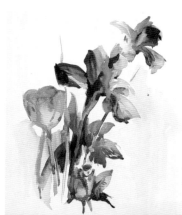

Staining gives the work a spontaneous and fresh look.

When doing work based on staining the brush should be thick and have a good point. After loading the brush apply the color immediately to the paper, always staining and drawing the dark zones that outline the luminous forms.

The stain must make the form clear and mark out the adjacent highlights.

Every brushstroke has covered a lot of paper and all of the stains in this magnificent picture mark off spaces or adjacent forms.

Tension on the water surface

When you fill a glass with water you will note that the liquid surface is convex. This is due to surface tension. The watercolor technique, given its capacity to spread over the paper, clearly tends to stain even though the paper texture and the water help to hold back the stroke and avoid it spreading randomly over the surface. The watercolor stain, however wet it may be, is limited to a zone by the surface tension of the water. Thanks to this characteristic the stain can be manipulated at will as it extends under the brush.

Impressionism

Impressionism broke with the classics. Before impressionism arrived on the arts scene the color of the forms was based on tone value. The volume of the objects was painted with gradations and dark tones of determined colors. Varying the value of a color was the principal technique for expressing volume. As impressionism evolved the shadows of the objects were painted with their own color, without tone gradations, and this lead to the emergence of colorism and the exploitation of contrasts between complementary colors.

Stains and details

Staining does not rule out details. In previous chapters we have done exercises in which the stain was the base of the color and the detail was developed once the lower color layers were dry. In sketches, too, it is common to combine the work of staining with the definition of the line. However, it is very important to observe the order of the superimposition of the colors. The most luminous colors must remain reserved because the darkest ones do not allow superimposition of lighter ones. Detail done on stains must always be darker than the stain color.

Staining and sketches

A sketch is an immediate response drawing: it must be spontaneous. The model can be expressed with just lines: the synthesis expresses the form. Stains, too, can mark off the forms. A sketch with stains can be as descriptive, or more so, as a line sketch. The brushstrokes can do a sketch rapidly.

Strokes can establish many elements of the model. Two aspects of the form have to be controlled: the internal form and the space that surrounds it.

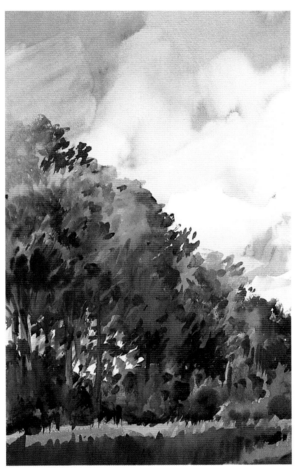

Complementary color stains do not define detail. All the small stains create dark or light color masses which are combined in the spectator's eye.

Staining and flat brushes

The flat brush is one of the best for all types of works with staining. Despite appearing to be not very precise, in practice it allows all sorts of strokes, in which the form is controlled, to be done: a flat brush allows the retention, loading and manipulation of a good water load. Moreover, its flat, straight point allows accurate lines to be painted.

Backlighting

Backlighting exercises are one of the best ways of practicing staining in watercolor. When a model is lit from behind there is a notable reduction in the quantity of details: the unnecessary ones are lost as the object is synthesized, making the representation of the object easier with stains which can be done in a very generalized manner with large strokes that join the forms of the model outlined by the strong contrasts with the adjacent spaces.

It is important to practice examples like this simple backlight: the drawing is defined by the stains.

Claude Lorraine (1600-1682), Landscape with a river, the Tíber from Mount Mario, Rome. British Museum, London. The use of backlighting has allowed the forms to be synthesised.

Richard Parkes Bonington (1802-1682); A Venetian scene, watercolor. Wallace Collection, London. In this example Bonington combines stains with careful detail.

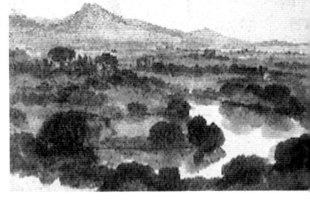

The importance of the paper

The paper plays a key role in the result of the stain and the synthesis of the forms. Thick grained papers are especially suitable for works with large stains and details that do not require pressing.

Thick-grained paper conditions the stains and the stroke and must therefore be used for certain works.

Watercolor staining

The work of a watercolorist can be very spontaneous. However, despite the freshness that can be expressed in watercolor, there are certain rules that have to be followed from the beginning. The basic design, or scheme, must have clear which are the light zones. Never can you paint a light tone on top of a dark one.

It is recommended to start the staining with light tones, although the stain may be very loose. Later, you can increase the tone with dark strokes. Whatever you do, remember that the luminous colors and the white of the paper must be reserved from the start.

Evolution of the form

Starting from a stain, interesting forms and elements which get close to the real model can be developed. Firstly the brush deposits the paint load on the paper and then it makes a form. For now do not worry about the details. Establish the luminous spaces before laying down and modeling the second stain. The proportions must always be respected. When the form of the stain evolves, always bear in mind the light or luminous spaces that separate one form from another.

A classic example
The way Rembrandt painted

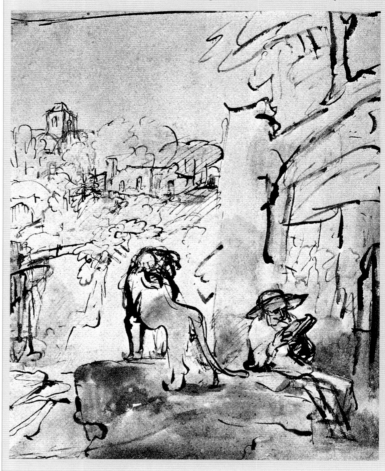

Rembrandt, this grand master of staining and forerunner of expressionism, developed a keen sense for synthesizing forms. His watercolor work is a perfect example of how to do complex forms with precise stains and different planes. Stains and lines are perfectly combined in his washes, realized without doing a drawing beforehand, and he always turned any error to his advantage.

Rembrandt (1606-1669), San Jerónimo en un paisaje (1653), dibujo a pluma con aguada, 19 x 26,5 cm. Hamburger Hunsthalle, Hamburgo.

Stains in sketches

Stain can make sketches: you do not need many colors nor brushes. In fact, one color and one brush can give rewarding results with a wash.

Another possible exercise is to use two colors and medium-sized flat brush. This limited range of materials will oblige the artist to do very synthetic stains.

Synthesis and forms

Staining allows 'drawing' with forms that are more complex than lines.

Stain as a base for watercolor

Watercolor tends towards stains. A picture can be set out rapidly and intuitively with stains, allowing greater accuracy when calculating the proportions.

Brushes for stains

The most versatile brush for staining is the flat brush.

Backlighting and synthesis

One of the best ways to understand stain synthesis is by using backlighting as it removes trivial elements from the model.

Stains: monochrome back lighting

Necessary Materials

- TUBE COLORS
- 2B GRAPHITE PENCIL
- 250G MEDIUM GRAINED PAPER
- FLAT AND ROUND WATERCOLOR BRUSHES (PREFERABLY SABLE HAIR)
- ERASER
- STICKY TAPE

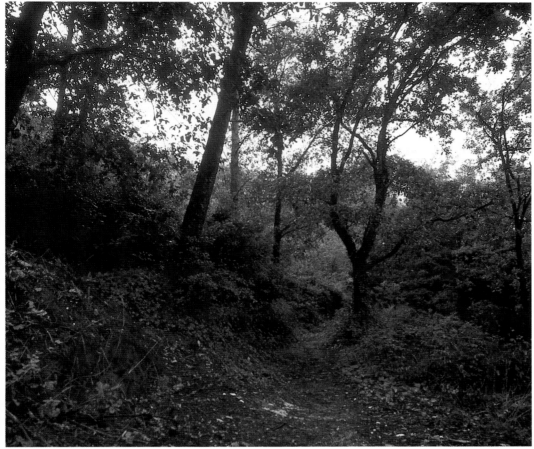

A thick forest has been chosen as the model for this exercise. In this image the light filters through the leaves and makes the details and textures disappear. The planes are unified by the intensity. They are separated from the rest of the picture by the variety of tones, highly contrasted against the highlights. A sole color will be used to paint this landscape. Each one of the zones of the picture will be treated as a stain.

1

The aim of the drawing is merely to place the main compositional elements. Try to get some sort of asymmetrical equilibrium between the elements of the landscape. Draw carefully in the places where the principal lights and darks will go, the tree and vegetation area in the foreground. Do not draw the branches or the leaves: they will be done directly with the brush.

2

Only sienna is going to be used. Monochrome will focus the attention on the way the stains are treated and the tone values in the light and distance. The interpretation of the model is important in this exercise. The model must be synthesized creatively. To separate the vegetation planes, consider the forest in the background as one tone without any detail, only the occasional tone change. Lay down a light wash and draw with the brush the limit between the vegetation and the sky. It does not matter if the lower part of the stain penetrates into the zones reserved for the darkest tones.

3

Between interventions the drying times are always important. Sometimes the background should be dry to gain the desired effect, and at other times you will take advantage of the moistness. Now let the background dry before continuing with the darkest tones. On the left, paint the darkest tone you can get from sienna. Use the wet brush to take pure color from the palette, but do not do any gradation. Tube colors allow opaque tones to be done. Draw the trees with careful lines. All of the dark stain is painted with the brush well-loaded. Synthesize the mass of vegetation with this tone alone.

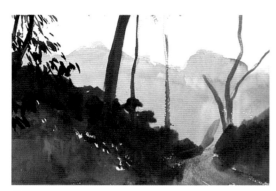

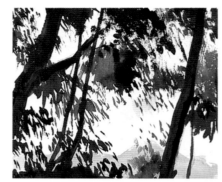

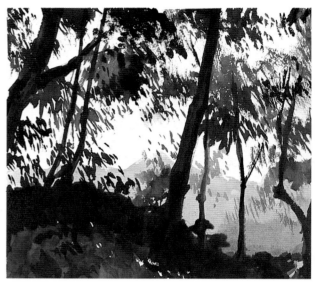

4 After lighting the previous color on the palette, do a new intervention on the foreground until you have completely covered the two dark masses that divide the picture in two. When you have diluted the color, brush over the zone rapidly as if it were just one stain. To gain more variety in the reference points, leave some zones unpainted. Finally, stain the central path with a midtone.

5 The principal elements of the composition have been resolved: large stains for the dark vegetation and ground zones. Finish off the drawing of the trunks and start to paint the leaves on the ground. Begin by marking off the densest zones, onto which light hardly falls, with dark stains. The edges are not defined. Use a fine brush, dragging with short strokes. The diagonal part of the watercolor is still fresh so the stain edges are not clear.

6 Pay a lot of attention to this part of the stain and line process. If by accident you stain where you did not plan to, you must integrate it into the fallen leaves. Work rapidly and firmly with the brush. For the finer lines, do dry strokes from the wrist. A lot of stains will be made with an almost worn out brush, using little paint. In the background, over the first wash, do some strokes to give texture to the vegetation.

Continue to do small lines until the lush greenery through which the light filters is finished. Finally, complete the contrasts in the lower part with new very dark stains that insinuate the vegetation forms. This landscape with a mysterious mood has now been finished.

7

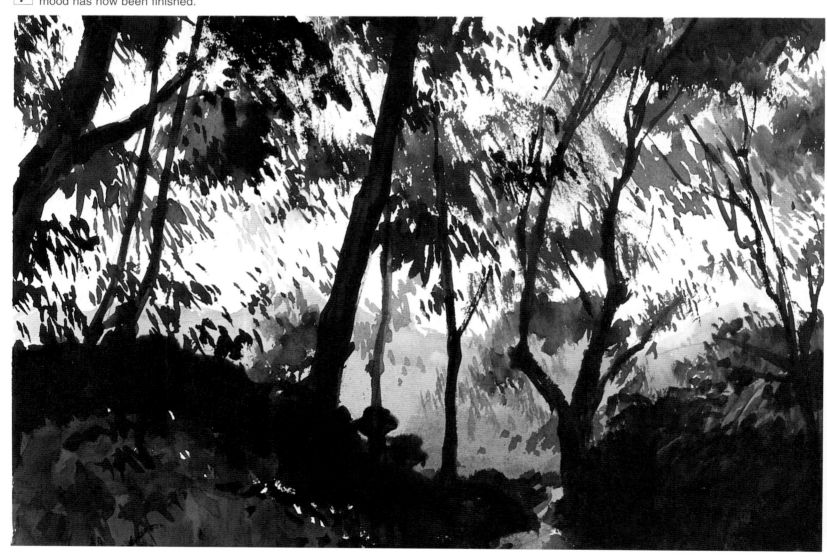

EXERCISE

Still life: the synthesis of details

Necessary Materials

- TUBE COLORS
- 2B GRAPHITE PENCIL

 250G MEDIUM GRAINED PENCIL
- FLAT AND ROUND WATERCOLOR BRUSHES, PREFERABLY SABLE HAIR
- ERASER
- STICKY TAPE.

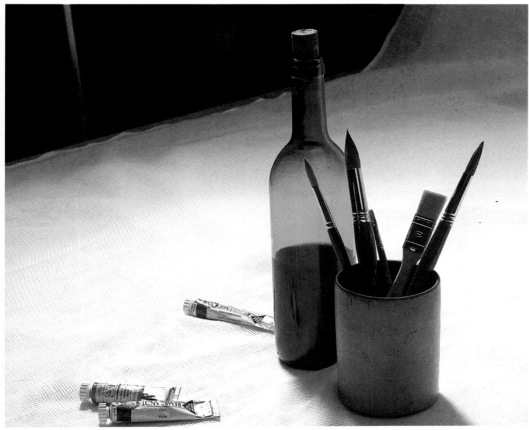

To further study stains we are going to do a new exercise, this time a still life. In the last exercise we examined monochrome staining, but this time we will work with backlighting in a studio. The changes due to the introduction of color will be noticeable. The synthesis of forms is going to be the principal objective. Always we will be working from a general level to a more detailed level.

1 Draw the forms in pencil making a basic design. Part of the bottle disappears out of the top of the picture. The left edge of the bottle is in the picture center so develop the other elements from this reference point. The largest elements are on the right, while the tubes balance the picture.

3 Wait for the first color layer to dry before applying in the next stage dense, opaque colors. The forms are defined by large stains. Apply sienna, mixed with a bit of carmine, to the bottle on the left. After rinsing out and drying off the brush take away the most luminous part of the color. Use the same technique to paint the bottle on the right. The adjacent color must be dry, although, in fact, if you are experienced it can be painted still moist if you do it quickly, taking advantage of brush pressure to drag excess color away.

Begin to paint with a large yellow stain. The wash is mixed in the palette and then quickly laid down. The whole background is covered before the edges can dry. Note how the paint has been applied and the form of the principal tones in the painting. Most importantly the areas designated for highlights have been left unpainted.

2

4 Use a luminous green stroke for the reflection of the bottle on the tablecloth. Give a final touch with a luminous stain of cobalt blue and sienna. The bottle edge is defined in sienna. Before it dries out start the green color, dragging part of the color. The green color must respect the area where the highlight will be.

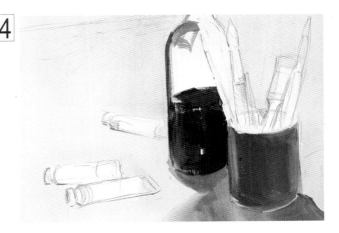

111

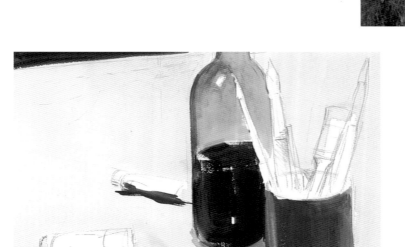

5 Begin to paint the green bottle color absorbing part of the sienna along the edge. The left is to be more opaque. Define the shadows of the watercolor tubes and the tubes themselves. The tubes are defined by the masses around them but are still actually unpainted.

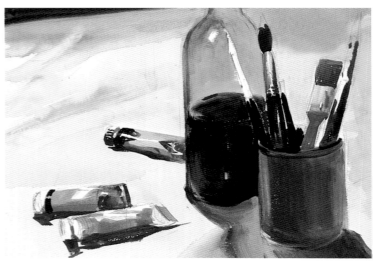

6 Paint the tubes with a few ochre stains. The volume of the model must be perceived through the highlights, the reserved background of the paper. Stain the principal tones of the brushes relying entirely on the highlights to give volume. Use blue and sienna to get a gray color that is diluted to give a gray transparency with which to paint the tablecloth background. Leave the most luminous spots unpainted. In the shadows of the creases, slightly intensify the contrast.

7 A dark layer gives the final volume to the bottle. Retouch the form of the brushes with dark tones. Note how the yellow tone in the foreground stands out against the more subdued background tones.

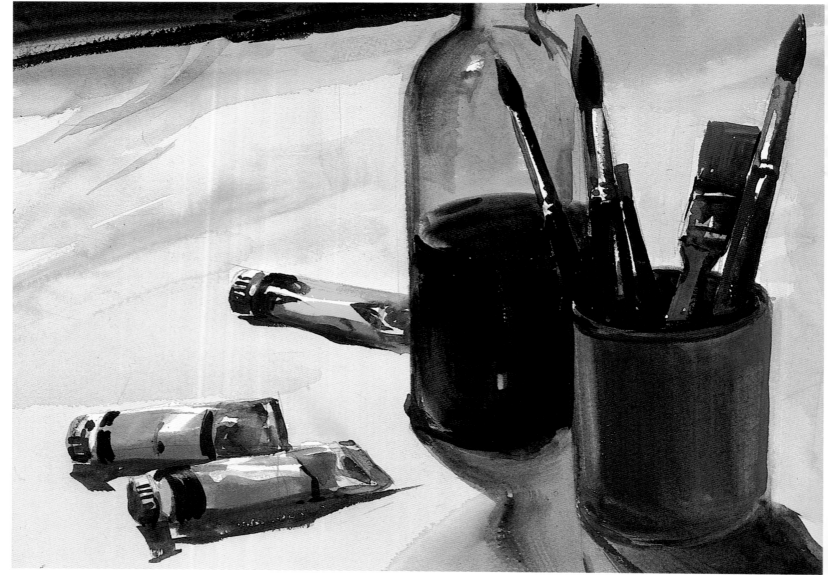

TOPIC 15

TONE VALUES (1)

Value is a concept strongly linked to drawing. In reality, it originates from the techniques which allow volume to be perceived through tone gradations in drawing.

When this concept is applied in painting grays of every color are obtained. All the colors can be tone gradated. With other media this can be a straightforward process but in watercolor it is complicated because there is no white paint and it is a medium characterized by its transparency. In this chapter we are going to tone values in watercolor and explore the value of white when working with grays.

The fundamental concept

Value refers to the degree of lightness or darkness of an object. Values are tone gradations of a color which define the amount of light received on one spot in relation to another. The value does not depend on one tone but on all of them. It is a fundamental concept to do the modeling of forms or chiaroscuro. In watercolor painting it is very important to master values so that you can situate the shadows and the transition towards light zones.

TONES AND WATER

Values and scales of gray

A very practical exercise is to do gradations of one color to study its value possibilities. A scale of grays is easy to do. Start from the most intense tone the color allows and add water to get more luminous tones. Use these tones to paint any theme with the values well ordered.

Color and value

Value is related to tone. This means an object can be valued with just one color by mastering its gradations from its maximum intensity to its maximum transparency. Value can be given to a color by using its own tones or by adding other colors to obtain different chromatic nuances. As some tones are darkened, using different colors enriches the original tone. For example, carmine can benefit from the introduction of other colors like violet and blue which darken and make cooler the original color.

The values must make clear which are the lightest tones.

On top of light tones the darker tones which increase the perception of luminosity have more value.

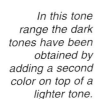

In this tone range the dark tones have been obtained by adding a second color on top of a lighter tone.

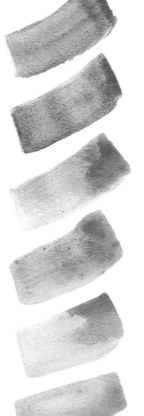

Comparison with modeling

The wash result must be constantly compared with the tone that corresponds to the model so that it is not saturated and dark tones do not go where light tones should be. The right value can be obtained by increasing the tone of the most luminous colors or by placing dark tones. In the first case place the most luminous tones, leaving room for the highlights. The tones are put down from light to dark, as has always been practiced. In the second case, the grays establish the comparison with the darkest tone. This process allows tones to be adjusted in a way more similar to drawing or charcoal values.

A range of grays starting from blue. This is the beginning of the tone values.

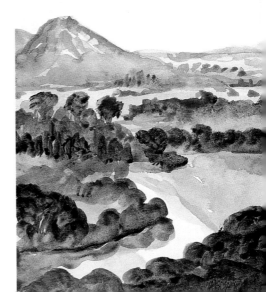

Valuation from the beginning to the end

Valuation must not be done all in one go. It is a process of evolution that lasts all the work. Once the basic drawing design has been done, when you start painting the first stains values are already coming into play. In this type of piece the tone values are dictated by the needs of the drawing. The values give a new stroke to each drawing zone and the tones establish the volumes.

From the moment the first stains are laid down the principal values must be established: highlights and shadow zones.

As the painting process advances the valuation increases. If the tones merge together the values model, or give volume, to the forms.

Taking advantage of the broken color on the palette

During a long watercolor session the palette gets dirty with the leftovers of mixes. This color is normally not defined as there are a variety of mixes. This tone, created by chance, can be taken advantage of to get grays or as a transparency for tones which are too light.

The values in this gradation start from the most luminous tone on top of which darker tones have been added. The darkest tone has been enriched with the brush cleaning water.

How to intensify a tone

When working with wash the tone values can be increased or gradated ,by adding color . As we saw in previous chapters, a luminous color (transparent) can be tone enriched while it is still wet or even once dry. In the first case just add a little dense color so that it immediately blends with the base color. In the second case, apply a layer as transparent as the first. These two layers combine to give a darker tone.

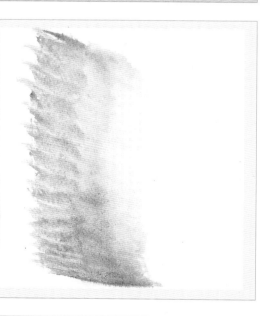

The tone becomes intense as the solution is made less watery.

How to key down a tone

On a recently painted surface the tone can be gradated by adding water or dragging out paint. A dry brush will absorb part of the color and make the area treated more transparent. A clean, wet brush can gradate a color. Using a wash can gradate a tone until you achieve the desired effect. However, a wash will only give lighter tones than the original.

The English school

The English school was pioneer in the use of watercolor. The technique of the English painters was fundamental in achieving that this medium was recognized in its own right and not just as a complement to drawing. It is worth studying the great masters like Bonington, Turner, Peter de Wint, John Varley, etc.

English watercolors are an obligatory reference point for all watercolorists. Note the feeling with which John Varley developed the values in this example called 'York', watercolor, 47.2 cm by 21.9 cm. The British Museum, London.

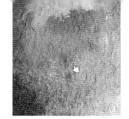

Light and value

The values of the objects in a painting depend on the light that falls on the tones. The light cast on the model can be studied in stages and catalogued according to its intensity. An exercise can consist of choosing a painting a studying where the most luminous tones are. They correspond to the points of maximum luminosity. Then look for the darkest points. The zones selected correspond to the shadow areas.

GRADATION AND VALUES

After observing this work by Peter de Wint it is possible to synthesize the principal tone values.

To speed up the drying

In some cases, above all when painting superimposed layers, it is recommended that the first layers have completely dried. The drying process can be speeded up by adding alcohol to the water in which the brushes are cleaned. Alcohol evaporates very quickly enabling you to paint much more quickly.

Value and contrast

Valuation is the gradation of grays on the surface of a picture. Contrast is the juxtaposition of two tones which intensifies their effect. The more subtle the valuation is, the less contrast there tends to be as the distance between one tone and the next is less with midtones or blendings. The most radical contrasts cancel out midtones. Work can be done with value in which there is a contrast between the background and the figure, but in very contrasted works the valuation diminishes because of the optical effect of the different tones. In value pieces you must avoid the use of radical contrasts.

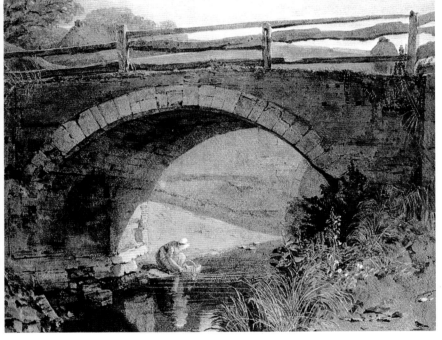

Peter de Wint, A Bridge Over A Tributary Of The Witham River in Lincolnshire, watercolor. Tate Gallery, London.

Value and depth

One of the most commonly used recourses by watercolorists is value to give different depth sensations in a picture. The procedure is to progressively gradate the tones of the planes as you go back in the picture.

In this rapid sketch the background has been painted with a very luminous wash. As the planes come to the foreground the tone contrasts have been intensified.

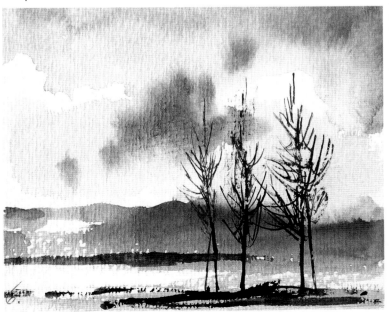

In strong contrast pieces the effect of value tends to disappear.

The tones in the background are much more luminous and transparent than the nearer ones. This is a tone scheme which shows how the tones evolve as they get deeper, and can be applied to any theme.

Simultaneous contrasts

Simultaneous contrasts are produced when two consecutive tones are placed next to each other to intensify them. A dark tone is perceived as much darker if it is placed next to a light one. And a light tone seems lighter if it is surrounded by darks.

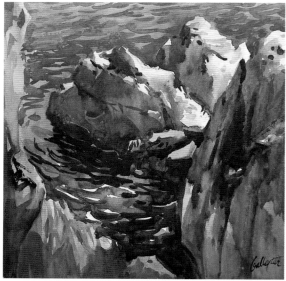

In this sketch you can appreciate how the simultaneous contrasts intensify the glow of the rocks and strengthen the adjacent shadows.

Pay close attention to these pairs of stains above and below. Which of these ochre tones is darker? They are identical but the light tone on the left increases the contrast compared to the ochre next to the strong blue tone.

Complement ary colors (red and green) intensify each other.

Chromatic contrast

Tone contrast is the result of putting a dark tone next to a light one. A chromatic contrast is established when the colors used are complementary. The effect of the tone values can be combined with the contrast between the complementary colors. This will produce a third color in harmony with the other two. For example, if red and green are combined, when they are used together they produce an off-red which allows a soft blending between the two colors.

A classic example

The way Claude Lorraine painted

In this exercise, as in the others throughout the book, we are not aiming at an exact copy of the original. We analyze the way the painter went about their work.

Lorraine was a great watercolorist who had a perfect mastery of tone values. As you can see in his work in got all that he could out of tone values to insinuate distance and depth.

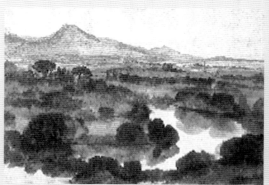

Claude Lorraine (1600-1682), Landscape with a river, *view of the Tiber as seen from Mount Mario, Rome. British Museum, London.*

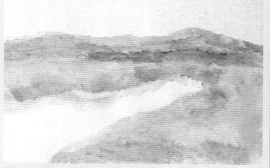

First he stained the picture with a luminous tone. Painting onto wet he added values that enables the different planes to be made out.

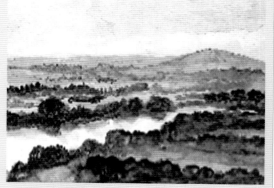

The intensity of the contrasts increases as the planes near the observer's view point.

Values and grays

To understand the concept of value correctly different intensities of gray can be established for each gradation level.

The value of an object

An object under an indirect light source casts many shadows. Each shadow tone corresponds to a different value.

Value and light

The values depend on the amount of light that falls on an object. If the light is direct very contrasted zones will be formed. The variety of the shadows will decrease, therefore, intensified contrasts will decrease the value effect.

Simultaneous contrasts

Simultaneous contrast is produced by two tones which are set off against each other. A tone is perceived as more luminous when it is surrounded by dark tones, and vice-versa.

EXERCISE

A horse: a value based approach

Necessary Materials

- TUBE COLORS
- 2B GRAPHITE PENCIL
- 250G MEDIUM GRAINED PAPER
- FLAT AND ROUND WATERCOLOR BRUSHES, PREFERABLY WITH SABLE HAIR
- STICKY TAPE.

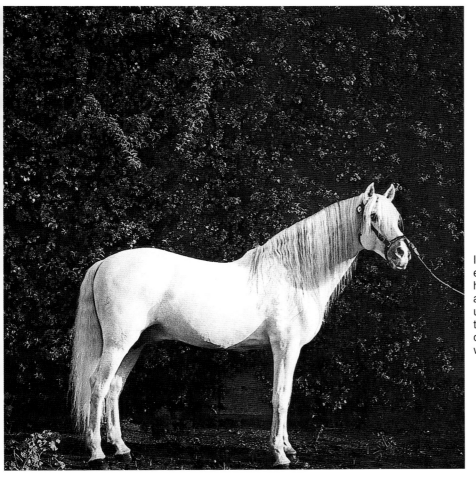

In this chapter we are going to do an interesting exercise in which we practice what we have dealt with up to now. The model will be a white horse: first we will address the values and then we will use simultaneous contrasts. As always, pay special attention to the drawing. The dark staining in the background will help to define the limits of the figure.

1 Start drawing the basic lines. Simple forms make it easier to study complex forms. Fitting the form in is an important question. Look at the space around the horse. Try to mark off a rectangular shape around it. Pay attention to the paper. Draw the head and neck with triangles, the body with in a trapezium, always keeping the proportions right. Once the basic forms have been resolved, draw the head, the haunches and the abdomen.

2 Work on the scheme you have drawn. The basic design process is finished when the lines are definitive. Until then you have to correct it as many times as is necessary. The small bump on the haunches between the back and the back legs has been corrected. Do the definitive outline of the head and place the eye, the mouth and the reigns. Pay special attention to the form of the legs. Start the upper part with a triangle which goes down to the knees, where they get a little wider before thinning towards the hooves.

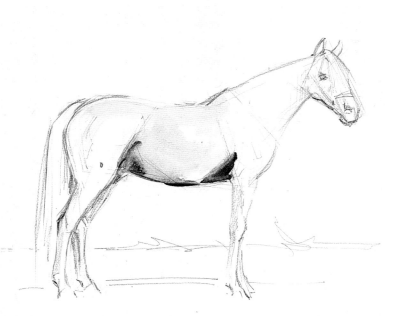

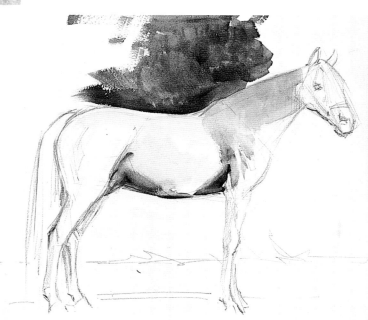

3 Once the drawing is complete, paint the first values on the paper. The highlights have to be reserved. The white of the paper will be surrounded by almost transparent stains: a wash so transparent that it is only a little different from the paper background. Use this wash to paint the softest grays inside the horse around the most luminous spots. Leave them reserved. After doing these values establish the most luminous points in the picture. Paint the darkest part of the shadow under the horse. The rest of the tones will be midtones between the first wash and this last tone.

4 Make a quite transparent wash, but less so than the first one. Once the first tone is dry, paint the upper part of the neck, the mane. This wash consists of sienna and blue, which dominates. Prepare a sienna tone with a dash of blue, and paint the tail area. Address the value of the hind legs for a second time. If you look at the picture you will see three stages in the process of putting in the values. The first stage are the points of light surrounded by soft grays. The second stage is the almost transparent gray. The third stage are the gray midtones of the haunches and the neck. The dark tone on the stomach enable you to compare the different values. Start to paint the background and establish the first complicated contrast. As the background is darker than the horse, the latter will take on greater luminosity.

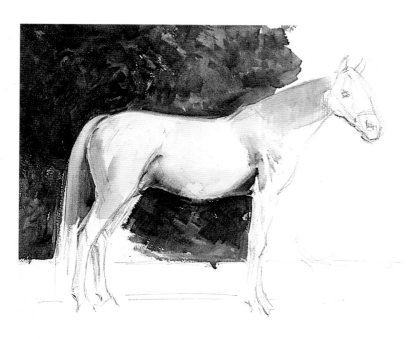

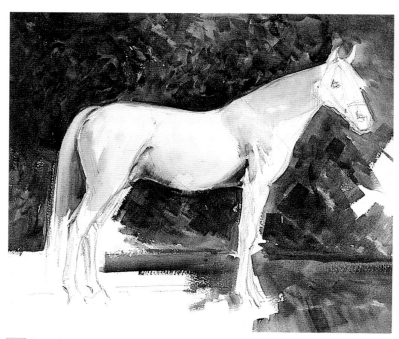

5 Paint the left side of the background with alternative strokes of sienna, umber and some blue dashes. You can use watercolor from pans or tubes. However, to obtain variety in the dark tones, either opaque and transparent, the tube form is best. It has to be good quality. Paint with short brushstrokes, changing the direction and the pressure.

6 Lay down denser and darker tones in the upper left corner than in the center. The upper right zone is painted with a homogeneous texture, always maintaining the horse's outline. Paint part of the floor in sienna. Towards the background change its value by adding a bit of burnt umber.
Compare this step with the last one. Haven't the inside tones of the horse been enriched?

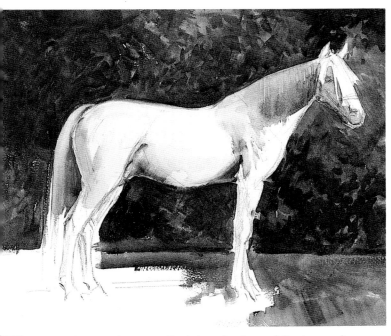

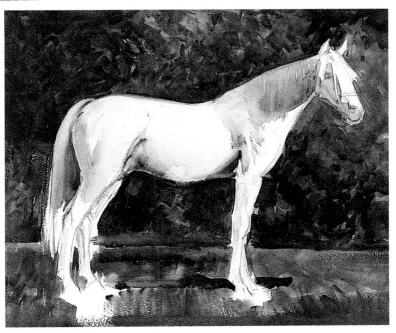

7 We now have to focus on the internal values of the horse. As the background has been painted in dark tones, the initial values are now too luminous and the strong contrast between background and figure partly cancels out the gradation of the grays. Paint the horse's face in very luminous burnt umber. Leave a reserve on the nose and in its hair. Darken the mane with a very transparent blue. This will provoke new tones that will give new values to the original tones, which are now midtones compared to the darkness of the background. Paint the rest of the lower background with short, dark, opaque strokes. The previous colors read through the new strokes.

8 Use burnt umber to paint the shadow of the horse on the floor. Complete the background all around the horse. You can perceive the contrast between the two zones that make up the background. The ivy covered wall is dark and thick. The floor is much more luminous. Less color interventions have been made: only sienna nuanced with some dashes of burnt umber and a little blue. The strokes on the floor where it joins the wall are long and horizontal. However, the brushstrokes in the foreground are short and vertical.

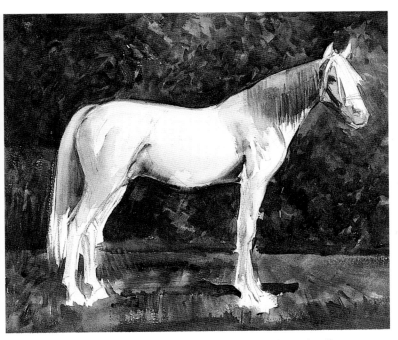

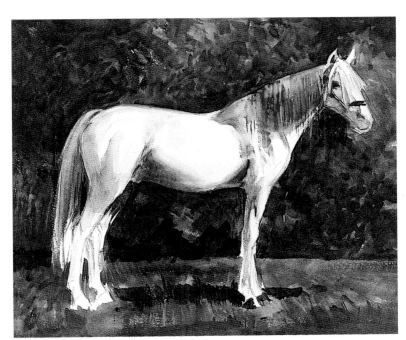

9 Continue working by modifying the values on the animal's legs. The direction of the stroke is important, as are the white spaces left open on each side of the strokes. There are pure white spots on the knees that stand out against the background. Use a sienna with blue, grayish color to cover the mane area completely with fine strokes, giving it texture. Paint the eye with two dark, small lines around its eyes.

10 Continue the valuation process on the legs. Without waiting for the last color to dry add a darker tone in the most shadowy areas. Key down the tone of the illuminated part with a clean, wet brush. Darken the stomach of the horse with a bluish brown tone. This same tone, further diluted, can be used to strengthen the darks on the rear legs. This new value effect makes the volume of the animal stand out more. Paint new, bluer, strokes on the mane. Use a dense, dark blue to paint the entire lower zone and go over the shadow on the floor.

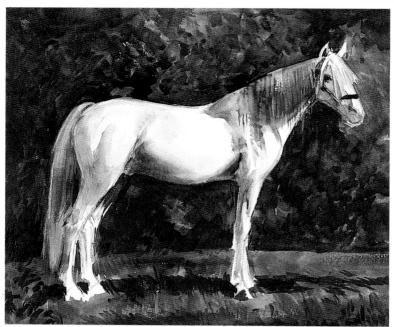

11 Complete the hind legs of the horse respecting the highlights and increasing the tone where greater darkness is necessary. The same gray tone can be used to paint the tail. Drag the brush to take away part of the color. Focus your attention now on the background and the floor. Dark brown tones mixed with blue are used to intensify the depth. If you do dense dashes, insisting with the brush the new colors will mix with the last ones. Dark mixes of blue and sienna will complete the shadow on the floor and the blades of grass.

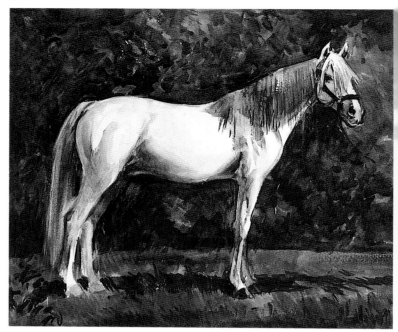

12 Increase the contrast of some shadows on the horse so that the highlights are intensified. This will increase the tone of the shadow behind the horse. Use a dry brush to drag part of the tone away from the shadow on the right leg. The shadow is going to define the leg. The small details like the ears, the nose and the dark mane are realized in burnt umber. Open up highlights to separate the stomach from the background by passing the clean, wet brush over.

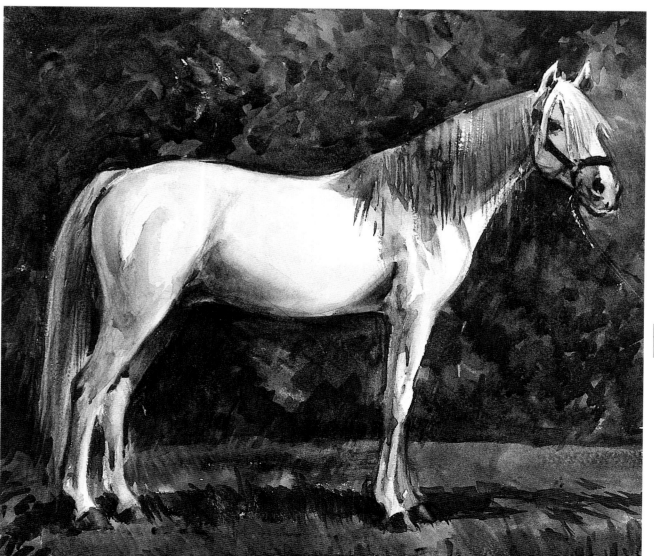

13

All that remains to be done is finish the hind legs. The shadow defines the hooves and offer a contrast with the most luminous parts. Use a clean, wet brush to finish the floor texture.

TOPIC

TONE VALUES (2) MODELING

Modeling a color is closely related to value. In many aspects value and modeling are the same, but not in all. Modeling takes advantage of tone values to fulfil its specific function in painting. Depict the object in such a way that it appears three-dimensional.

Tones have different values which can be blend into each other without there being a limit between them. Modeling creates a three dimensional effect due to the way the light falls on the forms, like sculpture. Modeling gives relief on the objects.

Light, modeling and volume

When an object is lit, either naturally or artificially, many light effects are created around it. Shadows give the model volume: if there were no shadows it would appear flat on the viewers. Therefore, the light around an object effects its visual texture.

VOLUME AND TONE

Modeling and merging values

In the last chapter we studied tone values. To understand modeling, go closely over the details of working with values and grays, or shading. Modeling is one way of understanding the different values of the shading (grays) and the blending together of tones. This was not necessary in the exercises of the last chapter in which values were addressed by superimposing gray tones. In modeling grays are approached according on the techniques of valuation. However, all dividing lines between tones disappear to give a volume effect.

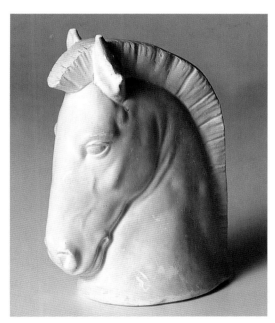

The lighting of this model can either bestow volume on it or make it completely flat. This would be good lighting for correct modeling.

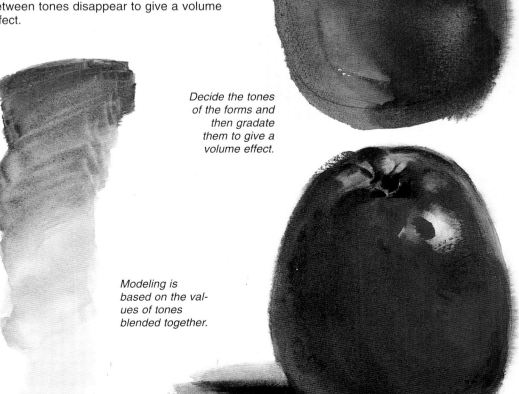

Decide the tones of the forms and then gradate them to give a volume effect.

Modeling is based on the values of tones blended together.

Shading or grays

It is a sound idea, especially to learn about value, to do exercises based on black and white photos. Grays allow you to appreciate the volume of the object and aid your synthetic vision. Drawing in pencil is another useful exercise which can be practiced if you start from a monochrome basic design.

Direct and reflected artificial light.

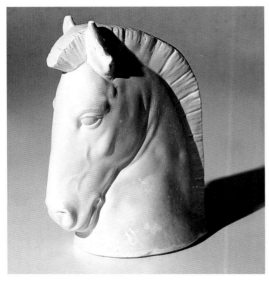

Skimming side-lighting will intensify the contrasts.

The lighting of the model is very important. It can only be manipulated when working in the studio; a landscape depends totally on the natural light.

You can work with a model lit artificially or nat1ly. Nat1 light allows soft contrasts but dictates the hours you can work. Arti1 light offers many possible manipulations and effects. You do not need a powerful spotlight. A lamp with a 100w bulb is sufficient. Sometimes a yellowish light can give a good ambience. The model can receive the light directly so as to increase the contrast in the darkest zones, reduce the midtones and give the modeling effects. If you want to obtain many tones do not shine the light directly at the model. Place a white cardboard reflector next on the object and point the light at this. The reflected light produces many soft, blended shadows.

Modeling and color

Modeling does not mean that a wide palette cannot be used. All the colors can be blended together: two colors can produce a third color with a midtone of a secondary color. If blue and yellow are mixed together they will merge to give green, which in turn will blend with the different tones of the original colors.

When modeling any object the tones will blend to give the illusion of a third dimension.

Look at this yellow vase and the way its shadow evolves. Burnt umber has been used: the color goes from its maximum tone (in the center) to its lightest tone (on the left).

Gradating one color on top of another produces a third color that evolves as a midtone. In this example green provides the link.

An example of the blending of three colors. The midtones are formed by the mixing on the paper.

Shadow synthesis

For a beginner it can be difficult to do a schematic representation of the shadows of an object. One trick is to look at the model with the eyes half-closed or with your eyes lost in the distance. The stain that appear represent the synthesis of the light zones in the model.

The importance of the shadows

Shadows have a visual weight which it is necessary to bear in mind from the beginning. A picture with a lot of shadow on the right while the left remains under bright light is out of balance. Shadow are tone masses which are distinct to the luminous zones. In the modeling exercises there can be a soft transition from light zones to areas in half-light. The dark zones always form a color mass denser than the light tones, but always the two zones must be balanced as the dark zones outline the luminous ones. The zones in which there is no transition from one tone to another produce a strong visual impact that in some cases must be keyed down by a midtone.

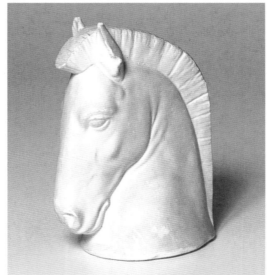

The same model as before but with diffused lighting. The shadows are softer and offer a wide variety of tones.

Excessive modeling

The blending of tones and the light models a figure. Bear in mind the elements of a picture that are to be modeled and those which must be given only a value treatment. Using just one palette recourse on the paper is very boring. If, however, you combine value and modeling different, enriching effects can be obtained, like luminosity and the definition of a form according to distance.

There is modeling in the valuation of these clouds. Look for the exact level of freshness in the tone blending.

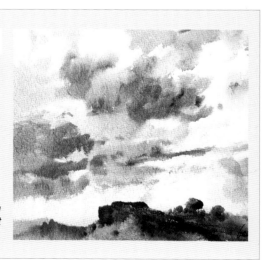

Starting the modeling

Watercolor allows work to be done onto dry or onto wet. The results are different. The light modeling can use either system and, of course, the finishes and challenges will be distinct.

Modeling on dry

Although dry watercolor is often talked about, this term can be misleading for all watercolor needs at least a little water so as to drag the color. However, the background can be dry or almost dry and this will decide to what extent the stroke blends with the color already laid down: On top of a completely dry surface blendings can be done that model the volume. Apply the dark color that is going to value the shadows. The brush must not be too soaked in the new color. Keep going over the clean color until it is blended with the layer underneath. Be careful that you do not open up white spaces accidentally.

MODELING ONTO DRY AND ONTO WET

Modeling onto wet

To do modeling on a wet background it is fundamental that it is not soaked. After passing the brush take away any excess humidity. By giving different values to the lights the volume effects will be obtained. Once again, the highlights must always be respected. It is always better to start the tone or color blending beginning with the most luminous. Value the other tones on top of the latter. Never penetrate with a dark tone into the lightest tones. Before it all dries out, drag the humidity from the most luminous tone to a midtone zone. Stroke with the brush until they are blended. Mixing both tones will produce an intermediate tone.

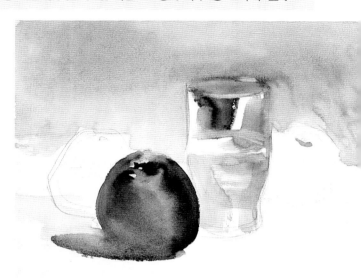

When the color is wet it allows tones to be rapidly dragged and highlights to be opened up.

Color order

Colors vary in luminosity. In the modeling process the order in which the colors are applied is fundamental. First lay down the most luminous colors and then the more opaque ones. Bear in mind that any light tone painted over a dark one will merely nuance its tone. The same thing happens with color. If ochre is painted on top of a burnt umber tone, there will be a slight tone intensification but apart from this ochre will not be detectable.

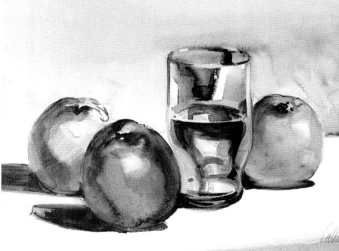

Here the modeling was done onto wet. When the background was dry the maximum contrasts have been added.

Long sessions

During long sessions the drying of the watercolor can often provoke a line between two zones. A large stain tends to dry in one point before it is completed. if you want to slow the drying down add a few drops of glycerin in the brush cleaning water.

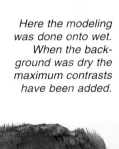

Blue has been blended on top of the dry background. The brush must not be too loaded as it is repeatedly passed over to effect the blending.

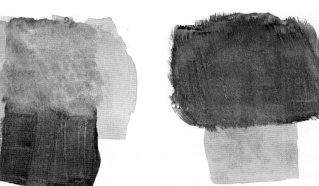

A dark color can always give value to a more luminous one. However, a light color will only lightly effect the tone of a dark color.

The water does the work

As you are working in watercolor, let the water do the work. Modeling onto wet greatly aids blending and the fluid paint is easy to handle.

On a lightly wet stain it is possible to delicately blend the color without leaving any brush trace at all. Wet the zone which you want to model, do a color stroke in the zone that you want to be darkest and then keep on doing this until it is blended into the moist background. The direction of the blending depends on the stroke.

Firstly a very transparent wash was applied. On both sides blue stains have been painted and then repeated brushstrokes merged the color with the background wash.

Modeling and gradation into wet

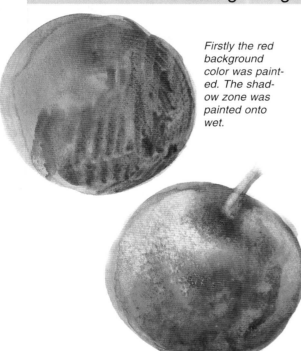

Firstly the red background color was painted. The shadow zone was painted onto wet.

When doing modeling work gradations can be useful to give volume effects. This is very common when working into wet as the paint more easily absorbs part of the color. The tones and hues blend with the still moist background. Firstly, do the general form with the base color, and then start to work on the darkest zone. The color will tend to merge because of the moistness. Before it dries out, clean the brush, dry it with a cloth and absorb part of the excess color in the lightest zones. As you are working on a wet surface the dry brush will drag part of the color towards the zone where a highlight is being opened up.

The humidity means that the color will gradate and blend.

Blend the shadow color with the *background color. Open up a highlight with a clean, wet brush.*

Modeling and value blending

Modeling is produced by blending two different values. To model the volume of an object, first you must value it and then you must blend the tones without there being differences in the gradation.

The weight of the shadows

The shadows have an optical weight that must be borne in mind when doing the modeling. A picture can be ruined by the shadows and highlights being out of balance.

Modeling onto wet

When modeling onto wet the first tones, always the luminous ones, surround darker ones that blend into the background humidity, prompted by the repeated brushstrokes. Highlights can always be opened up with a clean, wet brush.

Modeling onto dry

Modeling onto dry blends the darkest tones on top of the already dry base. The brush must be passed over repeatedly.

The way Marià Fortuny painted

Fortuny, like the majority of artists, went through different technical and creative stages. In this work he obtained the desired effect with very soft modeling. He hardly addressed the values, but the few he uses are very precise. If you observe the figure of the child you can appreciate two principal tones. The shadow has barely any tonal difference, but in the light zone the highlights give the body the required volume.

Idilio (1868) 22cm by 31 cm. Prado Museum, Madrid, Spain.

Firstly lay down the lightest tone and on top of it open up the luminous highlights.

Paint the shadow, blending the tone along the edge. The blending must be minimal.

Modeling grays in a still life

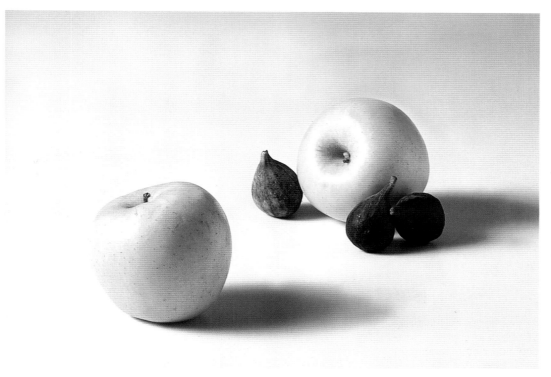

Necessary Materials

- SIENNA IN A TUBE
- 2B PENCIL
- 250G MEDIUM GRAINED PAPER
- FLAT AND ROUND WATERCOLOR BRUSHES, PREFERABLY SABLE HAIR
- STICKY TAPE

We are going to do two exercises with an almost identical model. The objective is to model the forms in monochrome and with color. Start by doing the basic design of the monochrome modeling. We are going to do the one-color wash technique. Pay attention to the shadows because the most luminous tones will be integrated into them. Throughout the exercise we will constantly be adding and taking away color. Be careful with the lighting; avoid excessively hard shadows.

1 Care must always be taken with the drawing: it must be a solid base to give a good final result. In this piece we are going to focus on the modeling which makes it even more necessary that the basic design makes clear from the beginning the spaces where the fruits will be placed. Draw the outline precisely, and afterwards with a much more subtle line the inside of the fruit where the value work will be done.

2 Do a luminous wash on the apple in the background, outlining the fig forms. Use a clean brush to immediately open up a pure white space that will be the principal highlight. This part of the work will be done on the wet background: the tones will blend easily. On the still wet apple, do a few dashes of a darker paint. The moistness will make it easy to spread the dark color in a gradation towards the right. Note how the apple shadow contrasts with the figs. Use a dark color to paint the shadow zone on the fig on the left.

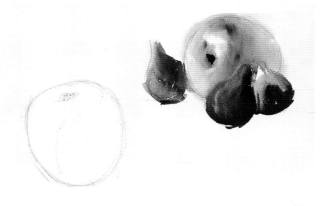

3 Let's work on the figs now. Complete the one on the left before the color dries out. Use a clean, wet brush to drag part of the color from the shadow zone to the illuminated zone. Paint the other two figs in the same way. Firstly, use the dark color to painted the shadowy zone. Then use the clean, wet brush to drag part of the tone to the light zone. The highlights of the figs are done by passing the brush over repeatedly, taking away part of the color. If we see that the color floods the zone that has just been opened up, go over it again with the brush. Be careful, we are not aiming at a perfect white. On the fig on the right we have left the dark stain to dry somewhat more, but not completely. When the lighter color was applied only part of the dark tone has blended.

5

Wet the brush in clean water and drag part of the dark tone of the apple until its form is completed. Observe the way the stroke spreads the tone. Always follow the spherical form of the fruit. If it turns out too dark, continue passing the brush after washing and draining it. The color must not be too diluted. While working on the dark shadow of the apple the left side has completely dried. Go over the latter with a homogeneous wash and continue working on the blending of the dark shadow tone. Paint the first apple shadow stain on the table.

4 Now, on the dry paint, do the darkest tones that define the most intense shadows of the figs. Use a midtone to paint the shadows cast by the fruits in the background. Paint the apple in the foreground. Greater detail will be added as it nearer to the viewer. Paint a dark tone that will enable you to do value effects on the light tones. Make the shadow spherical, but do not paint it completely, only the fragment which is shown.

Before the shadow cast by the apple is completely dry, do an eclipse shaped gradation. In this shadow mould the tones starting from the bottom of the apple. Darken the nearest part, while the parts further away are diffused over the background. The darkness on the apple is too intense. Go over it with a wet brush to model its form and to take away some tone. Lengthen the upper shadow of the apple and go over its outline, the drawing. Wet the brush and softly intensify the tone on the left. Lay in a very luminous, homogeneous wash over the background to unify it with the fruits. **6**

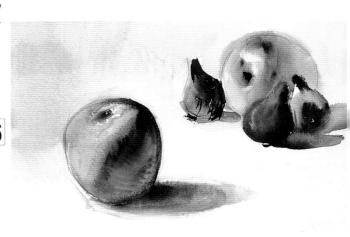

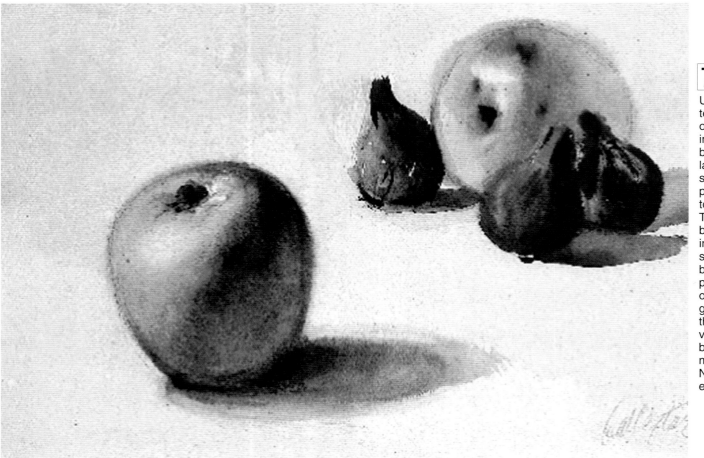

7

Use the clean, wet brush to complete the blending of the tones on the apple in the foreground. The blending technique is largely based on stroking, caressing, the paper until the different tones have been merged. Take advantage of the blending to slightly increase the contrast in some zones. Use dark brushstrokes to finish painting the shadow zone on the figs in the background. This will finish off this exercise in which value and modeling have been practiced on a monochrome still life. Next we will do a similar exercise in color.

EXERCISE

Modeling the color in a still life

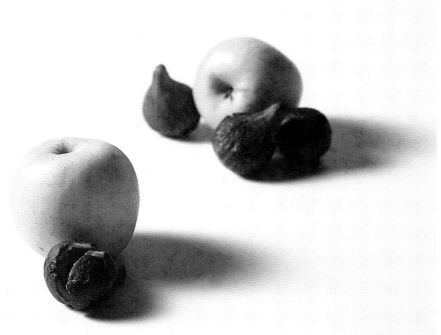

Necessary Materials

- TUBE COLORS
- 2B GRAPHITE PENCIL
- 250G MEDIUM GRAINED PAPER
- FLAT AND ROUND WATERCOLOR BRUSHES, PREFERABLY SABLE HAIR
- STICKY TAPE

This exercise has many things in common with the last one, but some aspects have been changed to avoid boredom. The elements are same so that the difference between modeling in monochrome and in color is observed. The treatment given to tone blending is similar to in the wash exercise, only that this time we will try to get tones from chromatic effects.

1 Do the basic design concisely, only placing the external lines and correcting the proportions between the fruits. Draw in fine lines the shadows cast on to the table and the shadow of the apple. Observe the position of the different planes between the fruits. The first plane is drawn below the second, insinuating an inclined perspective.

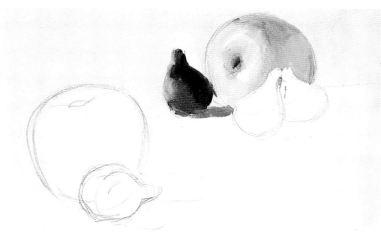

2 Start the color on the apple. Paint all its surface luminous yellow, but leave blank the highlights. in the palette add a little green to the yellow and darken the shadow zone, blending it into the yellow in the background. Use a dash of sienna in the darkest part. Wash the brush and take away part of the color from the shadow on the right. Compare this step with the same one in the last exercise and note how the monochrome tones correspond to the shadow gradations in the second exercise. Paint the shadow of the fig in very dark carmine violet and gradate the color towards the illuminated zone.

Paint the figs in violet tones. Use more blue on the fig on the left. First paint the lightest tone and on top of it the dark shadow tones. Here the color mixing is done directly on the wet paper. Water the violet mix down until you have a quite transparent tone and then paint the shadow cast by the fruits in the background. Start the shadow of the apple in the foreground in a greenish yellow color. Just as in the last exercise the brushstrokes were spherical, here too they must be. Observe the stroke direction. **3**

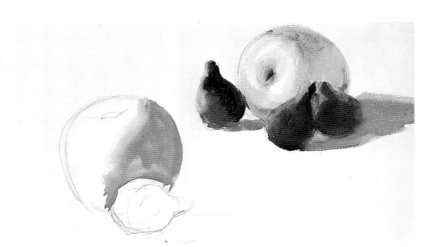

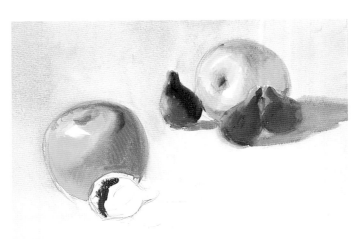

5

Paint the fig in the foreground with very luminous ultramarine blue, but leave some highlights so that the background shines through. Use the same color to do the shadow cast by the fruits in the foreground. The furthest tip of the shadow will blend with the background. On top of the luminous layer of the fig paint a darker stain, leaving some light spaces open next to where the apple stem begins.

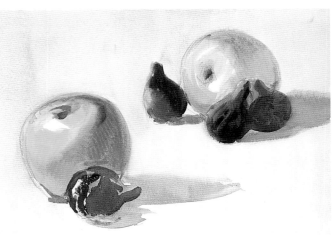

4 Use very clean golden yellow to paint the luminous zone of the apple. Leave a blank space for the most luminous highlight. Add a stroke of burnt umber to the upper part of the apple shadow and merge the three tones by modeling with the brush. Be careful not to stain the yellow zone. Use dark carmine strokes, hardly diluted, to paint the opening on the ripe fig. Use the brush cleaning water to lay in a soft transparency over all the background.

6

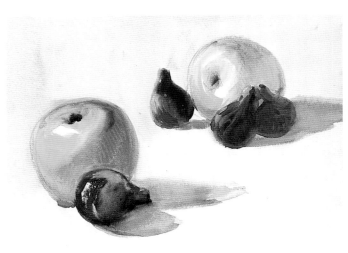

Paint the fig at the same time as working on the molding with the brush. Absorb the color in the most luminous zone. The dark tones are obtained with dark carmine and cobalt blue. In the lightest zones take away part of the color by insisting with the brush. On the upper part of the fig open up a highlight by passing the clean, wet brush over several times. Before it dries out, quickly paint an orange tone and let it blend with the violet.

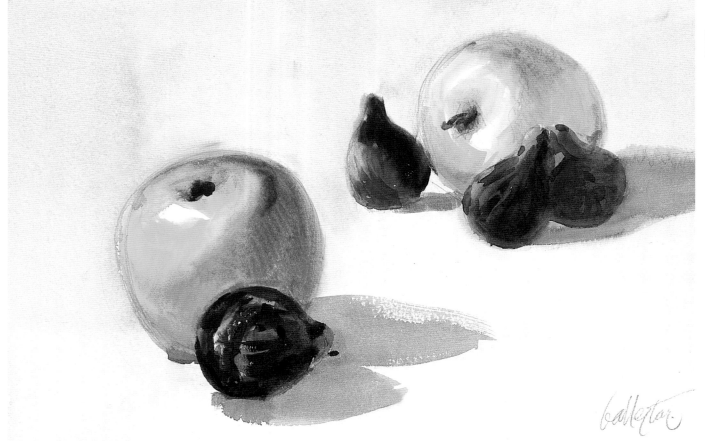

7

Once the excess humidity has dried, add some strong contrasts to the recently painted fig. In this way you will finish the modeling of its volume. Use the almost dry brush to define the shadow on the table. Allow the stroke to break due to a lack of color. This will complete this value and modeling piece. It is rewarding to compare the results with those of the last exercise. You will notice that modeling monochrome tones has much in common with modeling color tones.

TOPIC 17

CHROMATIC RANGES

Organizing the colors

The color of an object depends on the light it receives. A sea can appear to be red if the sky turns crimson. Or a person can have blue skin if they are in a cold atmosphere.

There are several ways of working with color appearance. Depending on its tone and intensity color can be divided into chromatic ranges. There are two pure ranges: the warm range and the cold range. The way they are used can completely change the picture

Choosing one range or another is a question of taste for the artist. Some prefer the warm range for doing intimate scenes or to intensify the drama of a landscape. Others prefer the cold range to reflect greater distance from the model.

Color is produced by the light reflecting off object. A beam of white light passing through a drop of water is broken down into the colors of the rainbow. White light is divided into the primary colors so mixing all the colors back gives white. When painting, mixing the primary colors does not give white blocks pigments have been used. A pigment is different to light and this means that chromatic ranges can be obtained from mixing. Chromatic ranges are described as harmonic because they establish a tonal equilibrium between the colors used.

HARMONY BETWEEN COLORS

Applying color

The first consideration when doing any type of pictorial representation is the relationship between the light and dark tones. Once this is clear, color can be introduced. A picture can be monochrome or tones can be replaced by colors, which in turn can generate tones so generating different luminosity in the picture. Watercolor allows many possibilities of tonal gradations. If you add to this the luminosity of its wide palette the result is one of the most colorist mediums that exists.

The warm range

Basically the colors of the warm range are magenta (red) and yellow, but if you add in earth tones you can obtain a range with a wide chromatic spectrum. Then the warm range would include these colors: yellow, orange, red, carmine, and the so-called earth colors (ochre and burnt umber).

There are many other colors that belong to the warm range. These can be nuanced by colors from other chromatic ranges.

The cold range

The basic colors of the cold range are yellow and blue, but by mixing them you can obtain an extensive range which includes green. All colors can be enriched by tones from other ranges. Of course, this does not mean they do not belong to the cold or warm range any more.

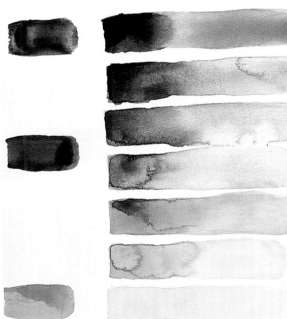

A mix of colors in which only warm colors have been used.

A mix of cold colors.

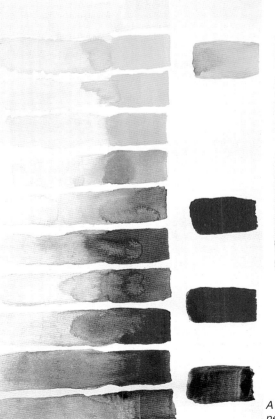

A cold chromatic range next to the colors that have generated it..

A warm chromatic range next to the colors which have generated it.

Value and color contrasts

Value contrasts can be established with one color. The darkest tone of a color can be contrasted as the tones are gradated towards more luminosity. Color contrast is obtained when two colors are set off against each other. The contrast is stronger if they are complementary colors, for example, green and red.

Color contrasts can also include value contrasts for either of the two opposing colors can be darker or lighter and this means it can have more or less presence in comparison to the other.

Combining ranges

Colors are not static within their range. Many colors from either range can only be obtained if colors from the two ranges are combined. A violet color can be obtained which tends either to the warm range or to the cold range. Violet comes from blue or from red. If you add more blue the violet will belong to the cold range. If red dominates the tone will be nearer the warm range. It is fundamental that the painter practices the different values possible from mixing colors.

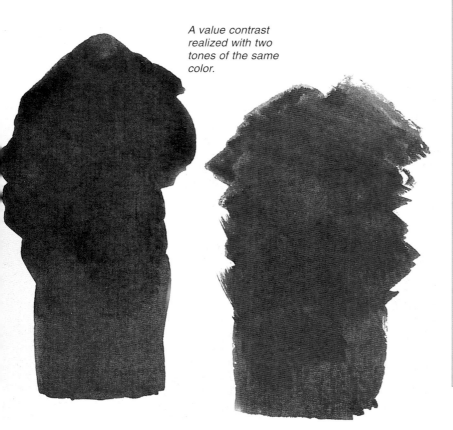

A value contrast realized with two tones of the same color.

A red can be darkened with carmine or with blue. The result will give very different results.

Here you can appreciate value work within the red color. It contrasts with the much darker green.

Color exercises

Mixes can be done on the palette but the result can only be correctly perceived if tested on the paper. You do not have to use high-grade papers. A plain notebook will suffice. When you are looking for a complex color test several tones in the book. Do small strokes of the ingredient colors so that you have good records.

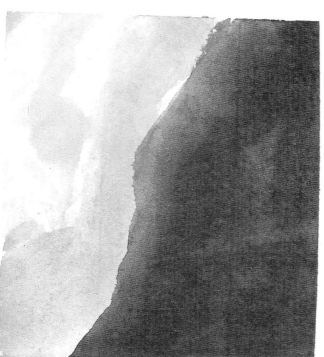

A color contrast realized by setting two complementary colors. In this case, green has been keyed down and red intensified.

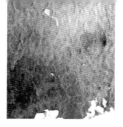

CHOOSING THE CHROMATIC RANGE

The water for the brushes

When you paint with watercolor during a long session you are constantly dipping the brush into the jar. Do not change this water unless you want to paint with very pure colors. Take advantage of it to dilute colors adding to them a tone which aids to unify the cromatism of the palette. It can also be used to create transparencies that harmonize the colors.

This is one of the possible broken tones obtainable from the dirty brush water.

Theme and color

There is no exact color to paint the skin, nor the top of a tree. Instinctively an object is associated with a determined color, without stopping to think that this visual perception is created by the objects around it. Even more importantly, the light that falls on the object gives life on the color, and this light does not have to be white. A tree top can be green but sometimes, for example when backlit by the sunset, it will appear so. Rather blue and violet tones will be evident. Likewise, the skin can be yellow, bluish or orange if it is chromatically influenced by the light and the objects around it.

It is important that a painter does not copy the colors of the model. He or she must interpret them.

The broken range

The broken is composed of all the dirty, off, or broken colors. When a broken color is painted among clean and pure colors, the result is ugly. However, when a broken color is part of a picture which includes many off colors the result is one of the most beautifully harmonic balances possible.

In the media where there exists a color white, the colors are broken by mixing them with a secondary color, or a primary color and a bit of white to gray the tone. As watercolor does not have white, the degree of impurity in the final tone is determined by adding other colors.

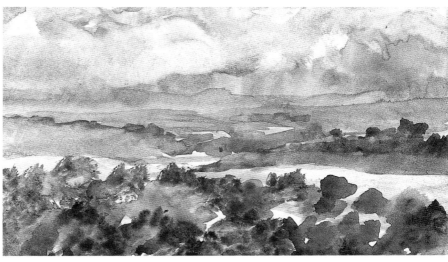

This picture has been realized with the colors along the side, and, of course, with the dirty brush cleaning water.

Which chromatic range must be chosen?

Sometimes you do not have to opt for one range or another. Many painters work indistinctly with one or the other. However, often, because of plastic criteria, they end up giving their work a warm, cold, or broken cromatism.

The range chosen will, in part, reflect the painter's mood and will certainly influence the beholder. Theme plays a key role in deciding the chromatic range chosen. For example, it is predictable that a cold range will be used to paint a rainy day. However, if the painter decided to use warm colors the scene would gain in dramatism.

The chromatic range selected forms part of the interpretation of the work and allows different aspects to be intensified, for example, the mood or atmosphere, or to increase the dramatism of the scene.

The psychology of the colors

Regardless of theme being painted, the colors effect the beholder's mood. The different chromatic ranges increase the psychological effect on them. Cold colors tranquilize while warm colors tend to excite or provoke.

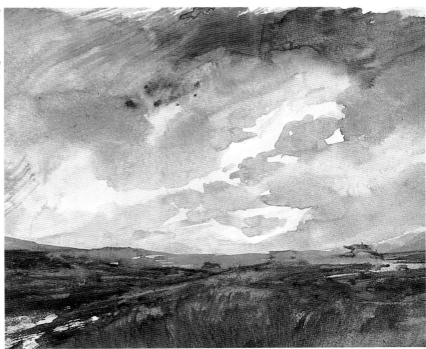

Contrast and distance

Tone and color contrasts of an object vary according on the distance from which they are observed. The further away the spectator is the less definition and contrast there is. Eventually there will come a point at which the object is a barely perceptible tone, or blot. In contrast, the objects close up to the viewer will be well defined and contrasted. This visual effect is constantly used by painters. The foregrounds are always painted more defined than the far away planes.

A chromatic scale in which the tones and colors have been interpreted according to the distance.

Intervention of one chromatic range on top of another

It is important that the watercolorist know where one range finishes and another begins. It is not imperative to limit the palette to the colors of the range to get a cold or warm result. Warm notes can be included into the cold range. They contrast that they provide will add balance. Likewise, cold tones can be included when painting a theme in warm tones.

The colors of one range can take on tones from the opposite range if small amounts of one of the other colors are added.

Two ways of expressing the same theme. In both examples colors from the other chromatic range have been mixed in.

Colors and chromatic ranges

The color of the different ranges can be nuanced with colors from the other range without losing their intensity.

Broken colors

White cannot be used in watercolor to obtain broken colors. Do the mix bearing in mind the white of the paper.

Contrasts

A light tone contrasts with a dark tone. This contrast is tonal. However, if you place a color next to its complement the contrast is chromatic.

Color and distance

From far off colors and tones are perceived less contrasted.

The way the Fauvists painted

Fauvism (1905) was a postimpressionist movement that comes from the French word fauve, meaning wild. They were a group of french artists who were influenced by Gauguin (1848-1903). They used vivid colors in immediate juxtaposition. The contours were usually in marked contrast to the color of the area defined. Tones disappeared completely and were replaced by other colors. Fauvist colors were not based on reality, although their work was representational.

Henri Matisse (1869-1954) did not belong to any group of painters. However, he did practice as many plastic experiments as he could. In this oil piece, which has a strong fauvist style, he uses complementary colors and allows some forms to be outlined.

Lemons and hydrangeas (1943), oil on canvas, 81 x 54 cm, Private collection, Lucerna.

Stain directly, drawing and painting at the same time.

The rest of the forms and colors are painted according to the initial approach.

EXERCISE

Using the cold range: a landscape

Necessary Materials

- TUBE COLORS
- CHARCOAL
- 250G MEDIUM GRAINED PAPER
- FLAT AND ROUND WATERCOLOR BRUSHES, PREFERABLY SABLE HAIRED
- STICKY TAPE

There is nothing better to practice cold range work than a river landscape with a host of green and blue tones. In this exercise we will study the cold harmonies, and we will see how warm colors can intervene, too, giving chromatic balance to the overall picture. The model chosen will allow us to practice different color ranges and to observe the optical effects of the model and its reflection.

1 Draw the principal volume of the model in charcoal. The river bank is above the half way line of the picture. The clump of trees is slightly to the left. It is important to place the objects correctly. Get the composition, color layout, and tonal and chromatic balance right. The four factors are linked together.

2 Place the background tones. This is a useful recourse in landscape painting, especially when the principal masses are against a uniform and ethereal background. Paint the background horizontally with a wash. Starting from the top blend in the following very diluted colors: cobalt blue, yellow, ultramarine blue and burnt umber cooled with green. Umber does not form part of the cold range but in the palette a bit of green has been mixed in to obtain an earthy olive tone.

Allow the background to dry so that the colors added do not blend. Observe the tonalities that the originally warm tones take on when they are mixed with green or blue tones. Do a horizontal stroke of ochre, light green and a bit of sienna. Do not do the mix on the palette. Instead wait the brush in every color and paint directly on the paper. The result will be a warm color with a cold tendency. Stain the central clump of trees with a very watery dark green. On top of this tone paint the darkest contrasts in the same green tone, but this time less watery and with luminous green in the middle.

3

Use the same warm color which was used to paint the shore to paint its reflection in the water. Darken the tone slightly with a little green, but do not change the color. Start to paint the reflection of the trees in the water using short horizontal strokes which define the inverted forms of the trees. Firstly paint with hooker's green (or dark green) and blue. As you work down the reflection use less dark tones.

4

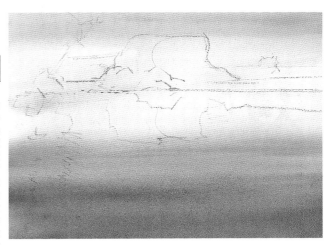

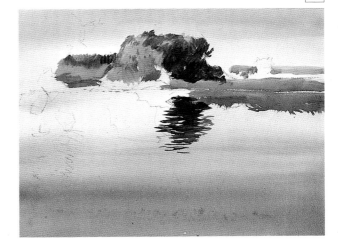

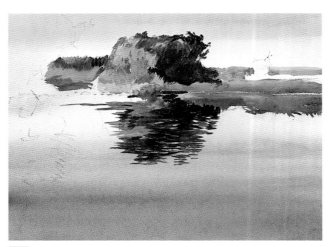

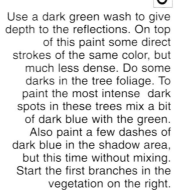

6

Use a dark green wash to give depth to the reflections. On top of this paint some direct strokes of the same color, but much less dense. Do some darks in the tree foliage. To paint the most intense dark spots in these trees mix a bit of dark blue with the green. Also paint a few dashes of dark blue in the shadow area, but this time without mixing. Start the first branches in the vegetation on the right.

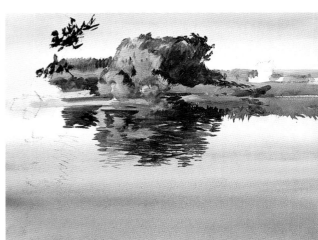

5 Continue working on the reflection zone. This time start the most luminous part in undarkened green so that a contrast is established in comparison with the darkest zone. Different contrasts are being developed according to the distinct planes. All the water area, where the reflections appear, is darker than the upper part.

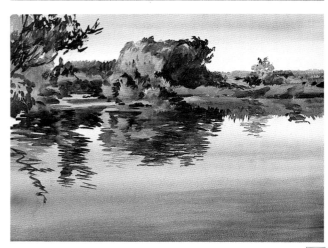

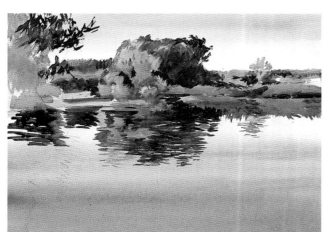

7

Now focus the work on the right of the picture. Firstly, stain the yellowish mix with ochre and some blue to cool it down. The stroke must be rapid and gestural. This yellow color will be the background for later stroke work. So no details need be put in. Continue working on the upper left corner painting the leaves dark over a light green.

8

Paint the structure of the branches and the leaves on the left of the picture. To paint this zone firstly draw the main branches with the brush and then do the little branches which are gradually converted into small stains that represent the leaves. At the bottom of this vegetation mass, paint in dark blue. Do the reflections in this zone as you did the highlights in the middle, but using a different green tone. Next to the riverbank use a much darker tone. The strokes to do this highlight zone are short and horizontal. Do some warm stains that will be a base on top of which to elaborate the reflections in the water. In some places the background reads through. On the right of the landscape add some luminous blue dashes.

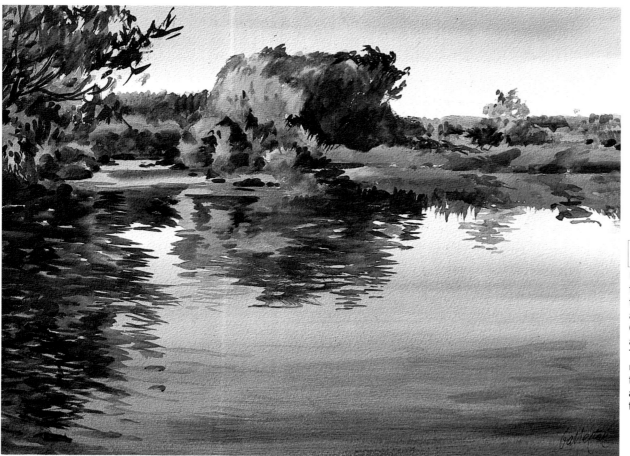

9

Use the brush washing water to darken and give shape to the lower part of the picture, always using long strokes. Complete the vegetation part and its reflection in the water. The mass of leaves in the upper part stands out against the yellow because of its detail and dark tone. This will give the picture equilibrium.

Using the warm range: a still life

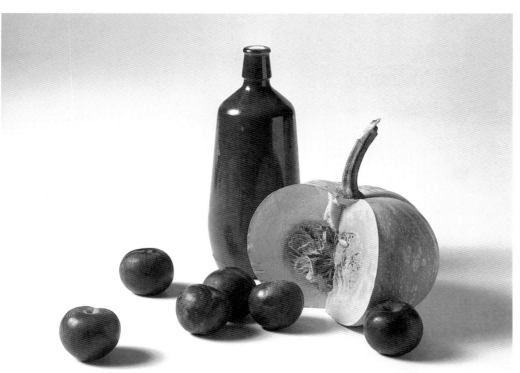

Necessary Materials

- TUBE COLORS
- 2B GRAPHITE PENCIL
- 250G MEDIUM GRAINED PAPER
- FLAT AND ROUND WATERCOLOR BRUSHES, PREFERABLY SABLE HAIR
- STICKY TAPE

If in the last exercise we practiced harmony among the cold colors of the landscape, in this exercise we are going to apply the warm range to a still life. The still life used an a model has a great variety of warm colors. However, some elements, like the pumpkin or some fruits, have cold tones. It does not matter that cold tones are included for they will help to compensate for the excess of warm tones in the overall effect.

2

Firstly lay in a yellow wash using a flat brush which will facilitate the work and allow the stroke to be controlled. Do not paint all the background but instead leave some spaces reserved to put in the highlights. These will be in dark stain areas. Increase the density of the color as you go downwards. Start to paint the inside of the pumpkin, on the right in a quite pure orange tone. On the left make it darker with a little blue. The orange color has been done with red and golden yellow. The blue gives it an almost greenish tone.

4

The dark parts of the bottle are painted after adding burnt umber to the red of the palette. The previous layer shows through this new darker color as a highlight. Also a new reserve is left so that the red of the background can be seen. Where the pumpkin is cut, it is painted with long strokes loaded with red tones. The part in the center is painted with a very intense red and the dark part is tinged with burnt umber. The outside is painted in a clear green, the brushstrokes merging with the orange colors. The plums are painted: one carmine red and the other dark violet blue. To warm this cold color it has been mixed dark carmine and cobalt blue.

1 Start to draw the basic design of the picture. Do the forms without going into detail. Do not rub out the double lines. What is most important is that the proportions between the object are correct. As the background is brighter than the model, when we paint we will be able to go over the contours of the forms without the pencil lines being too obvious. Not only draw the forms of the objects but also of the shadow. Place each of the shadows so that there are no errors in the painting.

Despite the fact that this chapter is about the warm range, we are going to incorporate blue and green touches to cool and to darken the shadows. Add thes touches to the pumpkin skin. Start to paint the bottle dark red mixed with a little sienna. Reserve space for the highlights. This color applied to the bottle is going to be the base for other darker colors.

3

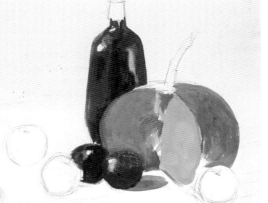

5 The remaining plums are depicted in a variety of warm tones, in red, carmine and yellow. The shadows are painted with a little burnt umber added to the mix, leaving the brightest points unpainted. The darker fruit is colored with warm tones: cobalt blue and dark carmine are added into the mix. Use supple strokes to paint the center of the pumpkin in reds and browns. The shadows of each one of the elements of the still life vary in tonality according to the color of the object that casts them: violet for the plums and slightly gray for the pumpkin. The brush cleaning water helps to obtain a harmonious tone for the color mixes.

6 Finish painting the plums, perfectly placing the colors to show the highlights and the shadows. Various blue nuances, or purplish tinges, when in contact with the warm colors, round off the tones of the fruit. The projected shadows are also painted: they vary in tone and warmth according to the colors that surround them. The nearest shadow to the pumpkin is darker than the others. The highlight of the bottle is contrasted with a mix of dark violet, but the brightest parts are left intact. The outside of the pumpkin is painted in a green mix with a dash of carmine, creating an olive tone that contrasts with the bright green and the lower orange area.

Define the background by going over it with a layer of burnt umber. This detail is not in the model but it improves the composition.

7 Note carefully the delicate variations in this step with respect to the last one. The definition of the volume of the two plums on the left is concluded. Although the contrast of the shadows of the plums are cold, the purplish tone produced from the carmine mix gives it a warm nuance.

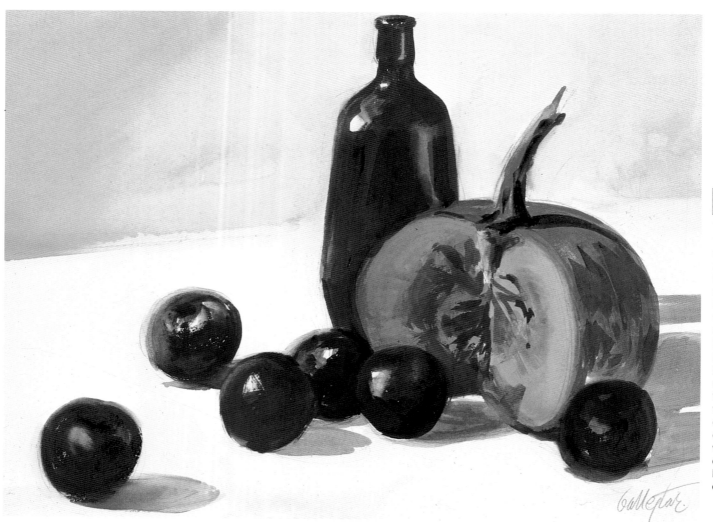

8 To finalize, warm tones that contrast with the different textures are used for the interior of the pumpkin. The chromatic ranges that have been used harmonize with the colors of the composition. Colors belonging to other ranges have not had to be excluded. This exercise has practiced the composition of warm colors but without excluding greens or blues, although when mixed with carmine or orange they have lost part of their original coldness.

TOPIC 18

SKETCHES

For the watercolorist the sketch is an extremely useful plastic recourse. It is vital for doing rapid work and can always be practiced during a journey or lazy moments when something interesting crops up. Synthesis and the ability to draw are basic however good the watercolorist may be at painting. The skill of the artist's hand is necessary to define the forms and the limits of the stains. The sketch must sum up all the essential characteristics of the model.

The line in sketches

Do not be afraid when you start to sketch. You will only be at ease when you have practiced for many hours. A sketch is more straightforward if the lines are thick, not thin. Remember that a good watercolor brush is very versatile so you can paint thick lines that will end up as fine strokes. Always practice looking at the model: a sole stroke can define a lot.

Giovanni Francesco Barbieri, el Guercino (1591-1666), landscape of a volcano, wash sketch. British Museum, London. Precise lines and staining are the principal recourses of sketching.

SYNTHESIS IN SKETCHING

Synthesizing with the drawing and staining

The model can be represented in many ways with watercolor sketching. The drawing-like line is combined with the plastic qualities of watercolor allowing immediate modeling. Earlier we saw that watercolor is much more directly related to drawing than other media. In a sketch drawing and painting work together and the dividing line between them is blurred. The brushstroke defines planes while the line draws outlines. No superfluous lines can be permitted. Sketching enables the artist to express the model rapidly and intuitively.

A tool for the watercolorist

A sketch allows the model to be represented without going into detail. It is not easy to do a well-done sketch. It requires a lot of practice and capacity to synthesize. Drawing is even more important in sketching because you cannot fall back on recourses like modeling or details. It is the line that represents the model cleanly.

Sketching can help to prepare for later work. A sketch done today can be used as the model for tomorrow's work.

A sketch gives the watercolor possibilities which enrich the model. Or it can provide useful reference points.

Close your eyes to see better

Often a model can be perceived as too complicated. This happens because you focus excessively on all the details and planes without taking in the overall effect. To see the model, half close your eyes and forget about the detail and the form definition. We will see an out of focus image with simplified forms. The representation will be much more straightforward.

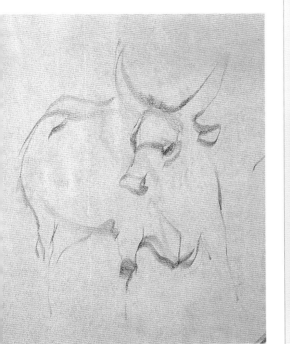

A sketch is the synthesis of the model. Stains and lines allow the forms to be rapidly synthesized.

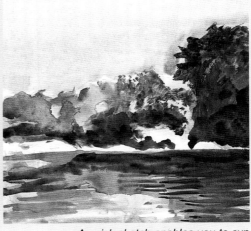

Look at this out of focus image. The unified volumes make it easier to study the overall effect. It is like an eyes-half closed effect.

A quick sketch enables you to synthesize any model, however complex it may be, in a few stains.

Staining and planes

A sketch only needs to be a rough outline, often provisional, that allows the painter to represent the model observed immediately. It must be executed speedily and accurately. Details are foregone with. The planes are done with concise, accurate strokes. They do not have to be as exact as the definitive watercolor.

Landscape sketches

Landscapes open up wide a wide horizon of possibilities when doing sketches. Nature can have vague outlines and this favors it being rapidly represented by lines and stains. Lay in tone stains to cover wide areas like the sky or great earth expanses or masses of vegetation. The darkest tones stand out against the background. Finally, any excess tone is removed with a wet, clean brush.

Quick sketches in the street

The street is a good place for doing quick sketches. You only have to sit on a bench with a note-book and a pocket palette. Anybody or anything can be sketched. A passerby can be sketched while waiting for the bus, reading or just idling away the time. If they are not moving, it is easier.

A pencil outline will help you to place the principal lines. Only put in the lines that really contribute to the overall effect. Get the proportions right.

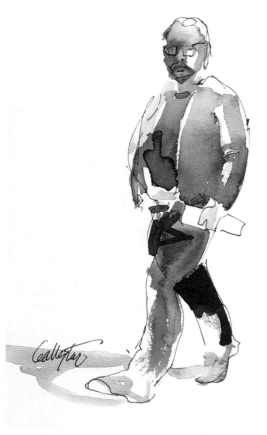

This figure has been realized with a few stains that synthesize all the planes. Afterwards the line has been gone over

Trying to represent a passer by with rapid brush-strokes is an exercise that tests the skill of the artist. After the sketch the staining separates the planes.

Reserving the high-lights is fundamental.

Still life sketches

A still life allows the model to be studied in depth. You have time to look at the model. You can also do quick sketches to study the effects of the light, colors set off against each other or composition questions.

Still life does not require so much attention as the figure because, for example, an error in the proportions does not have the same repercussions.

Observe the model, do rapid staining and synthesize the lines: This is the process for quick sketches. Landscape sketches.

TECHNIQUES FOR SKETCHING

A sketch in any place

Get into the habit of doing sketches anywhere. Watercolor can be worked with easily; it does not require the preparation of other media. A small palette box and a notebook fit into a pocket. There are even little cases that include a water deposit. An artist who is keen on doing sketches soon becomes skillful and will master drawing and watercolor recourses.

To resume is to synthesize

You must learn to see the model as a whole before representing it on the paper. The must complex forms can be represented by tones and stains, thus canceling out the complicated detail. The forms of the model will always be synthesized in the sketch. A sketch based on simple stains can express the model.

A few stains allow the complex forms to be synthesized, as is the case with these trees.

Watercolor comes from sketches

Before watercolor was considered as a painting medium equal in importance to oil, it was used to prepare for the definitive work. Artists like Leonardo, Rafael, and later, Rubens and Rembrandt, among others, used watercolor to draw or to do washes before completing the piece. In their time these works were not considered valueable but today they are held to be masterpieces full of spontaneity and vitality.

From wash to color

There is an order of synthesis for the sketch. It starts with representing the forms on the paper. Sometimes this need only be a stain. Then the color is synthesized and finally the tones. For example, take boats on the water. Firstly, the planes have to be laid out. Address the area that each stain is to occupy. Paint the principal form in luminous tones, and on top of this the stains that synthesize the different parts. Finally, add in the darkest tones that give contrast to the form. The tonal contrasts are realized with color. Painting on dry or on wet will determine the final finish of the sketch and the degree of blending in the different zones.

Compare these two sketches of the same model. The first has been done onto wet. The second includes detail strokes that has been realized on the dry background.

Details can lessen the final effect

When doing a sketch you can forget about details. The true secret of a good sketch lies in its simplicity. A sketch can represent the model with a few stains and lines. It is not easy but the artist who manages to develop a good technique will be better prepared to do definitive works.

A sketch should be easy to understand and explain. Here on top of a yellow wash the trees in the background have been stained. A gray tone has been used for the tops in the foreground. The branches have been painted onto dry, as has the foreground.

Plastic recourse in sketching

- A model must never be copied but rather interpreted with stains.

- The limits of the staining define the drawing of the model.

- Reduce the palette to the essential colors.

- One brush is sufficient for sketches.

- Take advantage of drawing techniques to enhance the staining effect.

- Any plastic recourse can make the sketch more effective: the brush head, nails, a felt-tip pen, etc.

- Use the dirty brush water.

- Look at the picture trying to capture it out of focus.

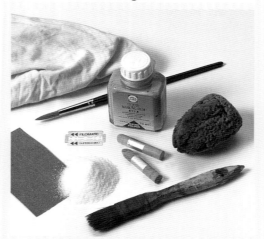

Some materials that can give plastic effects or generate textures and reserves in sketches.

The stroke models the form

In a sketch a great deal can be represented with a brushstroke. The pressure can vary so as to give thick lines or fine marks on the paper. If you are painting without a basic design drawing it is the stroke that defines the outline of the model. If necessary a thick stroke can do the contours.

A firm outline is simpler to do if there is a pencil line underneath. It gives security to the stroke. Other techniques can come into play too. When doing sketches the artist falls back more than ever on techniques like absorbing color with the drained out brush, scratching with the brush handle or intensifying the stain with lines.

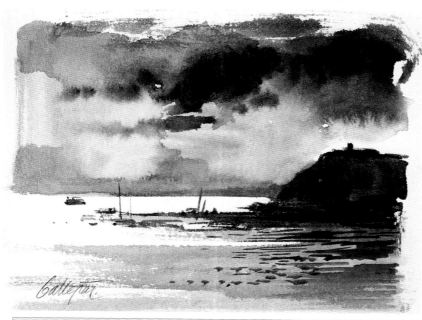

The strokes help to spread the stain and to mix and blend the tones, as has been done with this sky. Afterwards the same brush can be used to superimpose other stains and finer lines.

A classic example

The way Cézanne painted

Paul Cézanne, the great postimpressionist master and forerunner of Cubism, usually did not bother to draw when he painted, or rather he drew with the paint, and reinterpreted the model as he went along. The boldness of Cézanne when painting in great part stemmed from the great plastic capacity with which he did his sketches. In fact, even his most elaborated works still have the freshness of his most spontaneous sketches. This piece has been realized combining drawing strokes and color stains that make the highlights stand out.

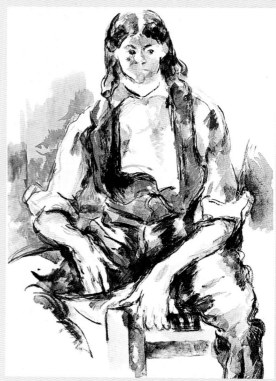

Cézanne (1839-1910), Young man with a red waistcoat (1902). Walter Filechenfeldt Collection, Zurich.

A good place for doing sketches

A zoo is ideal for watercolor sketches. The different animals present volume and drawing challenges. The watercolorist can try to capture the anatomy of a tiger, elephant or of a horse in a few strokes.

A tool for the watercolorist

A sketch allows the watercolorist to develop a rapid technique, pick up new skills and express the drawing through the painting.

Stains and planes

The forms must be represented with a few stains. The planes of the model are painted without going into details.

Details and the overall effect

Synthesizing the forms is fundamental to do a good sketch. The general forms absorb the details.

The brushstroke

The staining is done at the same time as the drawing. A stroke can fill a space and simultaneously do the contour, too.

Quick sketches

This exercise is very interesting for any watercolor enthusiast and the concepts developed must be used for other exercises. We are trying to show what must be put into practice daily by the painter if they want to do fresh and spontaneous works.

Four quick sketches have been put forward. Try to do them in one session. At the beginning it will be difficult, but with a bit of practice you will see that the sketches come more naturally.

Necessary Materials

- WET WATERCOLOR POCKET BOX
- 2B PENCIL
- 250G MEDIUM GRAINED PAPER
- WATERCOLOR NOTEBOOK, MEDIUM GRAINED
- ONE FLAT BRUSH AND ONE ROUND BRUSH.

Still life sketch

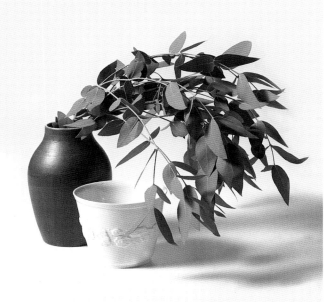

1

Anything around the house can be used as a quick sketch model, but there are advantages in choosing selectively. This series of quick sketches starts with a small still life. Despite the simplicity of the elements you have to make sure that you get the composition right. In this first exercise pay special attention to the highlights and the contrasts among the different objects.

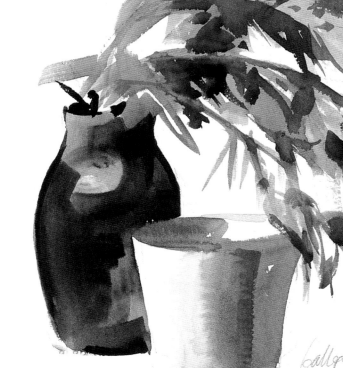

2

The basic design is made with a few strokes: precision is not necessary. Do not press too hard with the pencil, just enough to do a basic scheme of the principal lines. The sketching process is an immediate one. Firstly, paint the vase with a burnt umber luminous wash with a dash of blue. Use the flat brush and stain all the vase outlining its contours and marking out the form of the flowerpot. On top of the light tone paint with a darker one, circling around the highlight with the brush. Use a grayish green tone, obtained from the dirty water, to paint the shadow zone on the white flowerpot.

3

Finish the flowerpot by adding more of the same green used before. This stroke on top of the previous tone produces a dark cut. With the clean, wet brush merge the left-hand side of the shadow in a vertical zigzag. Using the same color with which the vase was painted, the form of its left-hand side is now profiled, pressing with enough pressure to perfectly control the stroke. The two colors that have been used so far can also be used to paint the stalks. Straight after paint **the leaves with a wide variety of superimposed tones. The darkest tones are put in once the lightest tones have dried.**

A sketch in the street

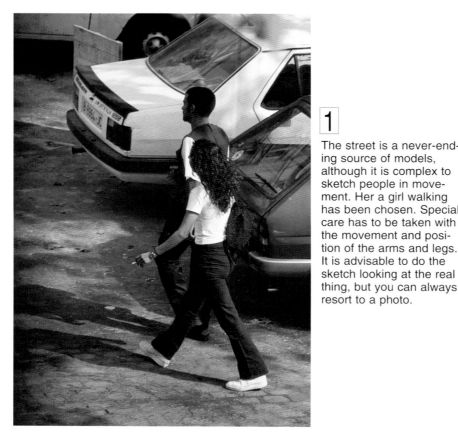

1

The street is a never-ending source of models, although it is complex to sketch people in movement. Her a girl walking has been chosen. Special care has to be taken with the movement and position of the arms and legs. It is advisable to do the sketch looking at the real thing, but you can always resort to a photo.

2

After observing the girl walking for a few moments, do a quick pencil outline of the principal lines. When the model is moving, the initial sketch is more important because it is certain that when the painting is started she will have disappeared from view. If you study this just started sketch, you will see that the main points of interest are the form of the head, the curve of the back, the knees and the base of the feet.
Use an orange color to paint the face and the visible arm. Paint the trousers which cling quite considerably to the body. First use a watery burnt umber and then add a little cobalt blue for the darkest zone. Water down this last tone and add some orange tone. It can now be used to paint the dark zone on her back, leaving the highlights intact.

3

The trousers are finished with the dark blue tone used to paint the dark area. They are not painted completely. In some zones the white remains intact. The hair is painted with the original burnt umber, darker on top and mixed with an orange tone at the back. The rucksack is painted in two quick goes: first with a very transparent red wash, and afterwards in the shadows with the same tone somewhat more opaque. Finally, when the flesh colors have dries on the face and arm, the small details that define the eyes, the mouth and the gray zone of the shirt are put in.

Nature sketches: a forest

1

Nature sketches are always more ethereal, or moody, than concrete objects as in a still life or a figure painting. If you contemplate a woodland area, like the one shown in the illustration, it could seem that it is a complicated subject because of the quantity of details that appear everywhere. One has to learn to see and to appreciate the impact of the image in just one look. You can see a very symmetrical composition with a bridge dividing it down the middle. Nature must be reinterpreted and improved, as much as is possible, varying the too perfect vertical, or horizontal, elements, such as the plane of the bridge or the verticality of the trees.

2

Here only the lines that demarcate the arch of the bridge and the riverbed, almost hidden by the grass, are drawn. With a great proportion of yellow mixed non-uniformly with green and ochre all the surface of the picture is covered, but for the part below the arch. With a very luminous green the upper shadows are painted: it does not matter if it mixes with the background color. The trees in the upper part are painted with a fairly transparent dark green. The trunks on the right are outlined with a small touch of burnt umber on the dark green. They are not completely vertical but slightly leaning. Paint the bridge with a very luminous burnt sienna wash. Loose strokes will allow the color underneath to show through. The zone under the arch is painted with quite opaque, dark green.

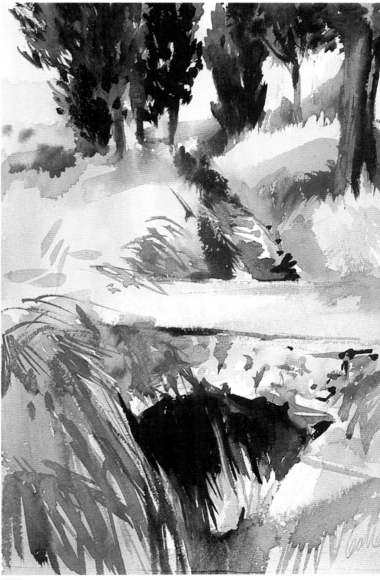

3

Once the preliminary sketch is finished, paint the contrasts that make the terrain and vegetation recognizable. The trees in the background are painted with small supple brushstrokes that allow the light zones to be seen. Add a little cobalt blue to the green to paint the dark part of the trunks and to put some dashes on the grass. Finally, paint the undergrowth with supple, gestural strokes in bile green, dark green and bright green.

Sketches: a cloudy sky

1 One of the sketches that is held in high esteem by watercolor enthusiasts is the painting of skies. All watercolorists frequently paint nature scenes. In this sketch we will do a cloud theme. A hazy model has been chosen, with the backlighting of the sun going down. Clouds can change their shape very quickly; this obliges the artist to work fast. By practicing the sketches proposed here you will acquire skill in rapidly solving the problems of doing skies.

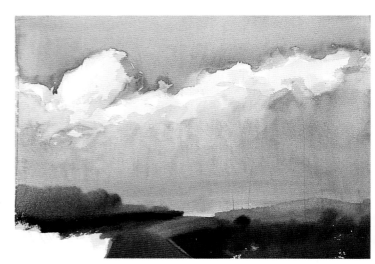

3 In the basic design, a line is drawn that defines the limit of the clouds against the sky. A second line situates the horizon. Starting from this sketch the form of the dirt road is indicated. Wet the brush with clean water and outline the shape of the clouds, without penetrating into the sky area. Paint the gray tones that model the clouds, leaving the highlights intact. Finally, the blue of the sky is painted. as the clouds are still somewhat wet, a part of the color merges at the limit. In this way the excessively sharp definition of the line is broken.

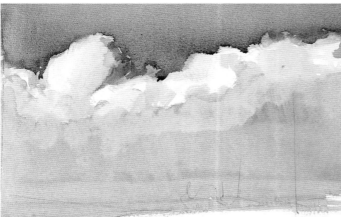

2 A cold gray is obtained with a cobalt blue and sienna wash: this is to increase the contrast of the clouds. While the background is still moist, paint the stains of the horizon that will blend in giving the right atmosphere. The path is painted with carmine mixed with violet and sienna. Add blue and a little violet to the mix on the palette. Use this dark color to stain the right-hand side.

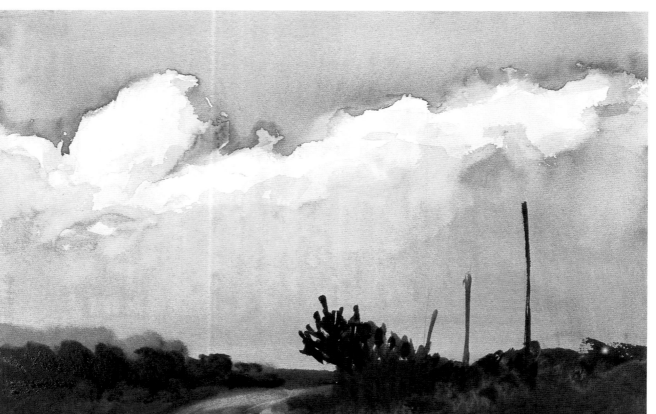

4

With a clean, wet brush a clear space is opened up in the upper part of the path and in the mud in the foreground. The sketch is concluded with contrasts of dark green in the bushes on the left. On the right, the green tone is enriched with dark violet.

TOPIC 19

FIGURE

Painting figures enables a wide range of technical and plastic possibilities to come into play. It is an obligatory reference point for all learners. When painting still life or landscape it is necessary to study the proportions of the different elements in the composition. However, when doing figure the slightest mistake will show the artist up. Proportion and synthesis are the principal foundations on which you build when learning to paint any figure, clothed or nude, correctly. A dressed figure can have the forms represented with stains. Painting a nude obliges the artist to synthesize even more.

Drawing as the basis for color

Drawing is the fundamental base of watercolor. You cannot paint a figure unless you understand the proportions and the forms. Drawing does not mean putting down pencil lines. In fact, you can draw as you paint: loose brushstrokes, stains and negative shapes can all draw the forms. In figure the most important question is observing the proportions between the different parts of the body, whether it is naked or dressed. The internal structure of a clothed body must be the same as a naked one.

FIGURE SYNTHESIS

Figure and painting

There is no object in nature that cannot be simplified into basic shapes in the drawing. When you look at a figure you have to think that it is easier to represent than it seems. However, you have to learn to see the model. The space occupied by the model can be broken down into simple geometric shapes. Construct the form basing your work on simplicity. When you have practice and experience you will be able to do this in your mind's eye.

Constructing the painting

The paint can be applied more easily if there is a basic design done. Figure is a theme that requires careful construction. Once the form has been schematized the light zones can be realized with simple stains. a brushstroke can define a whole plane. Use loose strokes, taking care not to penetrate into the highlights, to mark off the division between shadows and the illuminated area. Sketching is very important to learn how to situate the different planes with the paint.

Joining parts of the body

When you have learnt how to break the body up into simple shapes you will be well prepared to do the basic design.

In figure there are some reference points that have to be borne in mind: the line of the shoulders, the spinal column and the hips. Where they are placed will determine the pose and the look of the figure.

Once the different elements have been placed you can join them together with strokes. Be synthetic when doing this. In the last chapter we saw that sketching teaches you how to paint without unnecessary detail and only to approach the fundamental lines.

Divide the body up into geometric shapes, and then sub-divide it further. Observe the fundamental axes: the lines of the shoulders, the spinal column and the hips. The internal structure of the figure is based on straightforward lines and the way they are joined by color.

Simple geometric forms are relatively easy to represent.

The dressed figure: internal structure

When constructing a figure it is important to do a correct internal structure. This will enable you to give shape and volume to the figure without losing the proportions. However complex the clothes may be you can always observe the lines of its anatomy. Place the head, the spinal column, the hips, the shoulders, and finally the arms and legs. Then on top of this scheme the clothing can be addressed. Whether they are wearing a robe or trousers you will know where the joints are.

Before doing the external form it is advisable to calculate where on the body all the clothes or robes are supported.

Stains to start out

Once the internal structure of the figure has been resolved, the color can start to situate the planes. As always, it is necessary to have clear where the most luminous parts are going to be. The way the color is treated depends on how you are going to work. If you are not going to model with the colors the definite ones can be put in almost from the start. However, if you want to model the figure with the tones, the first stains have to determine where the highlights and shadows will go. The stains and shadow strokes are placed according to the anatomy of the figure. If a light zone will inevitably be adjacent to any shadow it may cast.

Here it is the staining of the shadow that defines the anatomy of the back.

What is contrapposto?

With contrapposto the forms are organized on a curving axis to give an asymmetrical balance to the figure. The way the shoulders and the hips are placed determines a very natural pose, very common in figure studies. One leg takes the weight of the body while the other relaxes. Likewise, the back can also be at ease, depending on the position of the shoulders. Then the hips come up and the shoulder line goes down. The highest hip and the slack shoulder correspond to the straight leg.

This scheme can be applied to a great number of figure pieces. Study it and practice.

Obligatory references

To learn about figure painting it is recommended to study the masters, and not only the watercolorists because proportion is the same concept in all media. In books, galleries and museums you can see how the masters resolved the challenges of the anatomy, proportions and light. It is worthwhile copying the masterpieces. You will learn more than you imagine.

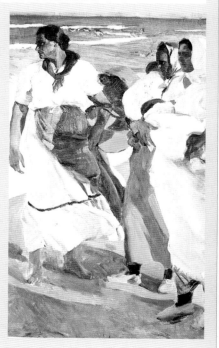

Joaquín Sorolla (1863-1923), Valencian fishermen (1915), oil on canvas, 133 x 201 cm. Sorolla Museum, Madrid. Despite the baggy clothing of these women, their anatomies have been perfectly studied. Observe the highlights in their clothing. The joints, arms and legs are all well defined.

146

Synthesis and form

It is important to control the evolution of the form. Once the elemental form is understood it is easy to do a more definite form.

Elaborating a figure can be broken down into three phases: doing a geometric basic design in which the forms of the model are synthesized.

Secondly, constructing the lines that describe the forms of the model. Thirdly, synthesizing the drawing to describe the model with a minimum of elements. When you have the form of the model, colors and planes created from the tones can enter the picture.

Start with a very simple shape. Just draw the form of the body on the paper.

Here the synthesis of the form is produced by the dark color that goes around the hand, by the shadow that defines the two planes of the hand, and by the fine strokes that suggest the fingers.

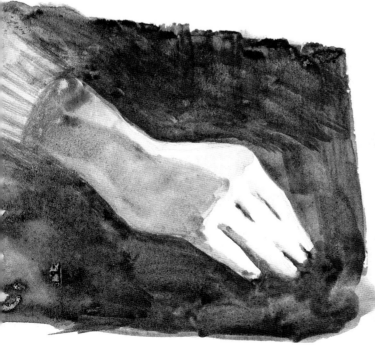

Highlights

When doing figure the placing of the light zones is very important. It is easier to know where to place them than to actually do it. It can be very frustrating for an enthusiast to see, after the hard work of elaborating a painting, how a supposed highlight becomes darker due to the gradation of an adjacent tone. This is not a problem if you know where the highlight must go. If it is covered by color, absorb it with a clean, wet brush. If the highlight has to be perfectly outlined you will have to insist with the brush.

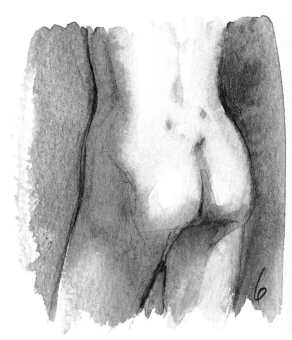

The highlights suggest volume because of the shadow zones that surround it. A highlight can be opened up by absorption or by keeping a reserve intact.

There are two ways to suggest volume with highlights: by using reserves or by modeling with tones.

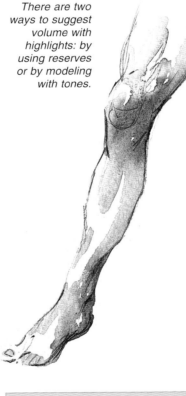

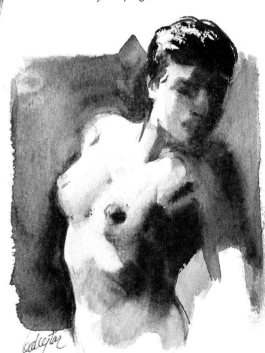

Avoiding geometric shapes

Although it is true that the figure can be started with basic geometric shapes, as you develop the piece you must eliminate the pure shapes. Inexactness gives nature its beauty. A chest may have the form of a trapezoid but it will never, unless this is our plastic intention, have right angles nor straight lines.

From the sketch to the finished figure

A figure is always developed by working on the lines and the original stains. It is important to know when to stop painting and to add tones and colors. Often the artist goes too far and spoils a picture that did not need another layer or transparency. Never clutter.

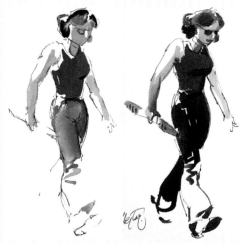

Outline and finished figure. Learn to stop at the right time. Some works are more time consuming than others.

Constructing the figure

The figure construction is based on simple geometric shapes. The basic lines must define the situation of the shoulders, the hips and the spinal column.

Figure with clothes: internal structure

The clothes are painted on top of a perfectly defined anatomic scheme. The folds and highlights depend on the joints and the way the body bends.

From the synthesis to the form

The figure evolves from simple elements, easily to recognize and to represent. On top of this scheme the form is synthesized.

Highlights and light zones

The highlights are defined by the position of the shadows, which must be carefully placed to suggest the right volume. The highlights can be reserved or opened up with a clean, wet brush.

The form through stains and color

The form of the a figure is not only represented by the brushstrokes. Color stains help to express how light falls on an object and the consequent planes. The colors of the figure vary depending in which plane they are painted. A figure has light planes and shadow planes. Even when the difference between the two is minimal it must be represented by the colors of the palette. A figure can be painted with just a few colors, but it will always be more interesting to look at if a plane in the shadow is separated from one in the light by a small tone variation. This tone variation also affects the highlights.

In this figure the forms have been resolved with large stains. There is a subtle difference between the illuminated part and the shadow. The difference also affects the highlights.

Some basic techniques on color

• Mark with luminous stains the principal shadows and reserve the luminous areas.
• The color of skin depends on the light. The skin tone is in part a reflection of the colors around it. A figure can be painted in greenish tones if this is the background color.
• Use the dirty brush water to do mixes. This will join the colors with a certain harmony.

These are some of the commonest colors for the skin.

A classic example
The way Sorolla painted

Sorolla is considered the master of light. His stroke was loose and he took advantage of minimum contrasts to obtain points of great luminosity. Such was his mastery of light and color that even his oils had the vitality and transparency of watercolor. Sorolla painted figure using his deep understanding of the material. His strokes drew together the stains of two different planes. When he superimposed two tones or colors, the intersection formed a third, darker tone which he took advantage of to suggest volume, or a shadow, or a fold in the clothing.

In this piece he used a wide chromatic range to do the skin colors. Note how, despite the superimposition of tones, he always respected the highlights.

Old man with a cigarette (1899), watercolor, 50.5 x 52 cm. Sorolla Museum, Madrid.

After a very concise drawing, do the first color stain on the wet background.

On top of the already dry color base, add the contrasts that give the skin its tone and the shape of the features.

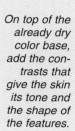

A clothed figure

Necessary Materials

- TUBE COLORS
- 2B PENCIL
- 250G MEDIUM GRAINED PAPER
- FLAT AND ROUND WATERCOLOR BRUSHES, PREFERABLY SABLE HAIR
- STICKY TAPE.

If a lot of attention must be paid to the subject, this is even more so with the figure. Before starting to draw you must try to comprehend the internal structure of the figure, and how the proportions of every part of the anatomy relate to the volume of the clothes on the body. Observe the model and try to guess which way the hip is leaning in comparison to the body.

2

Once the drawing is completed it can be painted. It must be done in a chromatic order that allows continuous work in different parts of the body with the colors mixed in the palette. Firstly, stain the hair with a red, blue and touch of sienna mix to give a violet tone. Leave a highlight reserved. Start on the skin color which will be a vivid yellowish orange. Again the highlights are left intact. You must not always paint with the same color intensity: water down the paint according to the light. The raised arm is painted with an intense color. Also use it on the face, but the left-hand side is less dense. Water down the paint. Finally the relaxed arm is painted with a very transparent wash. Once the color is dry the shadows on the face are painted in sienna.

In the last chapter we saw the process for doing sketches and how synthesizing forms helps us to develop complex forms. The figure is sketched with rapid strokes. Observe the proportion between the different elements of the body and how the principal lines relate to each other. Not one detail is drawn, and the lines that mark off the volumes are corrected as you go along. To make the drawing easier to understand the line of the shoulders and of the hips have been schematized. Special attention must be paid to the relationship between the axes of the figure.

1

3

It is the highlights that permit the volumes of the face to be suggested, and the change of tones denotes the different planes. With a vivid red the lips are drawn. The waistcoat is rapidly painted and the highlighted area of the beret. With purplish blue you paint the rear leg, taking color away from the thigh to suggest volume. The leg in front is painted in the same color as the other, but in a much more transparent tone.

4

Once the principal shading of the figure has been decided upon, start painting the contrast of the shapes and volumes, working from the shadowed areas. In this work there is no modeling of the colors, only valuation of the different tones on top of the dry background. Each original tone receives a color from its own range, superimposed, to suggest the volume. The arm holding the beret is rounded off with some brushstrokes of sienna, giving it shading. On the darkest leg the shadow is painted and the folds of the trousers are painted in with blue strokes. Be careful when placing the creases and highlights in the clothes: they must reflect the shoulders and the knees.

5

In the same way that the folds of the trousers have been painted on the left leg, now the same is done on the right. The original blue color is the base of the darker tone that is applied now. On the left leg the tone tends towards violet. The right leg is painted with a much purer, but highly luminous, blue. The shoes, with the highlights left open, are painted black.

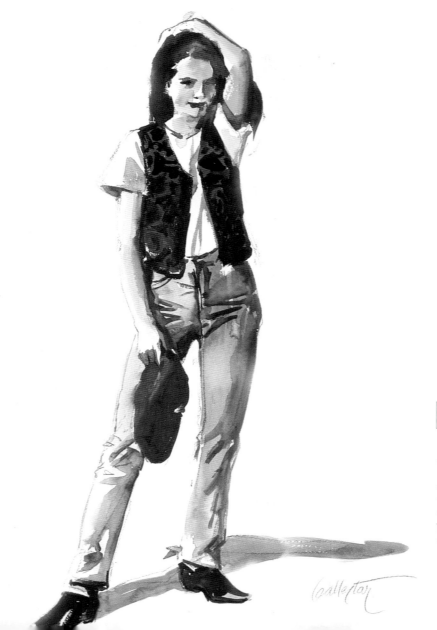

6

Take off part of the color next to the thumb and paint in a new very transparent layer of the same color on the arm. All that remains to be done is the shadow cast on the floor. Thus the sketch of a dressed figure is concluded. The importance of waiting for the paint to dry when superimposing tones without them mixing has been seen, and how the synthesis of color reinforces the original drawing.

A nude figure

Necessary Materials

- TUBE COLORS
- 2B PENCIL
- 250G MEDIUM GRAINED PENCIL
- FLAT AND ROUND WATERCOLOR BRUSHES, PREFERABLY SABLE HAIR
- STICKY TAPE.

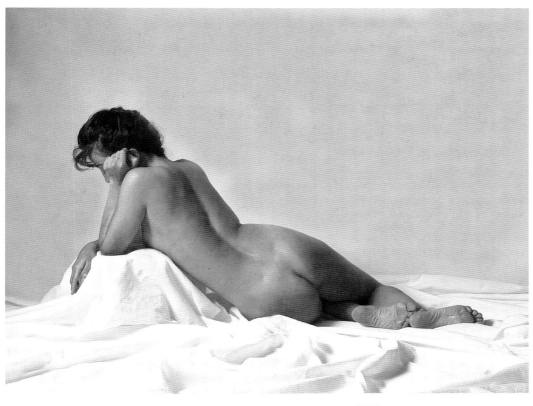

A naked body is more complex than a clothed one. The cloths can hide the greater part of the anatomy so the study of the forms has to be done with a very well-structured scheme. This exercise does not propose a very complicated model. The main challenge is to suggest the volumes with the shadows. On top of the picture that will be used as a model some lines have been superimposed to make it easier to sketch the principal planes. The lines 'a' and 'b' correspond respectively to the lines of the shoulders and hips.

1

Starting from the simple geometric shapes drawn on the model, outline the figure. The back fits into a trapezoid, the pelvic zone from the waist to the hip fits into a square, and the legs and feet into a triangle. From these forms it is easy to define the basic anatomy of the model. The drawing must be perfectly finished before starting to paint. Once it is done, start painting the dark areas with burnt umber.

Continue to drag the color over the back. If necessary add more color, previously gradated in **3** the palette. It is easy to get the right tone for the skin with a transparent layer. As the paper is wet, it will be able to take more sienna on the side. All of this blends easily to suggest volume. Add a little faint violet around the armpit. Leave a reserve for a highlight in the lumbar region. Mold the buttocks in the same way and blend in burnt umber. Add a new transparency of greenish yellow which mixes with the other interventions.

2

With wet, clean brushstrokes color is dragged from the back in a soft gradation, reserving the strip of the spinal column. The process is continued with the shadow of the legs which defines the round shape of the buttocks and frames the shadow of the hip.

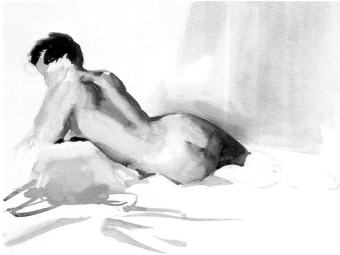

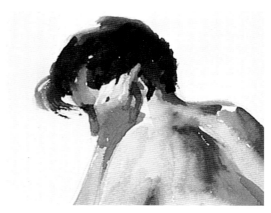

5

When superimposing tones or planes, synthesis or summary should be the main objective of the artist. A lot can be explained by well-placed shadows and by omitting unnecessary details. Therefore, to paint the hand the fingers are not drawn. This part is resolved with the dark shadows that surround the illuminated area. The back of the hand is contrasted with a slightly bluish burnt umber. The fingers are defined by the dark hair and the darkness of the shadow on the face. Finally, the shadow of the ear is painted. In turn, this defines the thumb. Use the same color to do a small stroke at the finger joint, like a shadow between the ring finger and the middle finger.

4 Give more definition to the armpit shadow. Paint with the background dry. Paint the hair in a tone obtained from mixing burnt umber and cobalt blue. It is important to bear in mind the way the figure integrates into the picture. As you can see, the skin color is determined by the lighting that surrounds it. Do a very transparent burnt umber and blue wash. Alternatively, the dirty brush water will do because it contains all the colors that have been used. Use one or the other to paint the background in a non-uniform way. Around the hip, increase the blue tone. Note the way in which the hand is painted. The fingers are defined by the highlight.

To paint the feet the contrast of the shadow of the legs is intensified and the most luminous areas are defined: the right calf muscle and the soles of the feet. The latter are painted with a very transparent burnt umber wash and a dash of blue. The brightest parts are left white. **6**

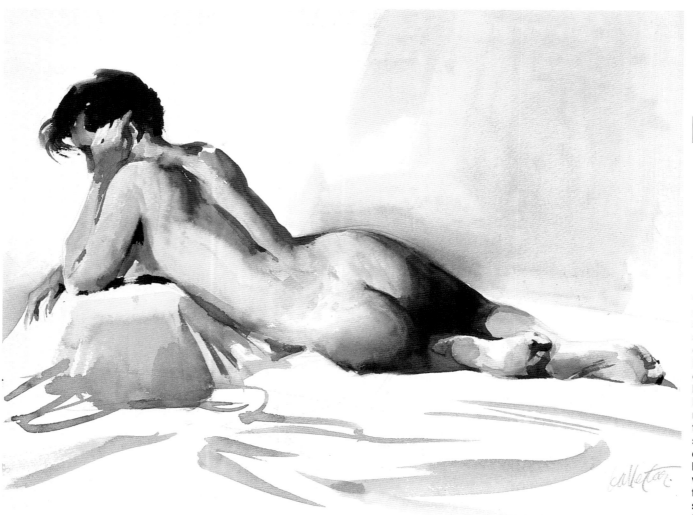

7

The contrasts of the soles of the feet are intensified with small brushstrokes that outline the highlights of the toes. The tone painted before must be completely dry so that the colors do not mix. The brush is wetted and drained off prior to gently brushing the shadow of the legs so that they have depth. Finally, the inside of the leg is contrasted and the buttock is defined. Pay attention to the modeling of the buttocks: the brushstroke must be curved and must blend the colors without destroying the shadows as it softly superimposes the tones.

TOPIC

NUDES

The human body is one of the most complex themes. It offers the artist many plastic possibilities. Although any pictorial theme is suitable for watercolor, the nude challenges the artist in such a way that it can be approached in diverse styles.

When painting nudes a whole series of questions and styles of representation come into play: composition, drawing of the anatomy, proportions, chiaroscuro, modeling and the color of the skin.

This theme has always been depicted in all art forms, since the beginning of time. However, the nude has never ceased to generate interest.

ANATOMY AND VALUE

The anatomy in watercolor

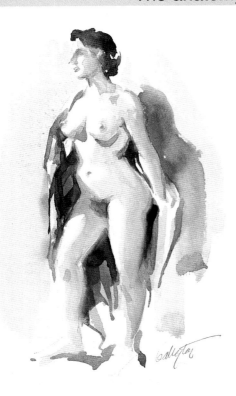

The nude is by a long way the most demanding theme that can be painted. A painter who can do a nude correctly can do any other theme. All the watercolor techniques can be brought into play when doing a nude. As the model represented is easily recognizable by the spectator any error will be discovered.

Representing a nude figure is the most complex theme that a painter can attempt.

Plane and volume

The principal problem for a watercolorist, once they have overcome the hurdle of doing the drawing, is how to represent the forms through tone and color. It should not be more complicated than for other themes. A body is painted in stages. Firstly, the drawing, then value from tones, and finally, if necessary, modeling. The different planes of the figure are joined together by the light that impacts on them. Volume can be suggested by the valuation of the shadows and the blended tones in the modeling.

It is important once the drawing is done to get rid of any pure shapes. An arm is not a tube, nor is a back like a box.

After doing the drawing and the forms, volume can be given to the latter by the shadow values and the modeling.

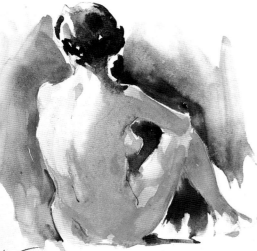

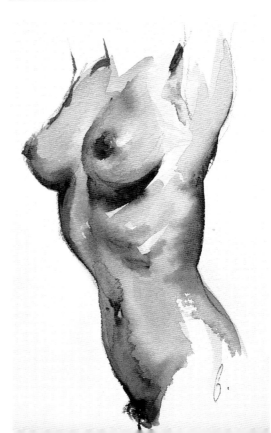

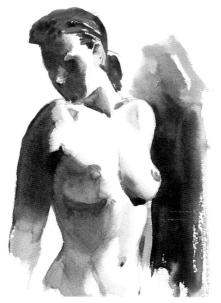

The shadow defines the forms

When the figure scheme has been correctly drawn you can set about suggesting volume by painting. Each body part casts its own shadow, although it is not always very noticeable. Everything depends on the lighting.

The positions of the first shadows suggest the volumes of the body. Once they are defined the work can continue with tone valuation or by modeling.

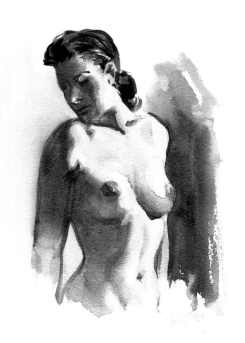

After the drawing the first stains situate the shadows cast by the different parts of the body.

The later work can be modeling, or as in this case, a simple valuation.

The overall effect and the details

Stain synthesis can represent aspects that when looked at on the model seem complex. Expressing forms through stains is based on the interaction of the planes. The darkest ones mark off and define the most luminous points. In the same way that a dark background can make the figure stand out, the dense colors or tones can outline the highlights. When you manage to construct part of the body using a dark tone, the details must not be exhaustive: they can be expressed through the adjacent dark tones. For example, if you have to paint a foot, do not paint it toe by toe. Suggest the details with the surrounding tones.

The dark tones outline the light tones. Similarly, the details are insinuated by the tones around them.

Get the contrast right

A common error among many enthusiasts is that they understate or omit the contrast effects when doing figure. Contrasts are necessary to suggest volume. You can establish a maximum darkness beyond which you must not go when doing the shadows. Just as a lack of contrast means that the volumes are understated, an excess of contrast will make the mid tones disappear.

Magazines and photos

An artist does not always have a person willing to pose as a model. Often they will have to rely on photos. You can find them in magazines and they allow you to appreciate the principal volume from the shadows. If you use pictures from magazine they should be good quality, with natural colors. Different exercises can be practiced like doing simple body studies with light, shadow and tone modeling effects.

Some high quality, good taste erotic magazines can offer the artist good models for representation.

Background and figure

When representing a figure the background must not be forgotten. This is very important because the final result of the work will depend on the relationship between them. It must be established from the beginning. Of course, the background can be left unpainted but this does not mean that it does not exist. If a figure is painted on a white background all the tone contrasts are influenced by this decision. If, alternatively, the background is painted once the figure work has been finished, it is likely that all the value and modeling work will change because of the new contrast.

Avoid cuts in the color

The cuts which are produced by superimposing washes can spoil any nude watercolor work. The skin must have a continuous texture so as to situate the different planes of the body. If by error a cut happens, you will have to try to blend it with the background. Another way of solving the problem is to make it part of the figure itself, for example, as a shadow.

Reserves and color absorption

When modeling a nude the brushstroke describes the part of the body that it is painting. As the form is modeled the new highlights are opened up by absorbing color. A highlight reserved from the beginning is not the same as one opened up by color absorption. The reserve can be perfectly outlined against the surrounding tone. Absorption highlights are always much more integrated into the zone: the edge remains diffused. Both techniques are combined when doing a nude, and allow different grades of lighting around the figure to be suggested.

Test the color before painting

Modeling the figure can be a complex task if the wrong tone is added. It is often difficult to know the result of adding two colors together. Always have available some paper of the same quality as that used in the definite work. You will then be able to test colors and washes

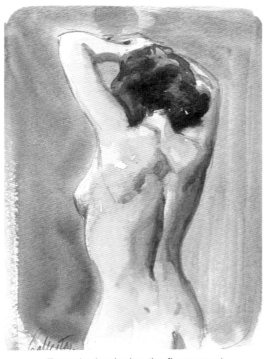

From the beginning the figure must be compatible with the background.

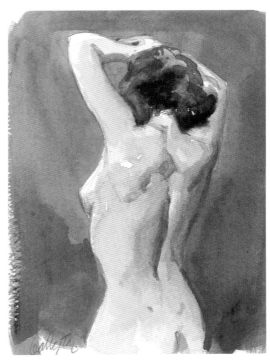

As the background changes so too will the figure contrasts.

Treat the color softly

Unless there is an atmosphere of direct colors and lights, the skin tones in the figure must have soft tones. This does not hold for impressionist or expressionist work.

The skin can reflect all sorts of colors so the work done with the palette is delicate. When the paint touches the paper it must have been studied beforehand so that the blend is subdued: avoid clashes. Skin colors can be enriched with little quantities of blue, yellow or green. The results should be low key, and not strident.

Tone blendings on the skin can give many colors which will be studied on the palette before going to the paper. Always get the proportion right. The stroke direction influences the modeling. The highlights opened up by absorption are integrated into the half-light zones.

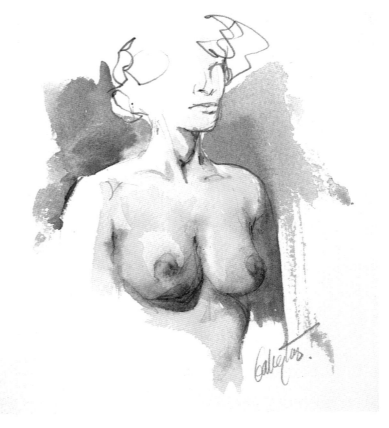

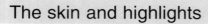

Hard and soft contrasts

The quality of the contrast is determined by the amount of light that falls on the model. Hard contrasts, as we saw in the modeling chapter, eliminate the midtones and their blending effects. This type of shadow is very common when doing quick sketches because they allow you to do a body with a few stains.

Soft contrasts are part of the modeling of forms. While doing a nude you have to decide what type of shadows you are going to use. Hard shadows are approached as darks from the beginning, while soft contrasts are gradually intensified on the figure.

The skin and highlights

The light around the model determines the color of the skin and the highlights. In the later stages of working on the figure the highlights are not always white. In fact, rarely is a pure white highlight left. The highlights are nuanced with color layers according to the light in the atmosphere. Therefore, we can do cold or warm highlights independently of the skin color.

Light and the skin color

The skin color is also a product of the light around the model. The light reflected by other objects has to be taken into consideration. If the figure is lying on a red sofa, this color will influence the nearby skin tone. The shadows will be saturated in red. Although a figure is realized without a determined background the lighting can be suggested by the shadow tones or the color of the light reflected in the skin.

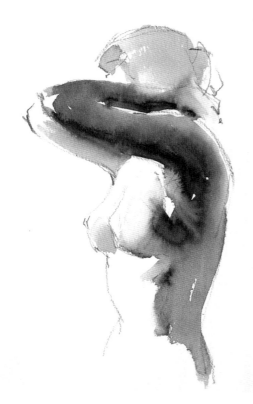

A classic example

The way Anders Zorn painted

This great Swedish painter was a brilliant engraver. Previously he had studied sculpture which gave him two advantages when it came to understanding figure: he had a clear idea of how volume worked and how it was modeled by shadow. Working as an engraver helped him to synthesize forms. This was noticeable in the virtuosity of the intimate or everyday scenes that he painted.

In this Zorn piece he combines contrapposto with movement. The highlights on the girls' bodies vary in intensity and color, perfectly describing the mood in the room.

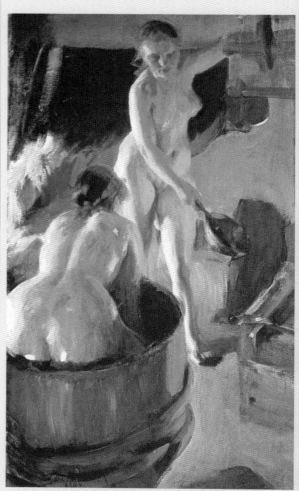

Anders Zorn (1860-1920), Girls from Dalècarlie having a bath, *oil on canvas, 1906. Nationalmuseum, Stockholm.*

Using hard contrasts allows the volumes to be seen rapidly. Even when we are going to do value work it is recommended to do a quick sketch in one tone to calculate the shadows.

The nude composition

Do a scheme of the figure based on geometric shapes. Later all the unnecessary lines will have to be removed.

Background and figure

The forms are decided by the shadows.

Shadow defines the forms

A dark background can be behind a light figure. Depending on the contrast, the tones of the figure will have to be compensated.

Light and the color of the skin

The color of the skin depends on the light that falls on it.

EXERCISE

A nude

It is possible that this is the most complex exercise we have done in the twenty chapters. A naked body presents many challenges: volume, proportion, the skin color etc. Do not lose heart: it will be possible for you. It is a question of study and mastering the techniques. The drawing is the first question that will be studied so the model must be looked at closely. Even though it will make it more difficult as far as is possible do the exercise with a real model. If you cannot find one, use a photo.

Necessary Materials

- TUBE COLORS
- 2B PENCIL
- 250G MEDIUM GRAINED PAPER
- FLAT AND ROUND WATERCOLOR BRUSHES, PREFERABLY SABLE HAIR
- STICKY TAPE.

If in other themes the drawing was important to be able to do the watercolor well, in nudes it is even more so. If the basic design is not well-constructed the proportions and the connections between the forms will be impossible. Look at the model: the shoulder line is sloped to the left, the hip line is in contrapposto towards the right. As one hip is slightly higher, the spinal column is curved a little.

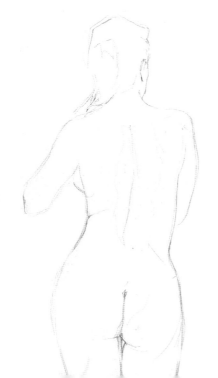

2

Start by painting the background to isolate the figure and to be able to establish the darks and the highlights from the white paper. The background is painted with a violet tone, done with carmine, cobalt blue and burnt umber. This color is applied very watery so that on the paper it takes on a luminous gray tone. Paint the hair with a very dark color, but leave the highlights intact. Stain the dark part of the face with sienna and burnt umber. Starting from the line that marks the spinal column start the painting of the back. Observe how the modeling is started on the background: sienna and a bit of carmine are used for the spinal column. Add a bit of luminous green to integrate the figure with the lighting. Leave the highlight on the arm reserved.

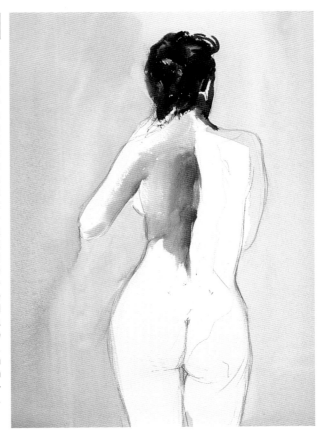

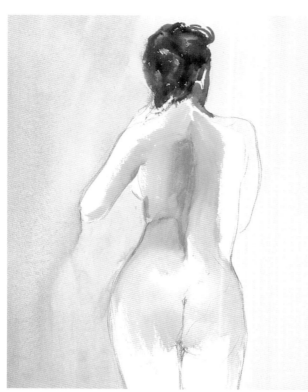

4

Continue to model the back, but first establish the maximum tone values so that you can blend the tones. Pay attention to the right-hand side. Do a dark transparent color with burnt umber and a little carmine. Use it to paint the arm and the right part of the back. Reserve the highlight that is reflected in the right scapula and gradate the tone towards the center of the back. In the neck zone and on the right shoulder leave a tone that outlines the figure. Intensify the contrasts of the shadows on the back with burnt umber mixed with sienna. Stain the shadow; it will later be blended.

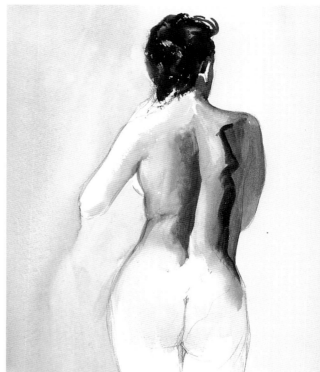

3 Water down the sienna tone until it is more transparent. Wet the brush and drag part of the color from the back towards the lower part where the highlights of the coccyx have been reserved. With a somewhat darker tone paint the right-hand side of the back and gradate the color until the lower right part is covered.

6

In this brief process you can clearly appreciate the modeling of the left buttock. Firstly do the stroke that marks the edge of the shadow and gives pert volume to the buttock. Then clean and drain off the brush to blend this zone, eliminating cuts between the tones. The lower zone is left somewhat darker to suggest more volume. In the area that has just been painted the lower part of the triangle is lighter.

Before the vertical stain on the right of the back can dry, model this zone. The modeling process is started with a clean brush, dragging part of the color towards the dark part until it blends into the background. The arm plane is now separated. Also model the hip using a curved stroke to give shape. Darken the right leg from the buttock downwards using a reddish color that marks the beginning of the shadow. Water the same color and paint just one stroke on the dry background **5** to do the contrast on the left buttock.

7

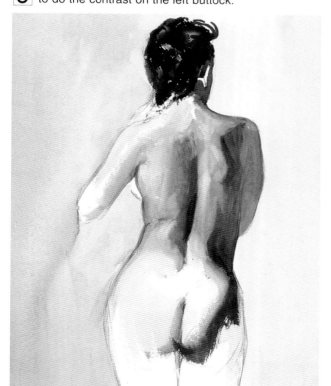

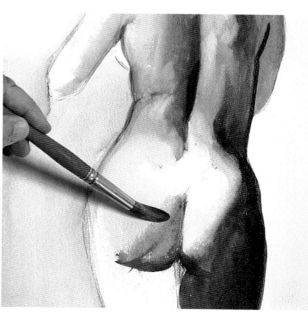

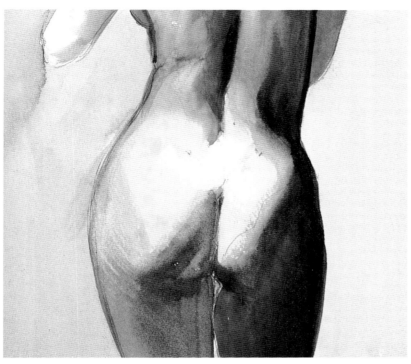

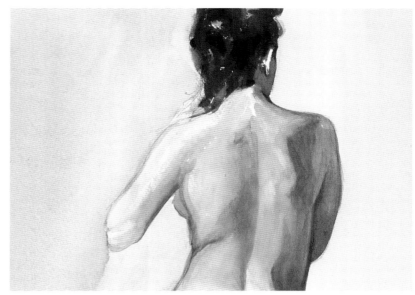

has to be made clear that the right arm is separate from the back, because up to now they have been in the same tone. Use very dark burnt umber and draw accurately from the armpit until the hip. When this color reaches the hip it must be blended with the warmer color. Do not wet the dry color because you must not open up a highlight. Insist with the dense color until you blend it with the lower tone. **9**

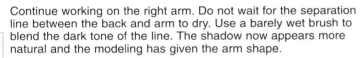

8 Use the same tone wash as before to blend the color of the left leg but keep the contrast with the buttock. Model the leg by gently increasing the tone in the middle. On the inside of the thigh the brush-strokes are vertical, while, as you near the hip, the tone blending is done with curved strokes to give shape. Make this tone more transparent and take advantage of it to darken the buttock. Use the clean, wet brush to open up a highlight in the shadow triangle.

As you can see, a high number of tones have been used for the skin. In this exercise sienna, umber, green and carmine have come into play. Now the part of the ear that had been left white is painted in a reddish umber tone. If it had been painted with the dark tone of the face, the red would have lost its luminosity. Modeling is visible in every detail. The ear is not painted with a uniform color: in the middle take away some of the excess color. Use a thin brushstrokes of burnt umber to outline the inside edge of the raised arm. Blend the tone to give volume to the arm. It is important to respect the illuminated zone. **11**

Continue working on the right arm. Do not wait for the separation line between the back and arm to dry. Use a barely wet brush to blend the dark tone of the line. The shadow now appears more natural and the modeling has given the arm shape.

10

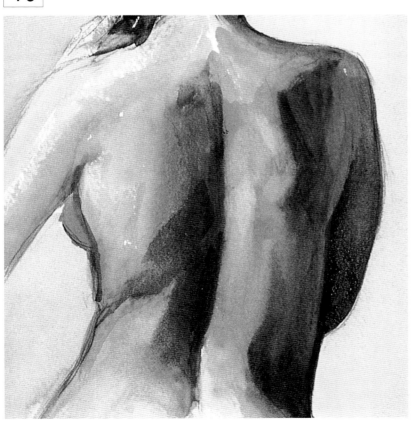

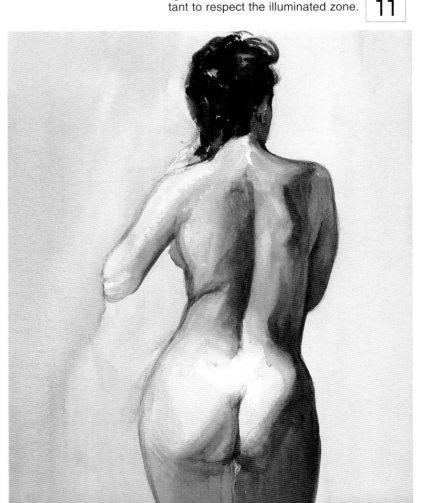

12

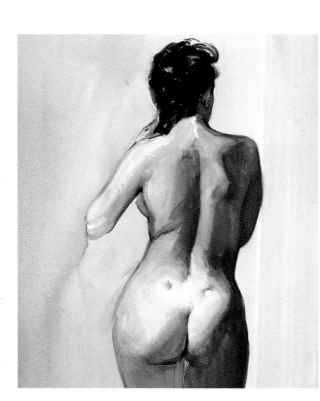

The tone and modeling work on the body has now finished. In the following steps we are going to add the necessary contrasts to round off the volume effects. Without contrasts the volumes would appear flat. Burnt umber mixed with cobalt blue can be used to obtain near black tones which will permit cold or warm tendency contrasts, depending on the proportion of the colors added in. If you are after a violet tone shadow, add a little carmine. Add another fine dark line, tinged towards burnt umber, to the inside of the arm. Wash the brush and blend the tone below. Use the same color to increase the contrast between the two buttocks. Use burnt umber to paint the dimples of the coccyx. Do a reddish brush-stroke on the right side of the back and darken the right arm.

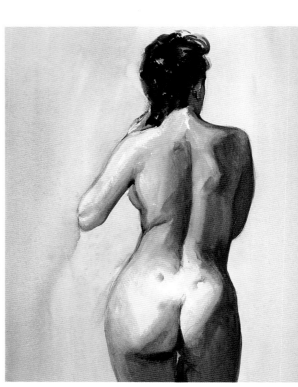

13

Continue working on the shadow con-
trasts, now on the lower part of the
body. Intensify the dark tone on the
left buttock above the leg. Paint the
shadow of this same buttock which
falls on the other buttock. Water
down this tone and without soaking
the brush, darken the leg. On the
inside right thigh do a thick, uniform
dark brushstroke.

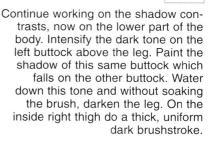

14

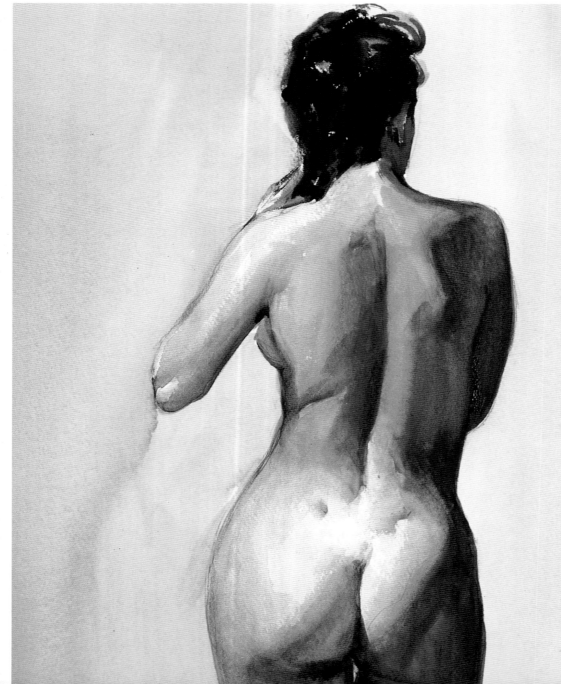

Use a clean, wet brush to take away part of the color from the left leg. Modify the shadow on the right. Finally, pass the brush wetted in burnt umber over the gluteus several times to give it shape. Before this shadow is dry, insist with the clean, wet brush until you open up a luminous strip. In this way you finish this nude work. It is advisable to revise it and to check on the principle techniques using other models, preferably natural ones. Photos can also help the learning process. Never forget that skill and experience are acquired with practice. Artists must express themselves freely. Paint every day, even if it is only a little. In every session you will learn to express your creativity more naturally.